Vanguard Productions

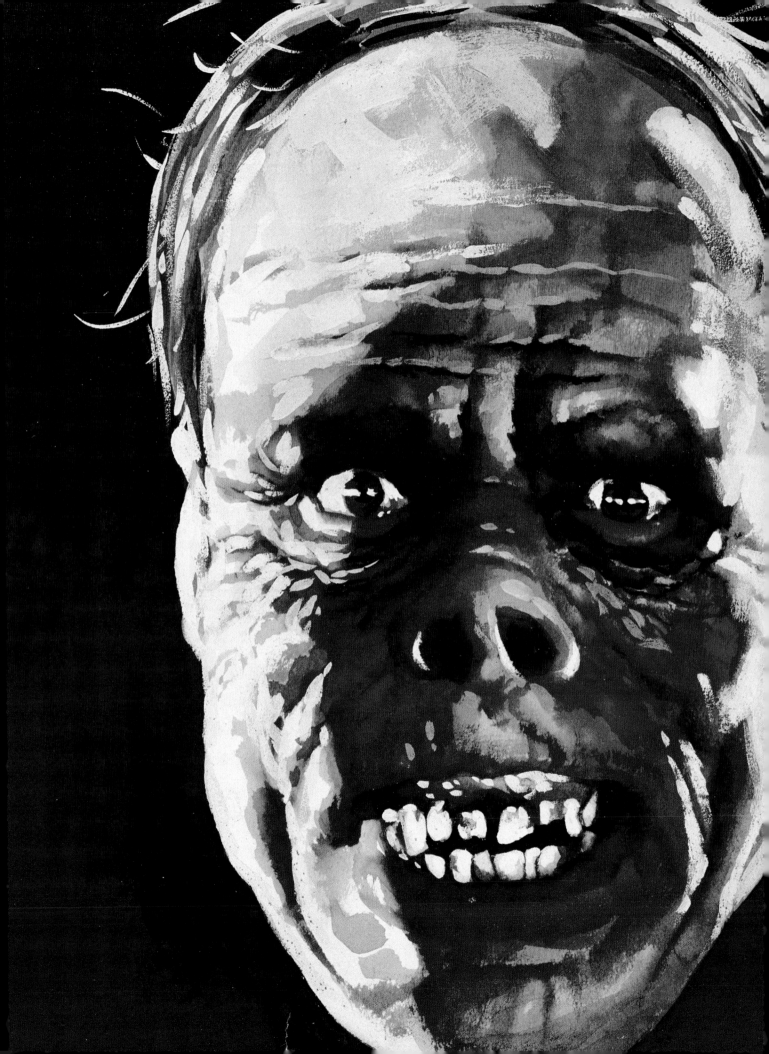

Famous Monster Movie Art of

Basil Gogos

Vanguard Productions

Dedicated to
Linda

Written, Designed and Art Directed by
Kerry Gammill and J. David Spurlock

Production and Design Assistance by *Dean Motter*

Additional production by Renae N. Essinger, Andrew E.C. Gaska,
BLAM! Ventures LLC, Jon B. Knutson and Peter Wallace.

Special Thanks to the following individuals for their assistance and contributions:
*Rob Zombie, Vincent Di Fate, Doug Murray, Roger Corman, James Bama, Rick Baker, Stephen D. Smith, Rich Oberg,
Ernest D. Farino, Ken Kelly, Greg Theakston, Dan Zimmer, Richard Halegua, Ron Borst, Greg Nicoterro, Tom Horvitz,
Daniel Roebuck, Dov Kelemer & Sarah Jo Mark, Neal Adams, Martin Arlt, Taylor White, David Villiard, Fred Taraba,
Thomas C. Rainone, Samuel M. Sherman, Forrest J Ackerman, Thomas Blackshear, Jaqueline Touby and Sam Calvin*

Images courtesy of: Richard Halegua: pg. 20; Illustration House, Inc.: pgs. 32, 34(l), 39(b), 41, 43, 44 (b), 45, 49(t), 54 (t); Thomas C. Rainone pg 46, 108;
Rich Oberg: pgs. 44 (t), 50-51, 64-65; Doug Murray: pgs. 73 & 86; Ron Borst, Hollywood Movie Posters: pg. 75; David Villiard: pg. 135 (t);
Dov Kelemer & Sarah Jo Mark: pg. 105; Martin Arlt pg. 137, 138; Rob Zombie: pgs. 156 & 157; Daniel Roebuck: pg. 158.

Deluxe Signed Slipcased Hardcover ISBN 978-1-887591-73-7 SOLD OUT
Regular Hardcover ISBN 978-1-887591-72-0 $39.95 • Paperback ISBN 978-1-887591-71-3 $24.95
1st Printing Christmas, 2005 (in stores March 2006) • 2nd Printing, July 4th, 2006
3rd Printing, Halloween, 2007 • 4th Printing, Halloween, 2009 • 5th Printing, Christmas, 2011

www.vanguardpublishing.com

Printed in China

C O N T E N T S

INTRODUCTION
by Rob Zombie

RIGHT:
Cover art for the Rob Zombie
CD, Past, Present and Future
by Basil Gogos (2003).

Rob Zombie is the former
frontman for the heavy metal
band, White Zombie. *His*
solo CDs Hellbilly Deluxe,
Past, Present and Future *and*
Rob Zombie presents The
Words and Music of
Frankenstein *featured cover*
art by Basil Gogos. Zombie
recently turned to film making
directing the horror hits
House of 1000 Corpses *and*
The Devil's Rejects.

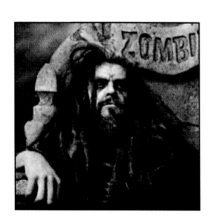

Before we get started let's define "genius" shall we. One of the many definitions of genius is "extraordinary creative power." Hmmmm… that sounds good. As we all know, genius comes in many strange and bizarre configurations, but unfortunately it is often overlooked due to the surrounding package it arrives in. Surely everybody is ready to call Mozart a genius or Picasso or even Charlie Chaplin. But, hell, add in a little fantasy or a horror twist and all bets are off. I can clearly remember back to my high school days spending many an hour arguing with my art teacher that Frank Frazetta was an amazing painter. "That's pure ridiculous teenage junk," I was told in that arrogant tone only a teacher can disburse. Of course all she saw was barbarians and sexy slave girls… I saw genius and, well, sexy slave girls. I think history has proven me right on that subject. Ain't that right teacher?

Anyway, why am I rambling on about Frank Frazetta? Well, because in the wide world of fantasy illustration taken to the level of high art only one other name comes to mind and that name is Basil Gogos. Once again this particular genius was brought to us all in the most oddball of packages… a seemingly lowbrow monster magazine. I am of course referring to the trailblazing, groundbreaking much beloved seemingly lowbrow monster magazine known as *Famous Monsters of Filmland.*

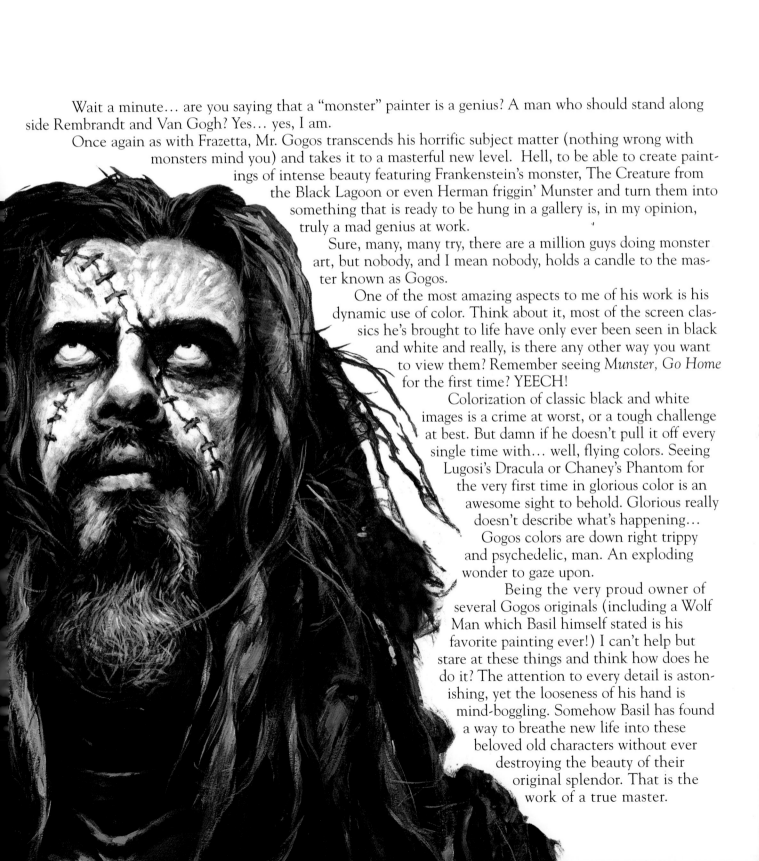

Wait a minute… are you saying that a "monster" painter is a genius? A man who should stand along side Rembrandt and Van Gogh? Yes… yes, I am.

Once again as with Frazetta, Mr. Gogos transcends his horrific subject matter (nothing wrong with monsters mind you) and takes it to a masterful new level. Hell, to be able to create paintings of intense beauty featuring Frankenstein's monster, The Creature from the Black Lagoon or even Herman friggin' Munster and turn them into something that is ready to be hung in a gallery is, in my opinion, truly a mad genius at work.

Sure, many, many try, there are a million guys doing monster art, but nobody, and I mean nobody, holds a candle to the master known as Gogos.

One of the most amazing aspects to me of his work is his dynamic use of color. Think about it, most of the screen classics he's brought to life have only ever been seen in black and white and really, is there any other way you want to view them? Remember seeing *Munster, Go Home* for the first time? YEECH!

Colorization of classic black and white images is a crime at worst, or a tough challenge at best. But damn if he doesn't pull it off every single time with… well, flying colors. Seeing Lugosi's Dracula or Chaney's Phantom for the very first time in glorious color is an awesome sight to behold. Glorious really doesn't describe what's happening…

Gogos colors are down right trippy and psychedelic, man. An exploding wonder to gaze upon.

Being the very proud owner of several Gogos originals (including a Wolf Man which Basil himself stated is his favorite painting ever!) I can't help but stare at these things and think how does he do it? The attention to every detail is astonishing, yet the looseness of his hand is mind-boggling. Somehow Basil has found a way to breathe new life into these beloved old characters without ever destroying the beauty of their original splendor. That is the work of a true master.

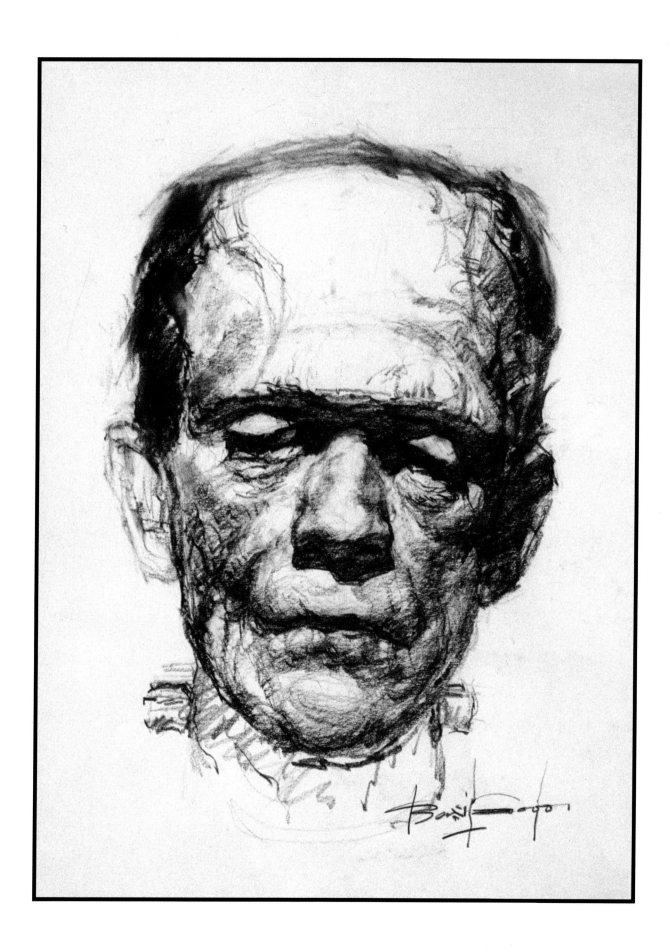

FOREWORD
by Kerry Gammill

Basil Gogos has been one of my artistic idols since 1965 when I feverishly ripped opened a package marked "Captain Company" containing priceless treasures—early back issues of *Famous Monsters of Filmland* magazine. Finally, I got my first up-close, full-color look at the image of Claude Rains as The Phantom of the Opera on *FM 10*. Through the eye holes of that motionless mask, I gazed into the soul of a scarred and misunderstood madman majestically cloaked in red, represented by bold strokes of paint and washes of color. It seemed incredibly realistic, but with an energy no photograph could capture. It had the spark of life that can only be granted by the hand of a loving creator. Well, maybe those exact thoughts didn't gel in my eleven-year-old mind, but I knew what I was seeing was really cool.

Those early *Famous Monsters* covers have become classic images of the "Monster Kid" era when it seemed every boy in the country had plastic models of Dracula or Wolf Man on his dresser and the high point of the week was the Saturday night horror movie presented by whatever ghoulish host the local TV station could dream up.

Although he painted strange characters in bizarre colors, Gogos never looked down on his subjects or his audience. His work possessed the slick, professional quality of the great commercial illustrators like Norman Rockwell, Austin Briggs or Haddon Sundblom and his talents provided the monsters with an aura of dignity and respect seldom bestowed on such misshapen creatures.

When I first met Basil Gogos several years ago at a horror fan convention I was surprised by the amazing amount of art he had turned out in recent years to supply the demands of monster fans eager to own prints or original works by the master monster artist. Each time I saw him he had more incredible drawings and paintings. The fact that there was not a book filled with these masterpieces grew more and more difficult to accept. Gogos said there had been talk of it before, but nothing had ever come of it. I became determined to make it happen or die trying.

I approached my friend J. David Spurlock at Vanguard Productions who had dragged me into the art book world a few years ago with the publication of *Kerry Gammill's Drawing Monsters and Heroes for Film and Comics*. A Gogos fan himself, David enthusiastically saw a Gogos book fitting well into Vanguard's extensive series on great fantasy artists and jointly we set about the task of tracking down as much of Basil's art as we could.

Although it was a challenging task at times, David and I were eventually able to gather a record number of the classic Gogos monster portraits from the 1960s and 1970s. Our goal was to present them in the purist form possible, preserving all the richness of the originals. In addition to many of those classic pieces, we have collected an abundance of Gogos' more current monster paintings and drawings which are just as powerful as his earlier monster works.

Although Gogos is most famous for his vivid monster portraits, David and I were determined to represent the full spectrum of Basil's career feeling that his fans would enjoy seeing examples of this versatile artist's work in other areas. A major portion of Gogos' livelihood in the 1960s came from producing covers and interior illustrations for the wild and wooly field of men's adventure magazines. While not the most sophisticated of publications, they provided work for many excellent artists of that time including Norm Eastman, Norman Saunders, Mort Kunstler, James Bama. Seeing Gogos' art from this colorful and often outrageous magazine genre will offer readers a fascinating look at what was one of the last havens for realistic artists during the waning days of the era of great magazine illustration.

My thanks to my publisher and co-editor, J. David Spurlock for allowing me to be a part of this historic publication. It has truly been a labor of love. Thanks also to the many people who have supported this project with information, encouragement or contributions from their collections. They all helped to make this dream project a reality.

Most of all, thank you, Basil Gogos for your cooperation and assistance, and for the decades of inspiring art that did so much to make being a classic horror movie lover an even more delightfully unique experience.

— your friend and admirer,
Kerry Gammill

BASIL GOGOS
A Colorful Life

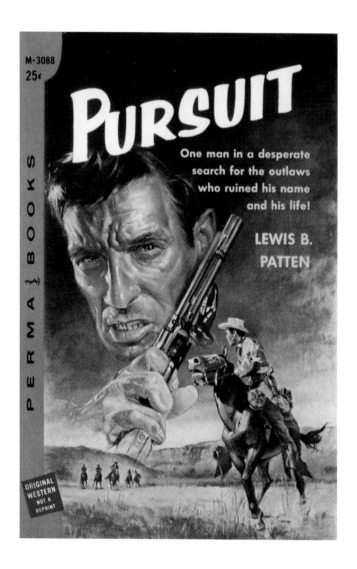

Basil Gogos' first professional illustration, the cover (in oils) for the Western novel Pursuit *by Lewis B. Patten (Pocket Books, Inc., 1959)*

Basil Gogos exudes the kind of Old World charm you might expect from someone with such an international background as his. "I'm from Egypt, of Greek parents," explains Gogos. "I lived my younger years in Egypt. I went to Greece for the first time when I was nine years old. I love Greece."

Although he spoke Greek, Arabic, and some French, Basil spoke very little English before his family came to the United States when he was sixteen. A few years earlier he had begun to show a talent for art. At first it seemed like his older brother would be the artist of the family, causing Basil to shy away from displaying his own creativity. However, when his brother suddenly lost interest in drawing, Basil picked up the pencil and was soon impressing people with his natural ability.

Basil's family was always supportive of his passion for art. "My Uncle Nicholas was a tremendous painter who made a living as a fine artist," says Gogos. "He was very encouraging. My grandmother was also an artist. She painted things on dishes and fabric and what-have-you to support her family."

As a teenager Basil became more serious about art. He began studying the work of the classical artists he admired and teaching himself to paint. He was constantly in search of good prints of paintings by the

Old Masters, which he would attempt to recreate as accurately as he could.

As a young man, Basil Gogos drifted in and out of various art schools while trying to find the right direction for his art. He studied art at the National School of Design in Washington, D.C., the Phoenix School of Design, and the School of Visual Arts in New York. Finally, at the Art Students League in New York, Gogos felt he made his greatest strides as an artist under the guidance of teacher and illustrator Frank J. Reilly. "He did commercial work and was a well-known illustrator at the time," says Gogos, "but his knowledge of art went far beyond that. He also stressed theory and the philosophy of art."

While still in school, Gogos did his first professional illustration work. Through an arrangement with a leading paperback book publisher, Reilly's students were occasionally given the opportunity to do paintings based on sections of upcoming paperback novels. The publisher would then select one of the paintings to appear on the cover of the published book. This program resulted in Gogos' first professional sale with the cover painting for a western paperback called *Pursuit*. After winning two more of these competitions, Gogos got an agent and started pursuing other professional illustration work in the paperback and magazine market.

Like many other New York illustrators of the late 1950s and early 1960s, Gogos found his most steady supply of work coming from the men's adventure magazines that were so prevalent at the time. These publications, mostly forgotten today, were somewhere between *Playboy* and *Boy's Life*. They provided escapist entertainment featuring adventurous stories of macho men making conquests on the battlefield, in perilous jungles, and in other areas of male interest. Although the subjects carried little prestige, Gogos approached the work as a learning experience and always strove to deliver the best job he could whether he was painting a battle scene or an alluring femme fatale.

"In those days there were many adventure magazines that needed illustrations each month, both covers and interiors," recalls Gogos. "It was good because coming right out of school, you had the opportunity to get work—not great work, not high priced, but it was work. It was a great chance for new artists to practice and get better."

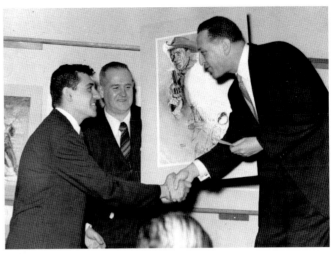

ABOVE:
Basil Gogos (left) receives a check from an editor from Pocket Books for his western painting which won first place in an Art Students League competition. Next to Gogos is his teacher and mentor Frank J. Reilly.

BELOW:
Gogos' award-winning oil painting as it appeared on the cover of Bar 6 Roundup of Best Western Stories. *(Pocket Books, 1960)*

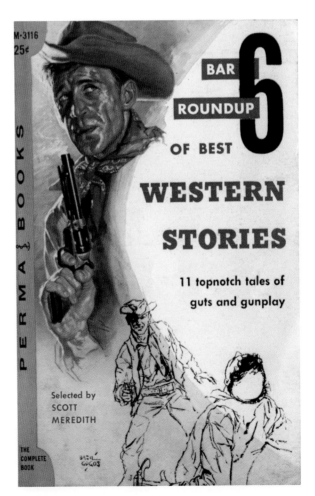

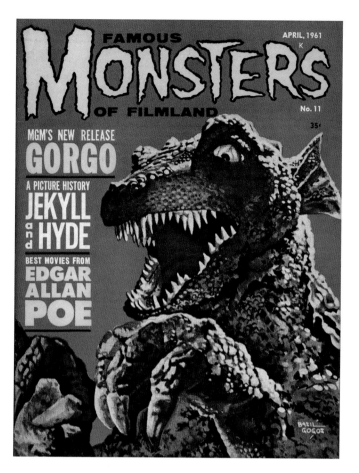

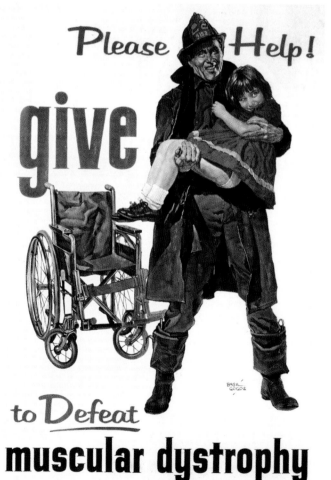

In the fall of 1960, Gogos received a fateful call from his agent that would have a major impact on his career. A young publisher named James Warren was searching for a new cover artist for *Famous Monsters of Filmland*, the magazine he had launched two years earlier with editor Forrest J Ackerman for young monster movie fans. Given a photo of Vincent Price as reference and told that the client wanted something new and different and colorful. Gogos took the job but, unsure how to approach the unusual assignment, decided to just let himself go and be as creative as he could. The result was so different that Gogos—nervous about delivering the finished work in person—asked his agent to take it in. The agent was nervous about it too, but finally agreed to deliver it. However, Warren was so delighted with the striking portrait that he immediately called his new artist to thank him and discuss more work.

This was the beginning of the unforgettable series of Basil Gogos horror portraits that have become icons of those monster-crazed days. James Warren trusted Gogos' instinctive feel for monster portraits and, once a design was decided on, gave the artist total freedom to interpret the image in whatever way he wanted, which gave him great satisfaction. Over the next two decades, Basil Gogos produced dozens of cover paintings for *Famous Monsters*, winning legions of fans who appreciated the sense of respect and class that an artist of such extraordinary talent gave these socially rejected creatures. Although Gogos continued to do work for numerous other publications throughout his illustration career, nothing gave him more enjoyment and artistic freedom than creating his wildly colorful and dramatic monster portraits.

After years of creating masterful illustrations featuring a wide variety of subjects, Gogos felt the need to dedicate more of his time to fine art and less to commercial assignments.

"I began to feel that illustration was interfering

ABOVE:
1961's Famous Monsters of Filmland 11 cover *featuring Gorgo (dyes and gouache).*

LEFT: *A poster for The Muscular Dystrophy Association painted in oils by Gogos in 1959 while still in art school.*

ABOVE:
Dapper young professional illustrator
Basil Gogos circa 1962

BELOW:
Spacemen 5 (1962)

RIGHT:
The face of a thrilled reader for the cover of the first issue
of Screen Thrills Illustrated *(1962, designers gouache)*

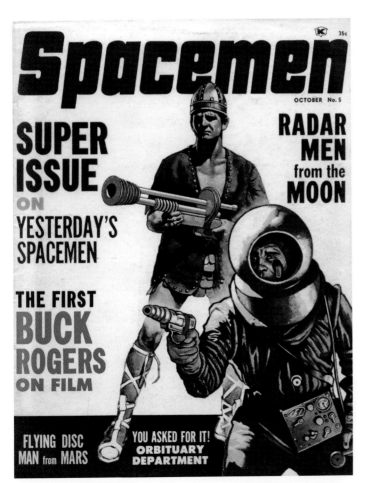

with my fine art painting and I decided to quit painting for money," recalls Gogos. For the next several years, he paid the rent as a photo retoucher for United Artists on movie posters and ads while devoting his off duty time to fine art.

During this period, Gogos' desire to keep growing as an artist led to the accomplished painter's return to art school in the evenings. "I needed studio time to get back what I had lost by working so long as a commercial artist," he explained. After assuring the teacher that he would follow instructions like any other student as long as he could paint, the seasoned pro joined a class of mostly beginning students where he was able to free himself of his professional habits and retrain himself as a fine artist.

"I enjoyed it because I could work from life again—drawing and painting from life, which I loved!" explains Gogos. "And I did some nice paintings there." Indeed, one of Gogos' paintings done at the school was awarded first prize by the prestigious Salmagundi Club. "I won the Windsor-Newton Award for best portrait done in watercolors from life."

Eventually, Gogos himself taught art classes which he found very fulfilling. "I taught for a couple of summers at a friend's studio," he recalls. "I had about twenty-four students. Most of them came from the Art Students League and they were beautiful. They learned. I reached them and they learned and they grew, which gave me an enormous amount of pleasure. We brought in models and they all painted or drew from life and it was lovely."

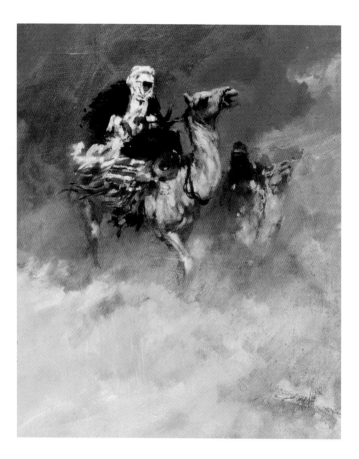

ABOVE: *Basil's only Orientalist painting,* Sand Storm *(8 x 10 inches. Oil on canvas board, 1993).*

BELOW:
The Brooklyn Bridge, 4 x 8 foot oil mural on masonite artist's board painted by Gogos while still in art school.

"I loved teaching. I discovered that I could teach and I could reach the students and they learned. I was very proud of that."

In the mid-Eighties, Gogos' commercial art career went through another change. "United Artists decided to move to the West Coast. It was either move west or stay in New York and look for something else," Gogos remembers. "I decided to stay. I put my samples together and started to look for other work." After working with a commercial art studio for a short while, Gogos secured a position at a major New York advertising agency where he spent thirteen years tirelessly turning out presentation art for various campaigns. "I was a senior sketch person for the agency," Gogos says, "and I loved being there. It was a very exciting life. I did fast work, and a lot of it, every day. I did print ad artwork and a great number of storyboards for TV commercials."

The mid-1990s brought a resurgence of interest in classic monsters. Older fans who never lost their love for the familiar characters were still hungry for more material on the horror classics while younger fans were discovering vintage horror films for the first time on cable TV and home video. Many of them were now finding out how much they missed by not being among the monster kids of the 1960s who experienced the horror craze and the early days of *Famous Monsters* firsthand.

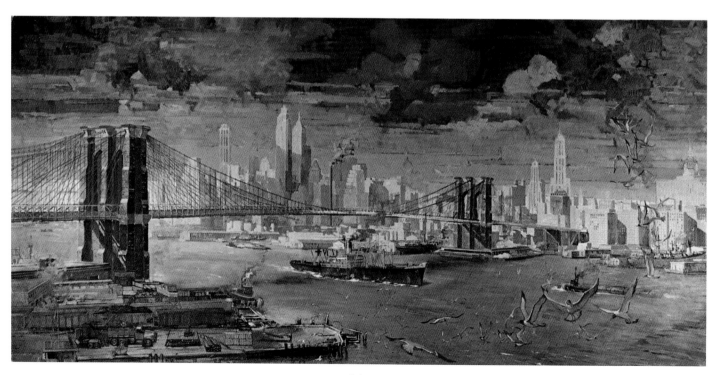

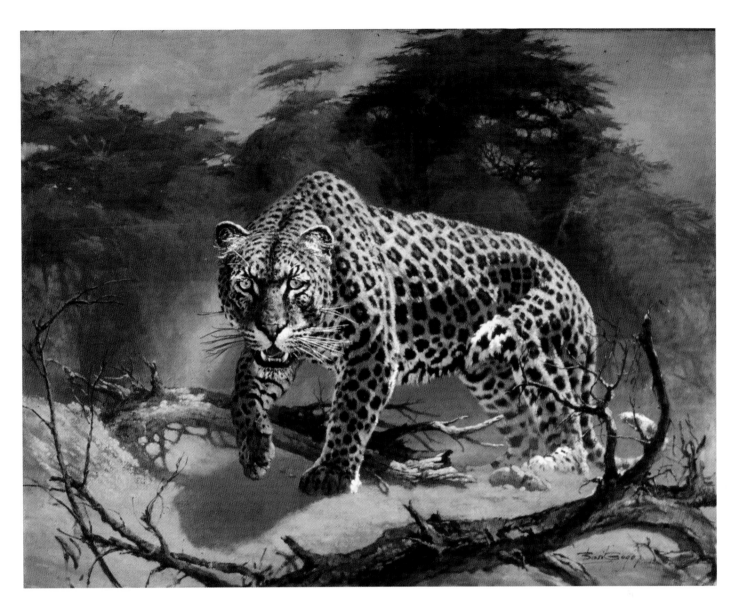

Gogos began to accept invitations from horror and sci-fi conventions on the East coast, where he came face to face with legions of fans finally able to meet the man behind the magazine covers that had made such an impact on them as kids. Inspired by the renewed interest in his horror art, Gogos launched a spectacular comeback into the world of monster art. He created a new series of paintings of classic movie monsters and produced limited edition lithographs, which were very successful among horror fans. Reemerging into the horror field in the digital age, he even entered the world of cyberspace with his own website, *www.basilgogos.com*.

Once the horror world knew that Gogos had returned to the monster business, offers

ABOVE:
Leopard, *24 x 30 inch oil on canvas (1995)*.

BELOW: *A recent 7 x 9 inch wildlife painting for a federal stamp competition.*

ABOVE:
Street scene from the Island of Hydra in Greece which was displayed at the National Academy. (watercolor, 1976)

RIGHT:
A concept for a paperback cover sample. Gogos never finished it because he felt it looked too much like the work of fellow Warren cover illustrator, Frank Frazetta.

BELOW:
The painting that won Gogos the 1980 Winsor Newton Award from the Salmagundi Club in New York for best watercolor portrait done from life.

began to come from magazine publishers, trading cards companies, and even rock stars who had been dazzled by Gogos' *Famous Monsters* covers when they were kids and now wanted his art on their CD covers.

Now retired from advertising, Gogos goes to his Manhattan studio daily to do what he loves best. Besides a steady stream of drawings and paintings for monster fans, he also paints straight portraits, nature scenes, and various other subjects. Recently Gogos entered some of his wildlife paintings into a national

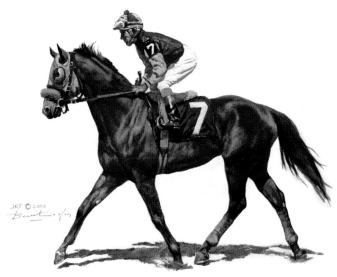

LEFT: Ghost Ships, *a Greek watercolor scene which was exhibited at the East Village Gallery in New York.*

ABOVE: *One of a series of recent paintings of race horses (2002).*

BELOW:
A recent photo of Basil Gogos with one of his classic monster paintings.

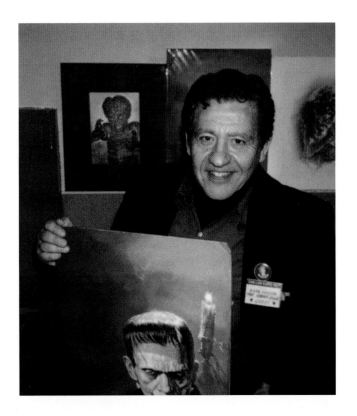

art competition where he ranked eleventh out of over 800 entries, mostly by artists who specialize in wildlife art.

Reflecting on his career, Gogos says, "Now I can look back at perhaps two thousand paintings and say, 'I think I must have done it all.' From book and magazine covers, to editorial illustrations, movie and theater posters, to portraits, murals, and even ad agency work—you name it. Sometimes it seems a lonely life, that of an artist, but I wouldn't be anything else. I don't regret one minute of it."

MONSTERS A-GOGOS
1960s Monster Mag Boom

The eventual pairing of Basil Gogos and movie monsters was one of those accidental but serendipitous things that just seemed destined to happen. While Gogos had enjoyed watching classic horror films as a boy, by the time he was a young man he was totally devoted to his art studies with the goal of becoming a fine artist. However, two years before Gogos entered the professional illustration arena, while he was still in art school, certain events were set in motion that would soon have a major effect on his life and career.

In 1957, Screen Gems released a collection of classic horror films to television for the first time in a syndicated package known as *Shock*. It contained most of Universal Studios' most famous vintage fright films, such as *Dracula, Frankenstein, The Mummy, The Wolf Man*, and their various sequels and spin-offs. *Shock* was a sensation among the kids of the late 1950s, and soon almost every major TV market had its own late-night spook show with its own ghoulish host to introduce the films, most with more than a touch of humor. Long before any form of home video, these weekly doses of horrific fun had become a communal experience for neighborhood kids throughout the nation.

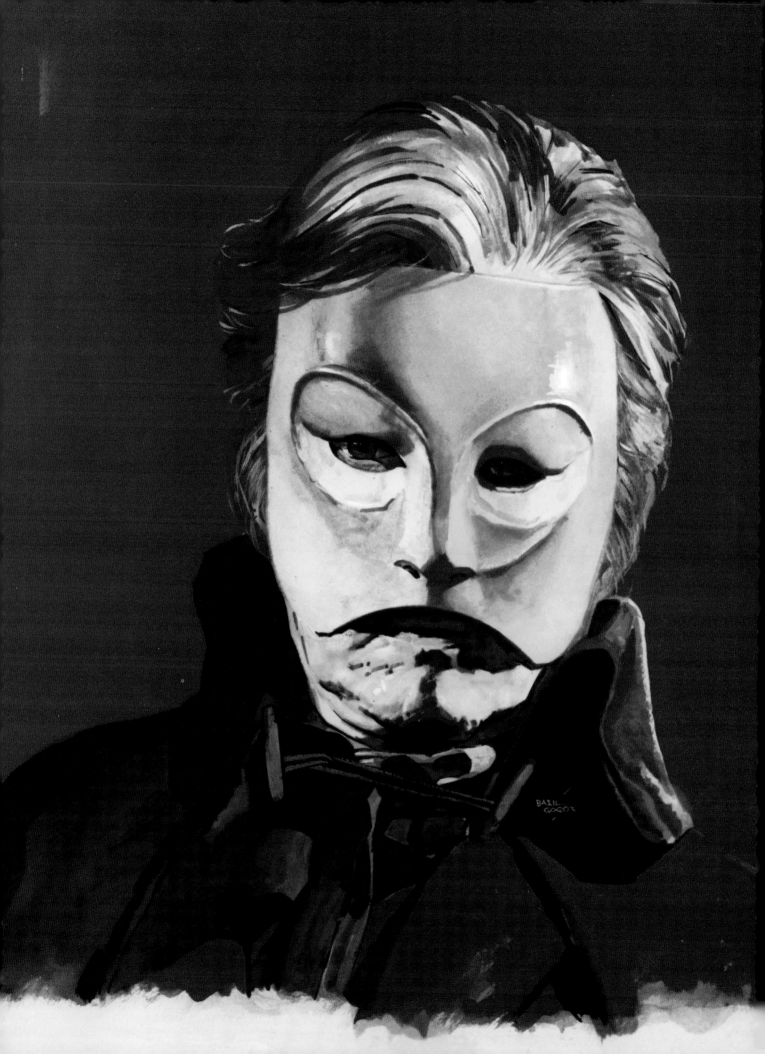

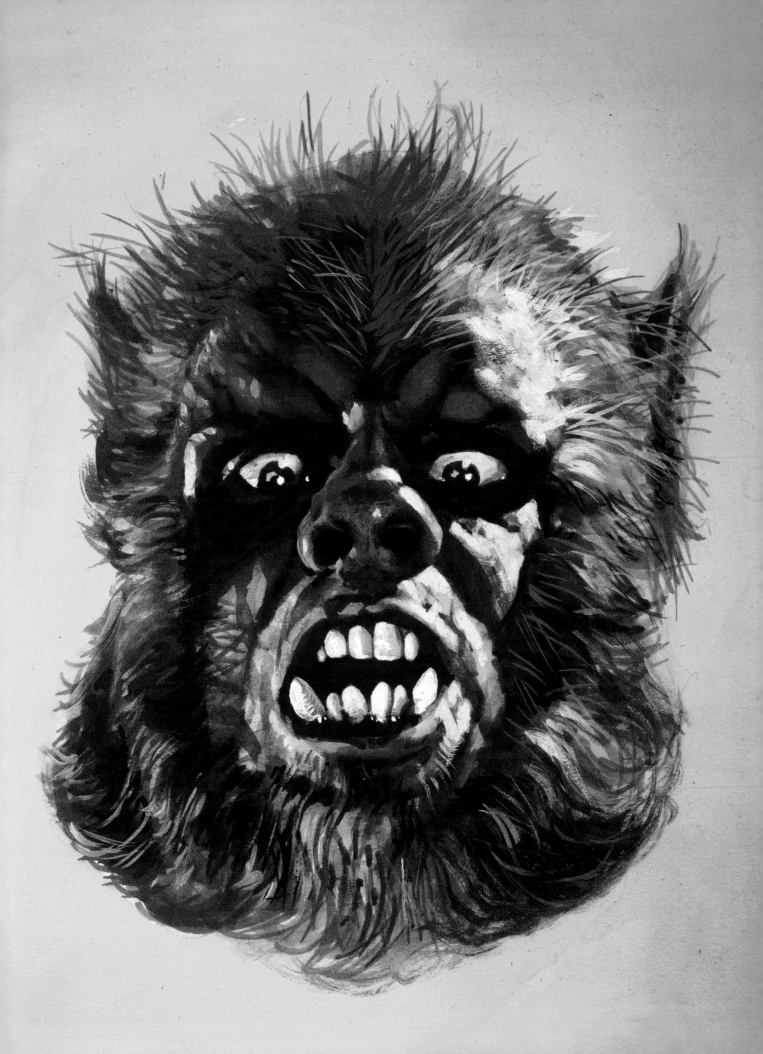

Also in the late 1950s, Hammer Films in England began producing the first of their popular series of Technicolor remakes of the horror classics, while American International Pictures was busily churning out low-budget horrors like *I Was a Teenage Werewolf* for the drive-in market. A groundswell was beginning and within a few years the 1960s monster craze would be in full bloom, bringing with it a myriad of monster toys, model kits, trading cards, board games, home movies, records, TV shows, and even monster bubble bath.

One of the major catalysts for this monster madness epidemic was *Famous Monsters of Filmland* magazine, the brainchild of an ambitious young publisher named James Warren. A fan of the genre with the foresight to tap the burgeoning audience of new monster fans, Warren published his first issue of *Famous Monsters* in 1958. It soon became a touch point for monster fans across the country who discovered that there were thousands of others like them.

Editor Forrest J Ackerman supplied commentary as well as photos and other material for the interiors from his world-famous collection, while Warren designed the magazine's layout and acted as art director. The covers of early issues of *Famous Monsters* were rather haphazard, failing to give the magazine a consistent image. The first two covers featured photos of James Warren wearing rubber masks (which saved him money on both an artist and a model). The third was a close-up photo of Lon Chaney as the Phantom of the Opera, which Warren had painted over in an attempt to create a colorful illustrated look. Warren's painted photo was a step closer to what he knew he wanted.

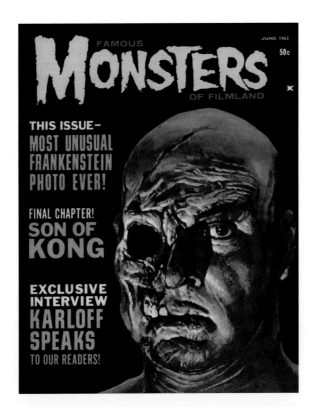

OPPOSITE:
Oliver Reed in Curse of the Werewolf *for the cover of* Famous Monsters 12 *(colored dyes and gouache, 1960).*

LEFT:
The title character from War of the Colossal Beast *for* Famous Monsters 23 *(1963).*

Ackerman suggested an artist he represented named Albert Nuetzell, who then provided cover paintings for the next five issues. Nuetzell's work was competent but Warren felt it lacked the polish and pop needed to help his new venture compete with the major magazines on the newsstand during that time of innovative art direction and topnotch magazine illustrators. After looking through samples brought in by an agent representing several New York illustrators, Warren commissioned a painting of Vincent Price from *The House of Usher*, leaving it up to the agency to select a suitable artist from among its stable.

"I probably got it because," recalls Gogos, "nobody else was cut out for it, or cared to do it. So the agent was probably afraid to give it to anybody else. I was the newest artist in the stable so he gave it to me. I was given the photograph and told by the agent that they wanted something unusual, something colorful, something new. I didn't know what he meant but I just let my hair down and did it. Then when it was finished, I was too embarrassed to bring it in. I made the agent do it. He didn't want to take it in at first, but finally he agreed to take it to Jim Warren. And then, of course, I got a call from Jim, who said, 'Where are you? Why aren't you here so I can hug you and kiss you?' In other words, he liked it. That started a romance that lasted for many years."

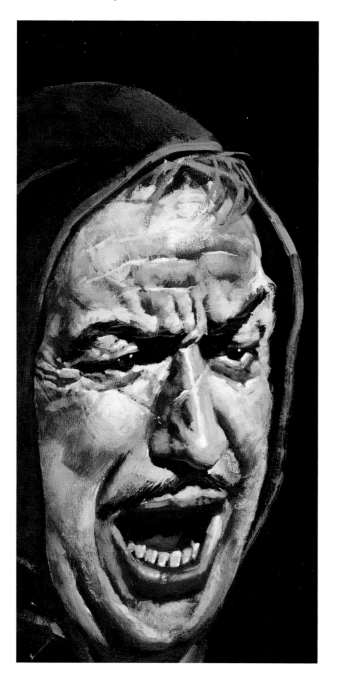

"Basil's monster art was an amazing gift for me as a filmmaker. Fans were scared once they had seen one of his portraits. They knew the picture would terrify them by the time they got to the theater."

— **Roger Corman**
Director of *House of Usher,*
Pit and the Pendulum and *Tales of Terror*

Gogos' third cover for Famous Monsters was of the prehistoric creature Gorgo, which caused a little confusion over the cover credit. "The printer called the publisher," remembers Gogos, and asked, "Is it 'Gorgo by Gogos' or 'Gogos by Gorgo? [laughter]. He didn't know which was the monster."

Gorgo was Basil Gogos' most colorful monster cover yet. Asked about his choice of colors, he says, "It was a lizard. It was a prehistoric animal. I mean, what color were they? Nobody knows, so I went ahead and used blues, greens, yellows... I used the more basic colors. These monster covers for Jim were my opportunity to cut loose and just pick any colors I wanted. They would all withstand color which pleased me to no end because the rest of the commercial work that I did was all kind of on the quiet side, because it was about regular people. But this was about monsters and I had a ball!"

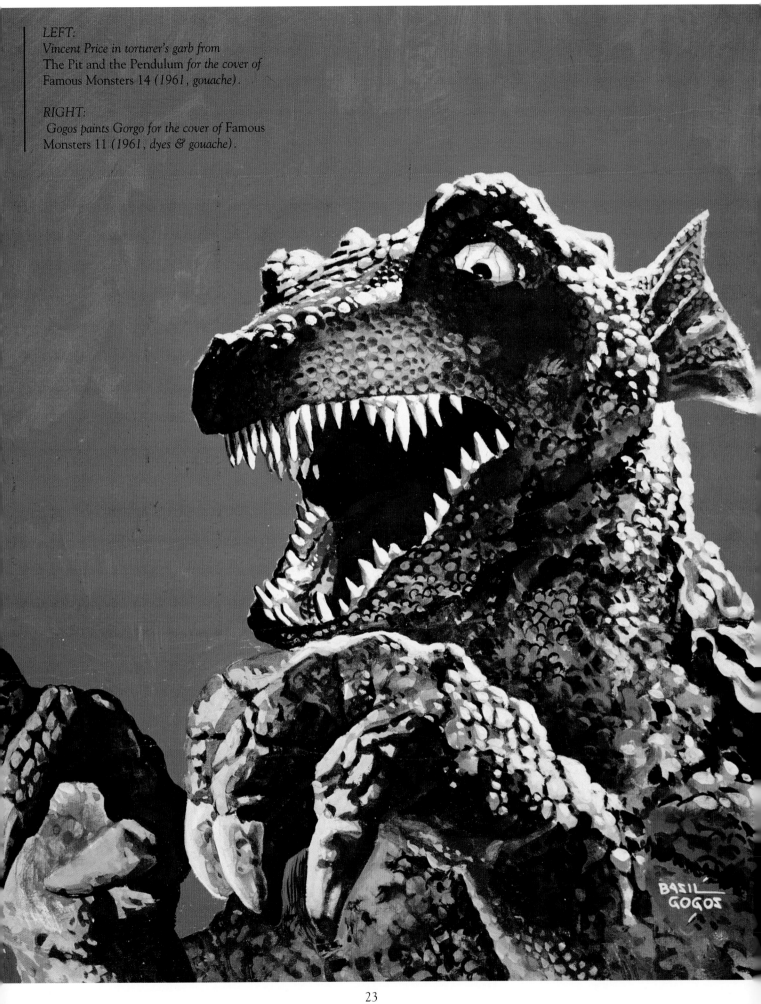

LEFT:
Vincent Price in torturer's garb from
The Pit and the Pendulum *for the cover of*
Famous Monsters 14 *(1961, gouache).*

RIGHT:
Gogos paints Gorgo for the cover of Famous
Monsters 11 *(1961, dyes & gouache).*

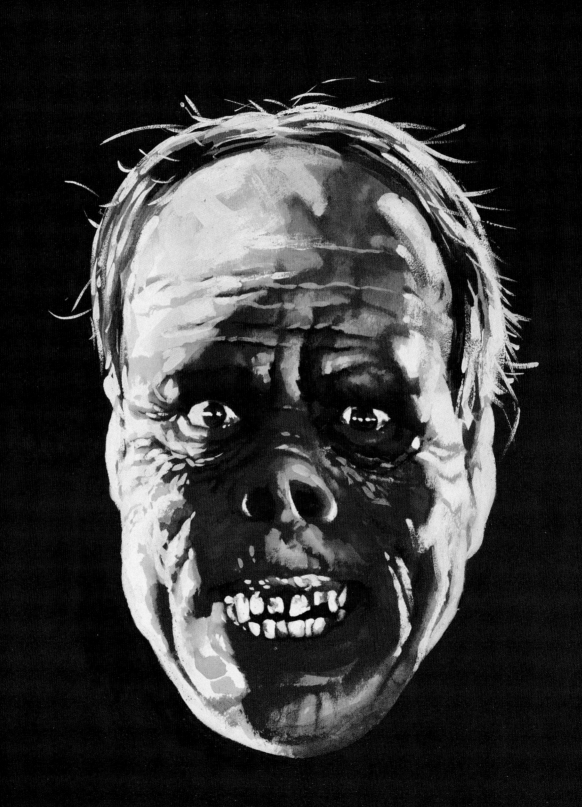

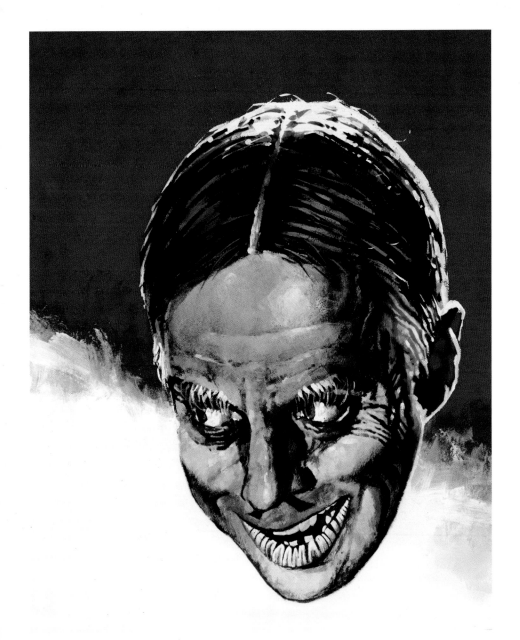

The cover of *Famous Monsters 16* featuring Gogos' classic portrait of Lon Chaney as the Phantom was done mostly in watercolor with opaques added for highlights. Gogos describes the different painting mediums he used on various covers: "In those days, I worked with dyes in the beginning, then I turned them aside and I worked with watercolor and opaques. And then I switched to casein. Casein was a wonderful medium except that suddenly, after using it for six or seven years, it started not to mix well chemically and it gave me a lot of trouble. So I switched to acrylics which are more transparent-sometimes too transparent. But that transparency usually helps, because you can change the color just by washing a different color over it. If you had a blue section in the portrait, and you wanted it to be green, you just washed a yellow over it and you never lost the drawing underneath. You never lose the original color, so by its being transparent, you could change the look of a painting in minutes and it doesn't hurt it if done carefully."

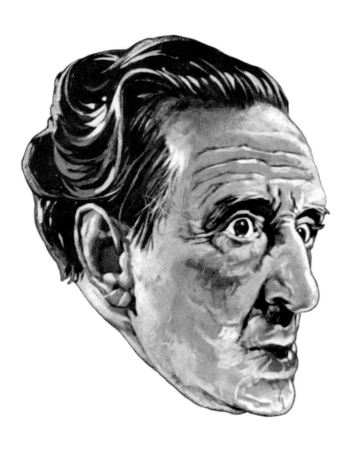

Famous Monsters 19 featured a trio of portraits; Basil Rathbone, Peter Lorre and Vincent Price from the Edgar Allan Poe anthology, *Tales of Terror*. Although mostly watercolor, Gogos wanted to try something different with it.

"Years ago, movie theaters in New York advertised the movie by asking artists to do original posters with one of the cheapest forms of reproduction which was silkscreen. I loved that process, I love silkscreen. By the time I got to the movie business no one was using silkscreen anymore so I became good at it but a little too late. But it didn't stop me from approaching that cover in a silkscreen way. That's why you'll notice that the color has more solid shades. In other words, it's all flat shades placed one on top of the other allowing the previous coat to dry. That one was the only one that I did for FM that was done like that. I wanted to try everything and I was given the opportunity to experiment. Jim would always give me a photo and say, 'All right, go to work. Do whatever you want with it', because he trusted me."

ABOVE:
Basil Rathbone, Peter Lorre and Vincent Price from the Roger Corman film Tales of Terror—*originally appeared on a dark purple background (Famous Monsters 19, dyes and gouache, 1962).*

OPPOSITE:
Chaney in London After Midnight *for the cover of* Famous Monsters 20 *(dyes and gouache, 1962).*

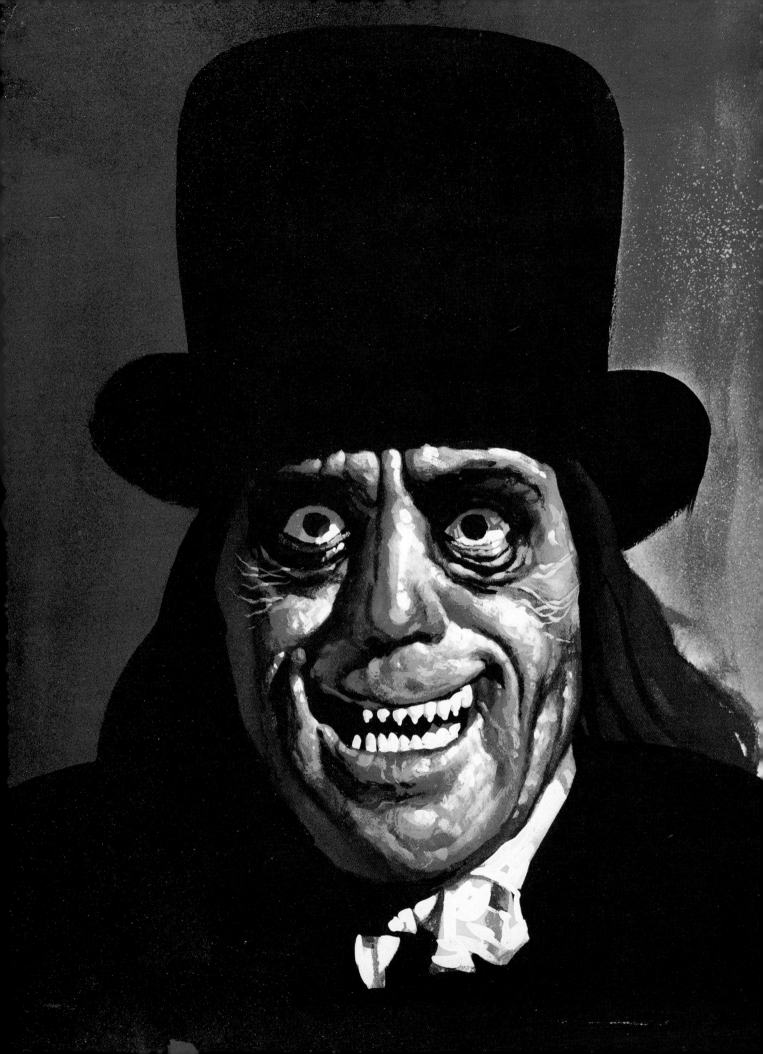

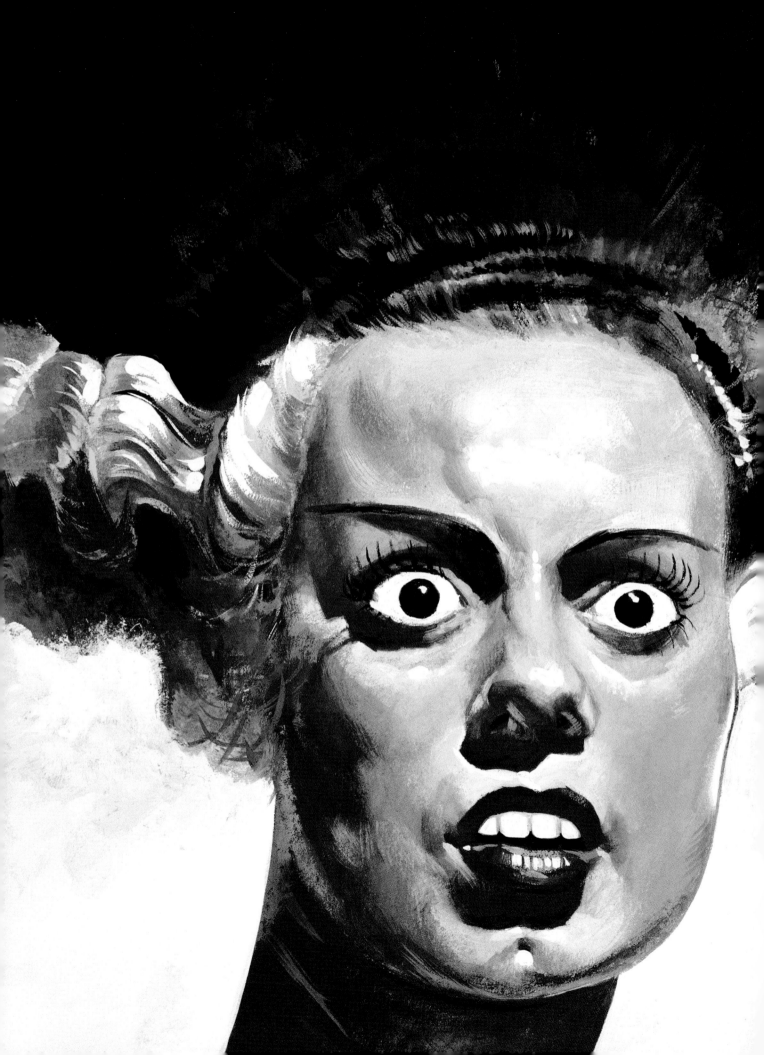

" *Basil Gogos' work in his field is second to none. His Frankensteins and Draculas are wonderful. When I did the art for the Aurora monster kits, I was basically doing advertising illustration and was no longer part of the magazine field. But I always frequented book stores and browsed covers. Basil captured in his covers the horror I felt as a child seeing the movies. I think his covers are superior to my monster kits. He is so good and, thanks to this collection, his work should endure.* "

— **James Bama**

James Bama is well known to monster fans as the creator of the box art for all of the Aurora monster model kits of the 1960s. He is perhaps most famous as the cover artist of sixty-two Doc Savage paperback books.

Before becoming associated with *Famous Monsters*, Gogos admits he had not been a particularly big fan of monster movies. "I liked monsters. I grew up with them. But I was not crazed over them because I was too busy doing other things; too busy to even think about doing monsters. But when I started working with Jim Warren, I found them to be very enjoyable creatively. They became the thing that I enjoyed more than any other type of commercial art that I was doing. So, as time went by and my work became more involved with monsters, I started to get a renewed love for them."

LEFT:
Elsa Lanchester in The Bride of Frankenstein *painted for the cover of* Famous Monsters 17 *(1962).*

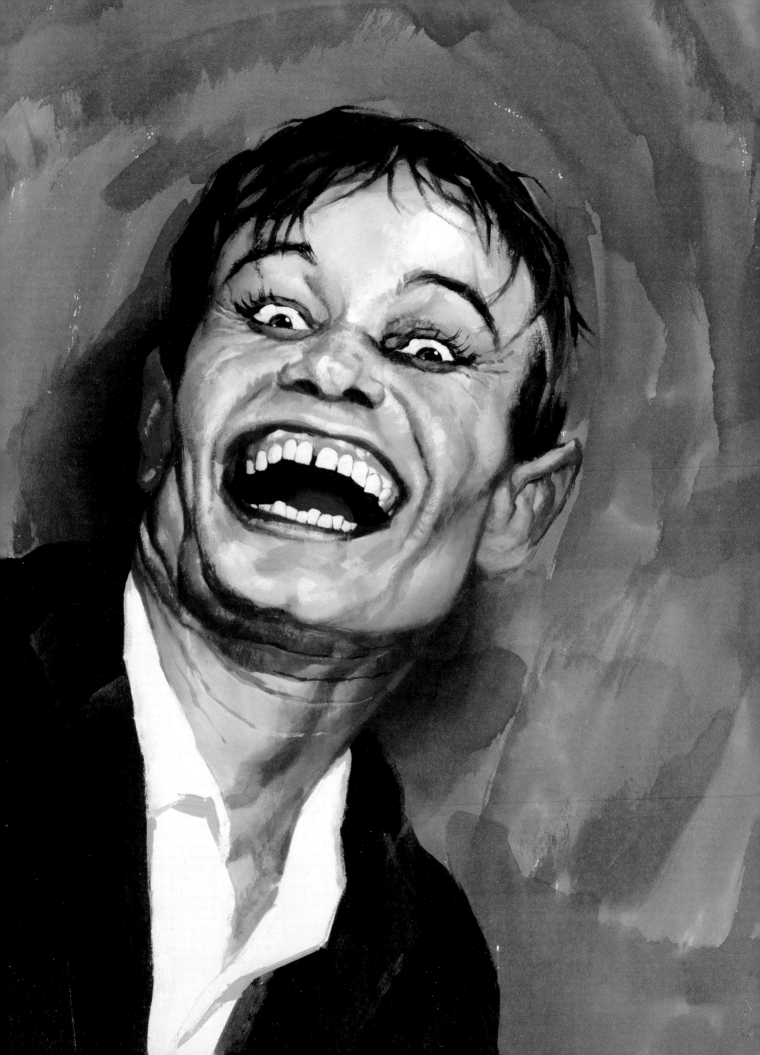

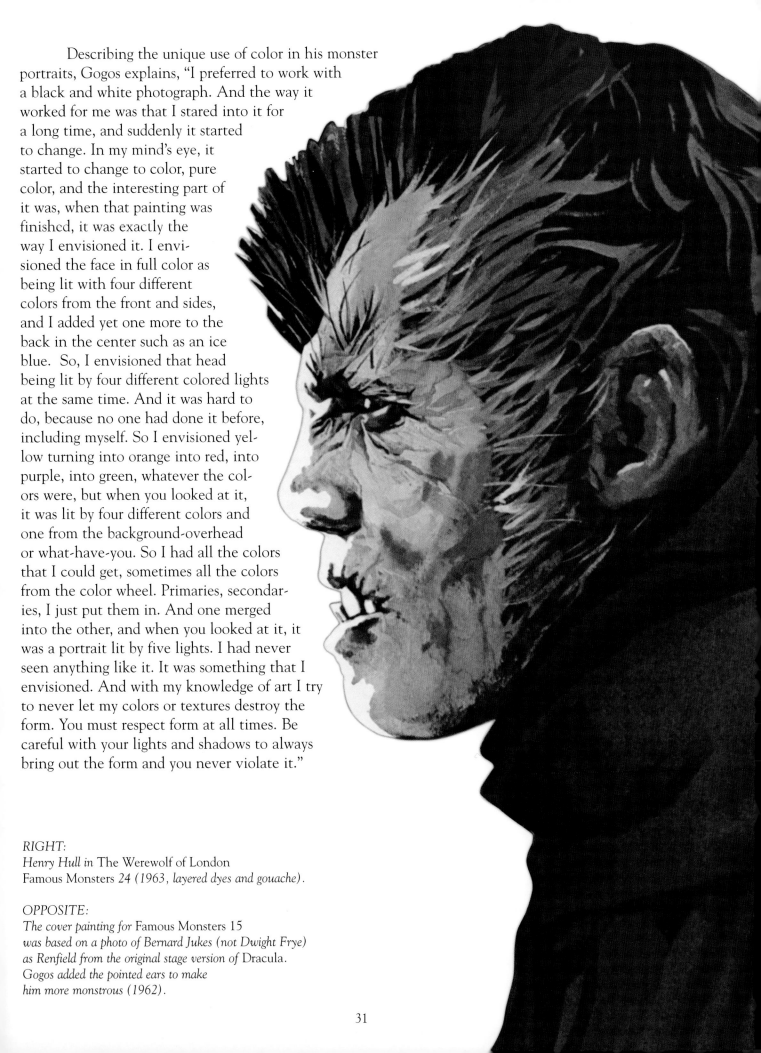

Describing the unique use of color in his monster portraits, Gogos explains, "I preferred to work with a black and white photograph. And the way it worked for me was that I stared into it for a long time, and suddenly it started to change. In my mind's eye, it started to change to color, pure color, and the interesting part of it was, when that painting was finished, it was exactly the way I envisioned it. I envisioned the face in full color as being lit with four different colors from the front and sides, and I added yet one more to the back in the center such as an ice blue. So, I envisioned that head being lit by four different colored lights at the same time. And it was hard to do, because no one had done it before, including myself. So I envisioned yellow turning into orange into red, into purple, into green, whatever the colors were, but when you looked at it, it was lit by four different colors and one from the background-overhead or what-have-you. So I had all the colors that I could get, sometimes all the colors from the color wheel. Primaries, secondaries, I just put them in. And one merged into the other, and when you looked at it, it was a portrait lit by five lights. I had never seen anything like it. It was something that I envisioned. And with my knowledge of art I try to never let my colors or textures destroy the form. You must respect form at all times. Be careful with your lights and shadows to always bring out the form and you never violate it."

RIGHT:
Henry Hull in The Werewolf of London
Famous Monsters *24 (1963, layered dyes and gouache).*

OPPOSITE:
The cover painting for Famous Monsters 15
was based on a photo of Bernard Jukes (not Dwight Frye)
as Renfield from the original stage version of Dracula.
Gogos added the pointed ears to make
him more monstrous (1962).

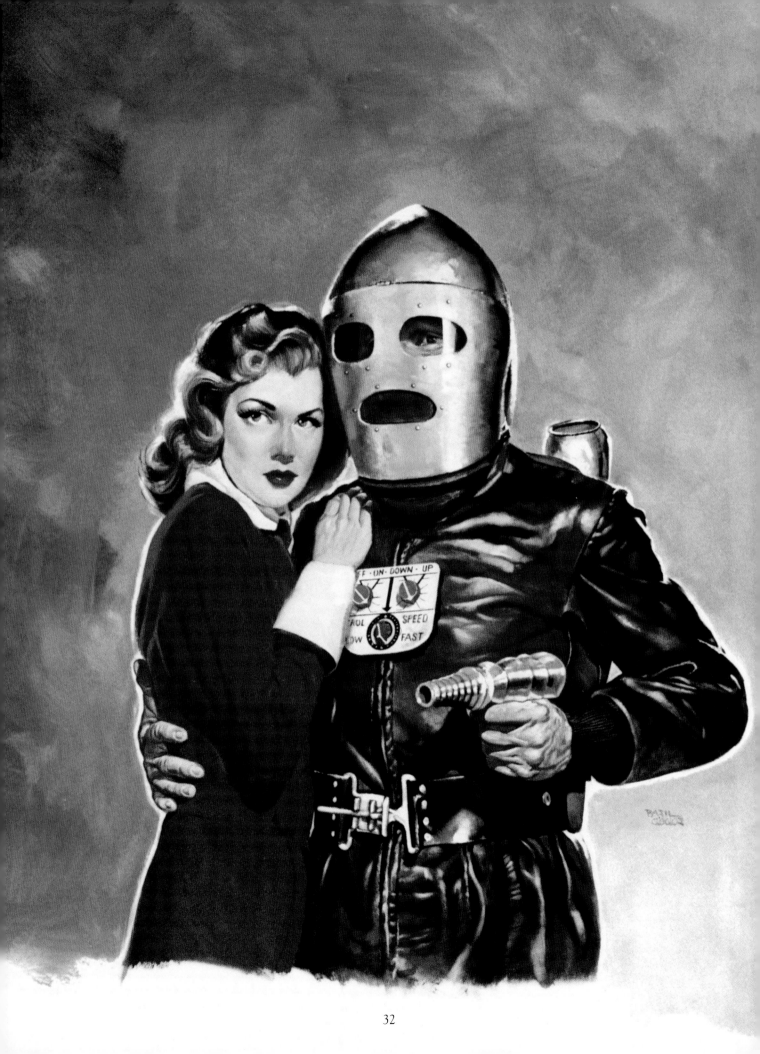

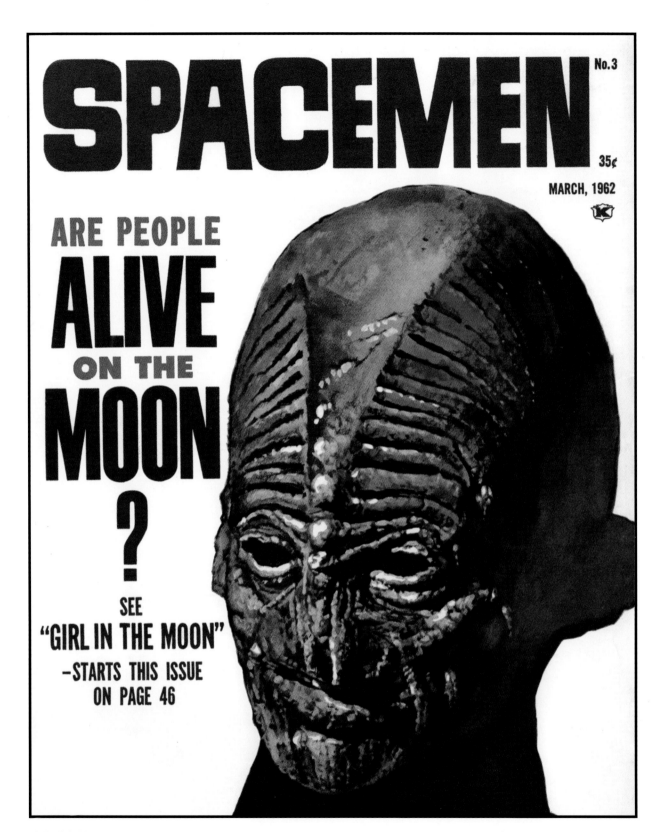

SPACEMEN

No.3

35¢

MARCH, 1962

ARE PEOPLE ALIVE ON THE MOON ?

SEE "GIRL IN THE MOON" —STARTS THIS ISSUE ON PAGE 46

OPPOSITE:
George Wallace as Commando Cody with Aline Towne in the Republic serial Radar Men From the Moon *for the cover of* Spacemen 6 *(Warren, 1963)*

ABOVE:
Spacemen 3 *featured a strange alien being painted in dyes and gouache (Warren, 1962).*

GOGOS GOES WEST
From Paintbrush to Sagebrush

BELOW LEFT AND OPPOSITE: Western art in acrylic and gouache.

BELOW RIGHT: The cover of Wildest Westerns 5 featuring Nick Adams from the TV series The Rebel (gouache, 1961).

The Old West was a fascinating, almost mythical period of American history which has been a favorite subject of many great artists over the years in both commercial and fine art. In the late 1950s, Westerns were extremely popular in almost every entertainment medium from TV to comic books.

Basil Gogos had the chance to do several Western paintings for paperback and magazine covers and found them very enjoyable.

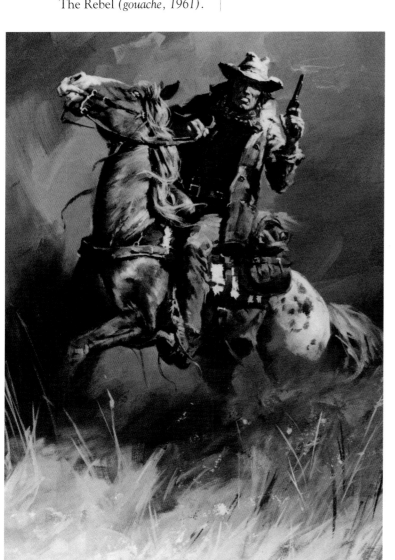

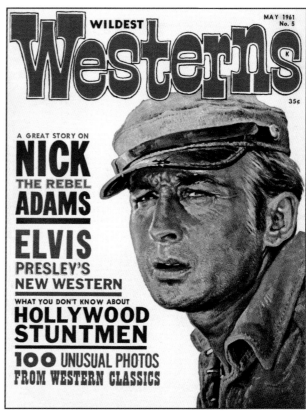

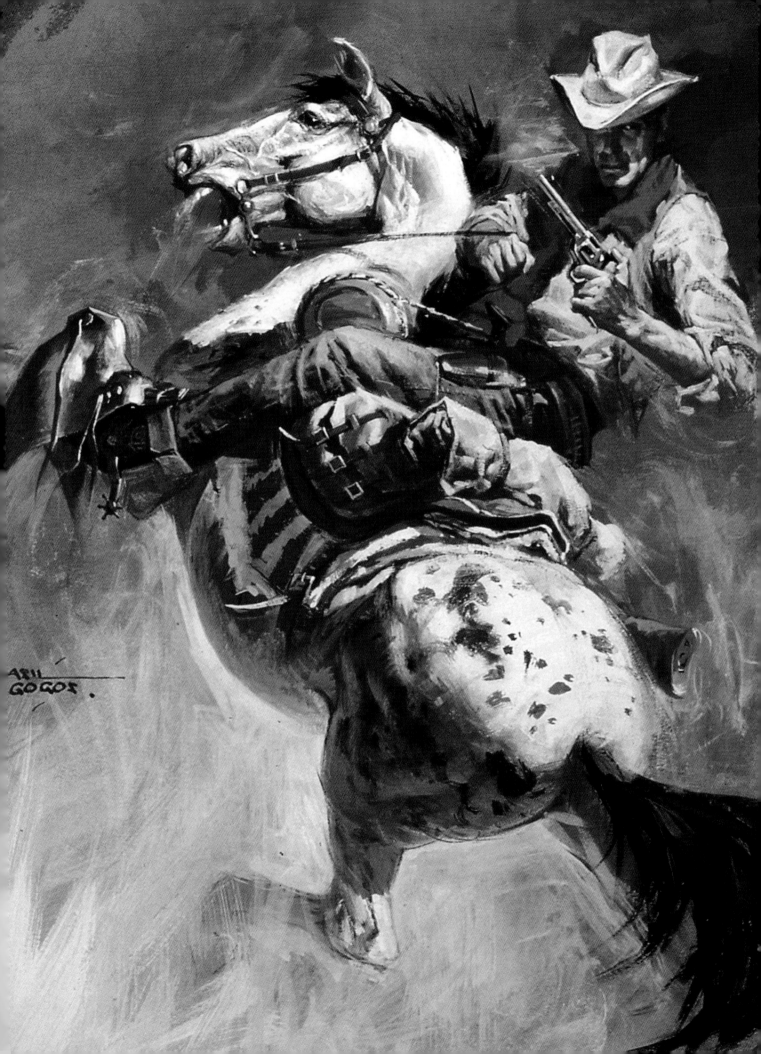

"It was part of the madness of the day to do Westerns and we all enjoyed doing them," recalls Gogos. "I loved painting Westerns. I guess if I had my way I would have done a lot more of them. I was very inspired by the Western art of the pulp magazines. They were bold and flashy and powerful-looking. The genre of the Western attracted me and a lot of other artists at that time and I found them very exciting. I loved the pulp covers I had seen from the late '30s and '40s, where the West was romanticized. I was very interested in what other people were doing with it at the time and I found it terribly exciting. I love painting horses and have studied the anatomy. I absolutely adore Remington. He simplified the horse to its basic form and his horses are alive. I think they're beautiful. If anyone is interested in painting horses, I suggest they study Remington because he simplified every-

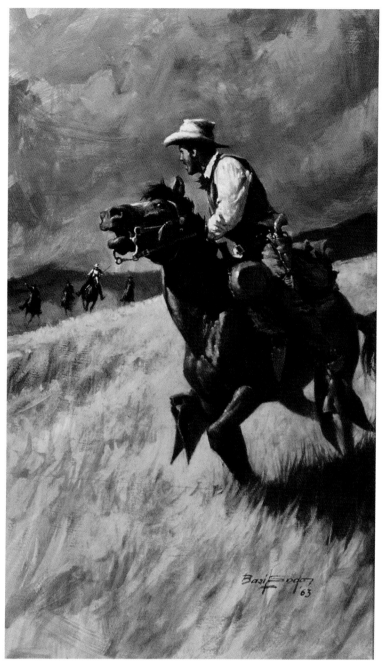

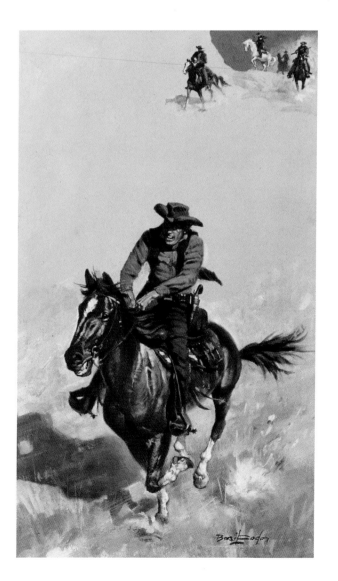

thing and made it more exciting. I wish I had done more Westerns but I was given other assignments, and before I knew it I was doing other things like war, like gothics, like 'boy and girl,' and before I knew it, it got me away from the Westerns."

ABOVE:
A reworking of his first paperback cover,
Pursuit *(oil on masonite artist's board, 1963).*

LEFT:
Ride Vaquero *(gouache, 1960s).*

OPPOSITE:
A military favorite (oil on masonite artist board, 1960s).

REAL MEN
The Men's Adventure Years

In the mid 1950s, a genre of magazine appeared which had evolved mainly from the pulp magazines of the '30s and '40s such as *True Detective*. Aimed at adult men, they sold male fantasies usually disguised as "true" stories of war, adventure, and sexual conquest. With titles like *Man's Life*, *Man's Action*, and *True Adventures*, they became known as "men's adventure magazines," though their nickname in the industry was "the sweats."

The stories and accompanying art in these colorful publications were sometimes downright outrageous in their attempts to capture the attention of male readers. However, they provided many fine illustrators with steady if low-paying work at a time when most major publications had switched mainly to photographs for their illustrations.

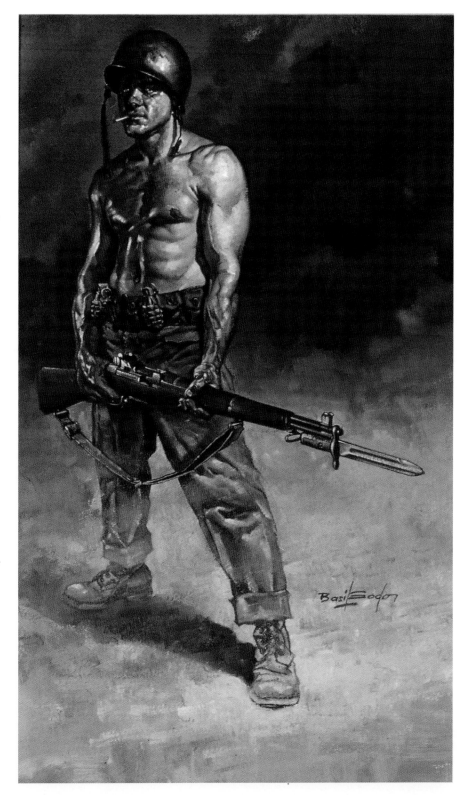

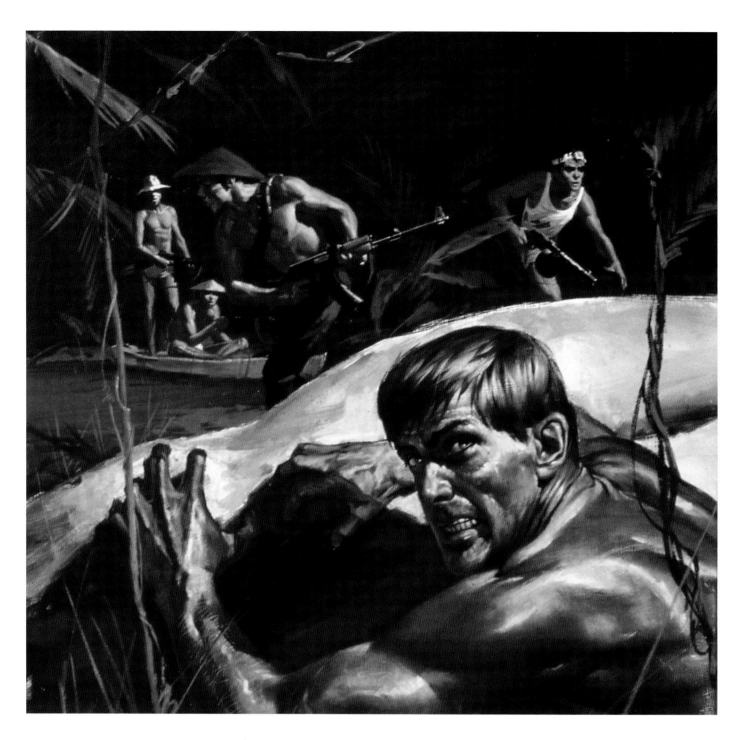

Today, because of their risqué and tabloid-like content and the caliber of illustrations they contain, these magazines are considered highly collectible pieces of Americana. Recalling the men's adventure magazine field, Gogos says, "In those days it was nice, because coming out of art school, if you are into a commercial vein of art, you would have work! All you needed was an agent. Even without an agent you could go around with nice samples and pick up work, because there was ample work for everybody. Even if you were on the lower rung, you'd still have enough work to do because most of these men's magazines demanded illustrations to accompany stories they were running. You were always busy, and you paid your rent! You didn't get a lot of money, but you were busy. And, from the opportunity that you had to work, you

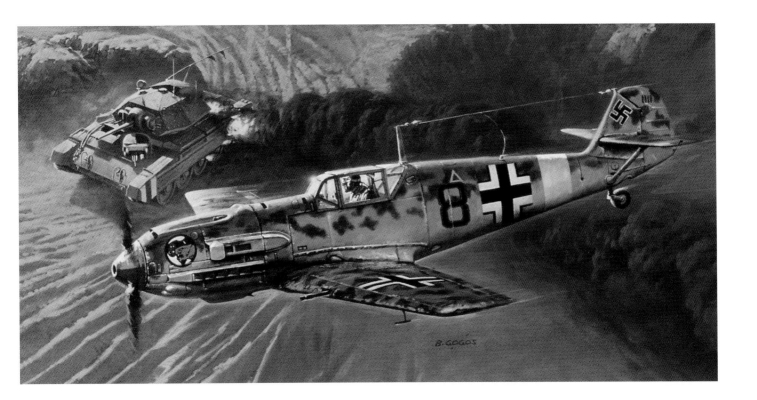

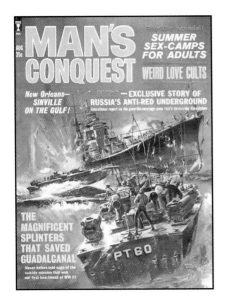

TOP:
*An ME 109-E4 done as a sample for
Monogram Plastic Toy Company.
(gouache on illustration board 1960s)*

ABOVE:
Man's Conquest, August, 1963.

RIGHT:
*Original cover illustration for the issue
of Man's Conquest shown above.*

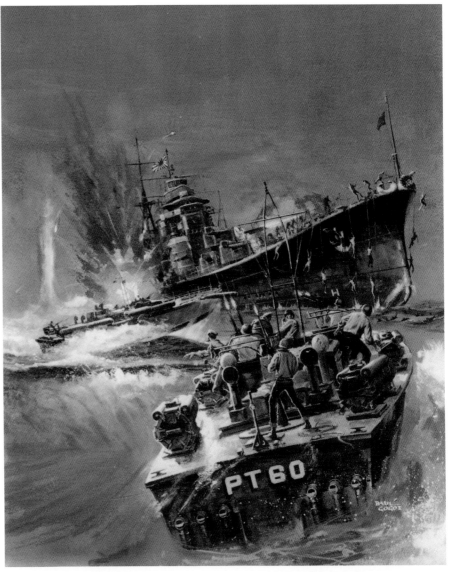

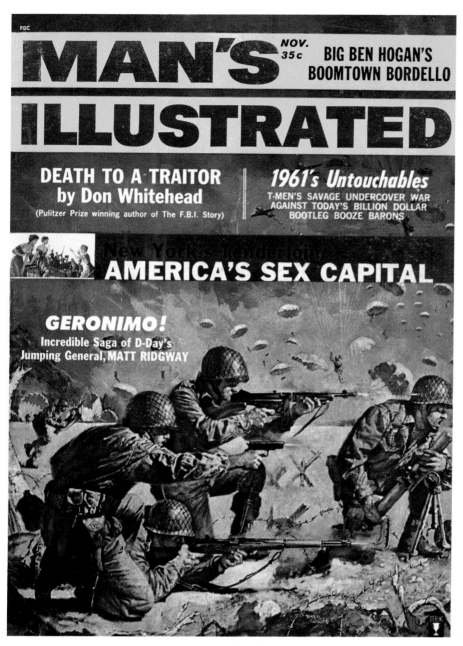

MAN'S NOV. 35¢ **BIG BEN HOGAN'S BOOMTOWN BORDELLO**

ILLUSTRATED

DEATH TO A TRAITOR by Don Whitehead
(Pulitzer Prize winning author of The F.B.I. Story)

1961's Untouchables
T-MEN'S SAVAGE UNDERCOVER WAR AGAINST TODAY'S BILLION DOLLAR BOOTLEG BOOZE BARONS

New York's Tenderloin
AMERICA'S SEX CAPITAL

GERONIMO!
Incredible Saga of D-Day's Jumping General, MATT RIDGWAY

ABOVE:
Man's Illustrated, *(oil on artist board, November, 1961).*

OPPOSITE PAGE:
Original Mens' Adventure *magazine cover painting from the 1960s.*

became better by more practice, and more practice, and more work. You became better at it, and slowly, you could move up a rung or two. But the point is that, in those years, there were many magazines that could use your talent, which is something you don't have today."

Magazine and paperback illustrators of that era were usually required to do their own research and supply their own reference material. Gogos explains the process most artists went through for each assignment: "As an illustrator, you would either read the script, or they would tell you what they wanted. Either the art director or the editor would tell you what the scene should be, or sometimes they would give you a script to read and then, of course, you would have to submit two or three sketches, and they would approve one. Then you'd take that idea, and you'd go to your studio, you'd hire models and you'd photograph the models. You might light them as they should be lit based on the story, and you'd re-create the people that should be in there, and what they're doing. Then after taking pictures, we had to develop the film. We would print the pictures ourselves, and then as soon as the pictures were dry, then you'd start working on the art. It would take about two or three days of the preparation, in order to sit down and actually draw the thing on the board. But by then, you were exhausted from the amount of work you had to do before you even started the painting! Then you'd have to sit down and start it from the beginning. It was a lot of work, but it was a routine that we all had to go through.

"When it was finished, whether it was an oil painting or a watercolor or what have you, then you'd take it in, and if there were no corrections, that was it. If there were corrections, sometimes you'd stay there on the premises and do the corrections, and then the job was out of your hands. But all this preparation had to be done for each illustration. By virtue of that, you became a good photographer as well. You became good at lighting to match the story. So you sort of produced a

scene from scratch, but you did all these steps before sitting down to paint. It was quite exhausting, but it was good practice."

To make their World War II paintings as authentic as possible, most adventure illustrators kept a supply of props and costumes on hand. Gogos had American and German uniforms and helmets for his models to wear and dummy weapons for them to brandish. Asked if he also kept a Sherman Tank sitting around his studio, he joked, "Oh, yeah. All the time. For vehicles I had to find the best information I could. I had a so-called 'morgue file' with photos I had gathered during my career so I had fairly good reference material. What I couldn't find, I had to make up. At times I used plastic models or whatever else I could get."

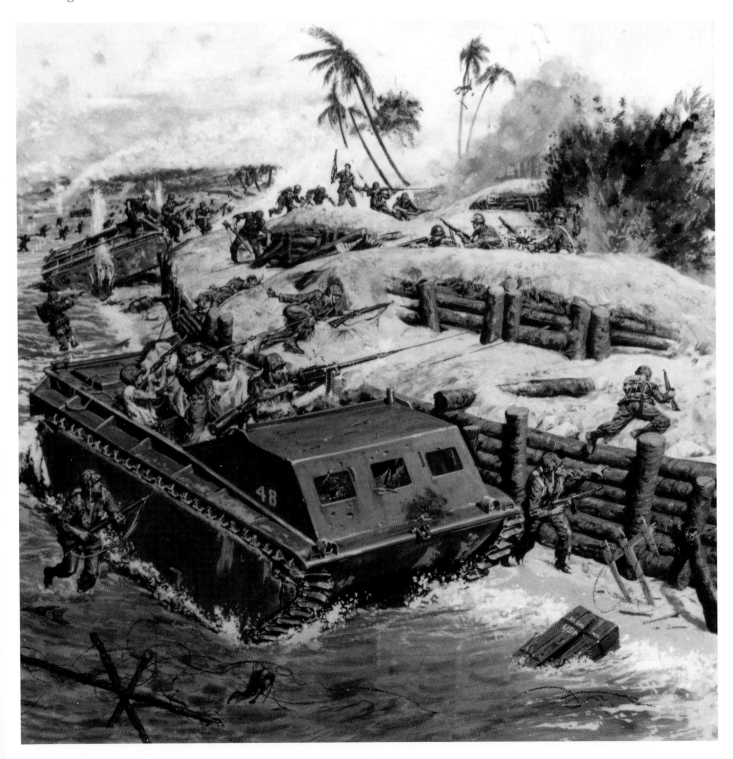

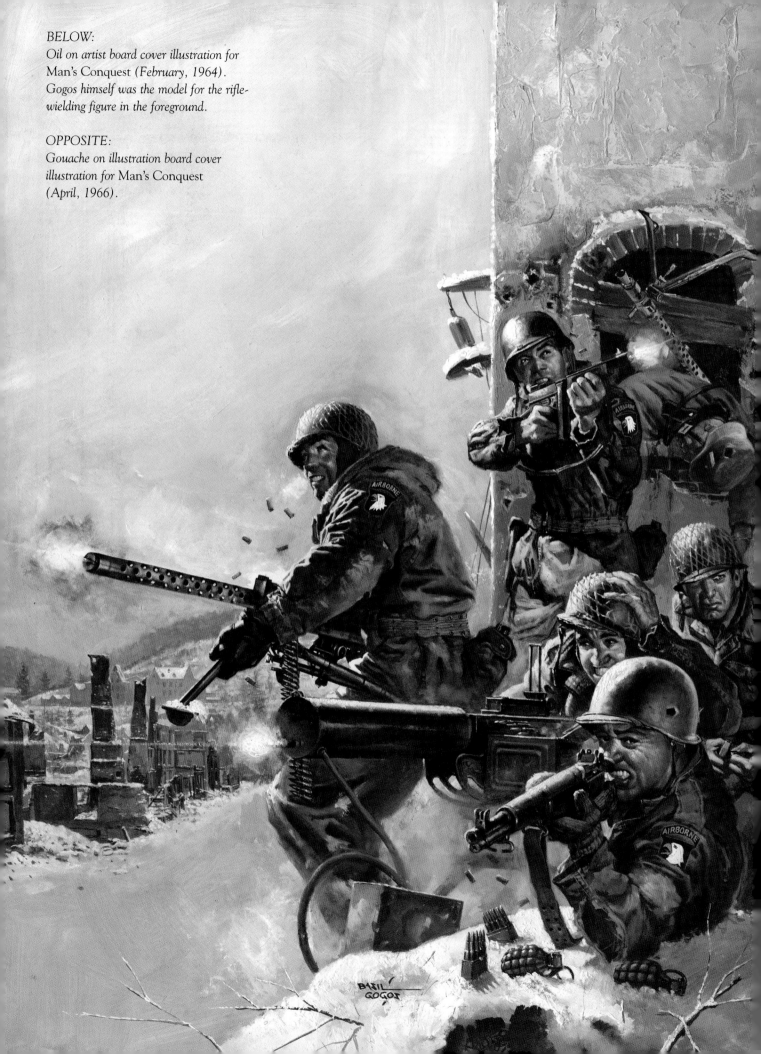

BELOW:
Oil on artist board cover illustration for
Man's Conquest (February, 1964).
Gogos himself was the model for the rifle-
wielding figure in the foreground.

OPPOSITE:
Gouache on illustration board cover
illustration for Man's Conquest
(April, 1966).

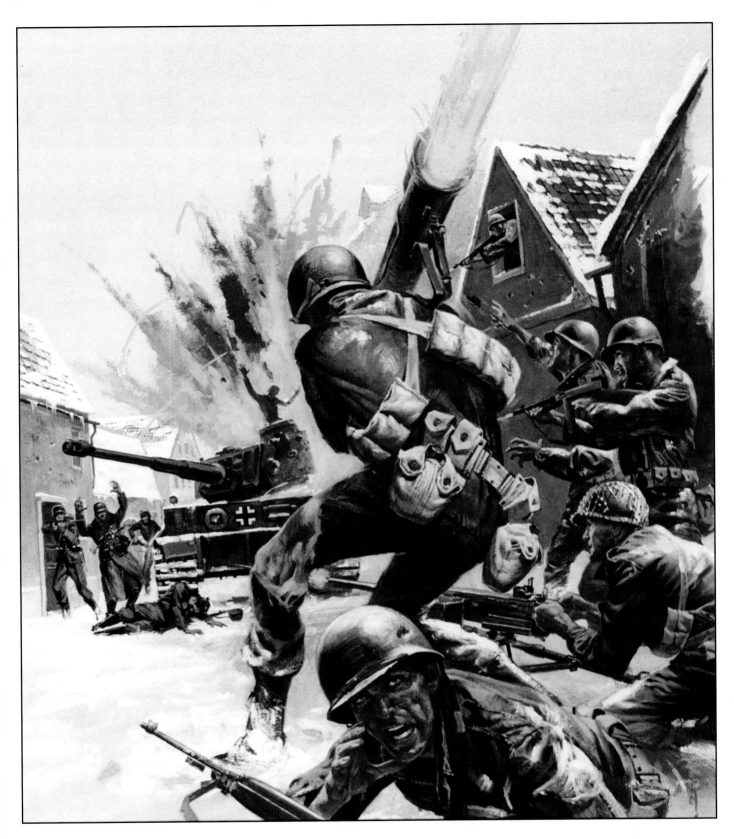

One item proved extra difficult to illustrate accurately. "I needed to show the instrument panel of a B-24 and I couldn't find a picture of it. I even called Consolidated in Houston to see if they had it and they said, 'No, we don't have reference for that. That was over twenty years ago.' I went all over to find it and couldn't. Of course, today, information like that is everywhere, but in those days it was hard to find a B-24 instrument panel. But again, you fake some, or you take it from another plane or something. Your hope is that if you don't know much about something, the reader may not know very much about it either, except that some of the readers were very well-informed, and they would let you know if you got something wrong."

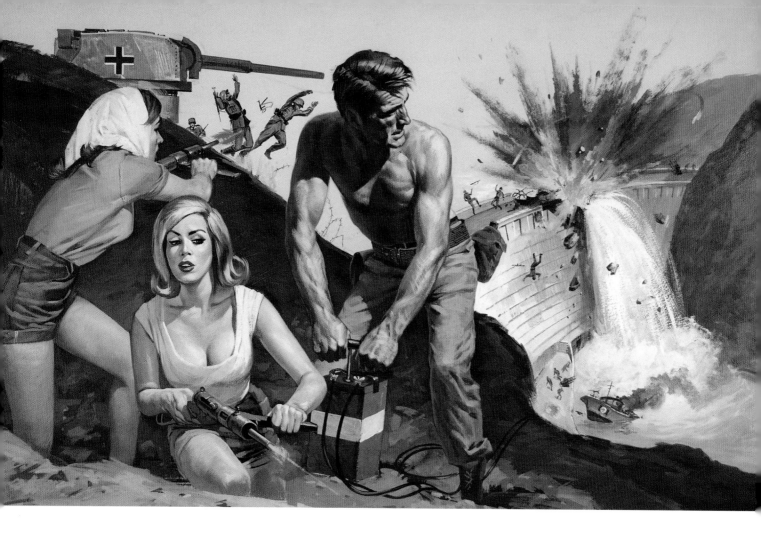

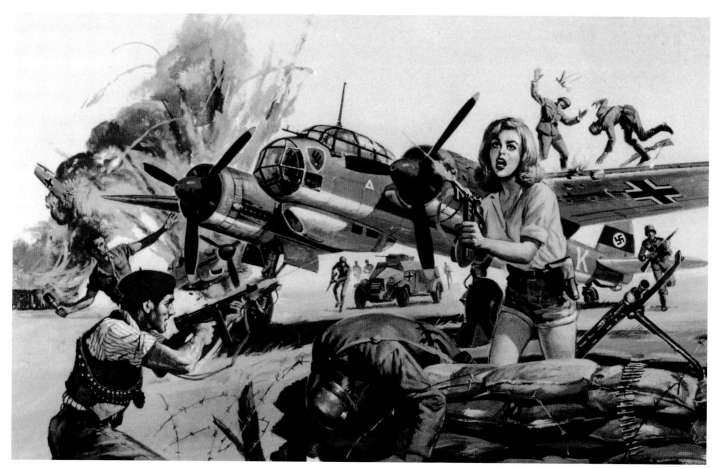

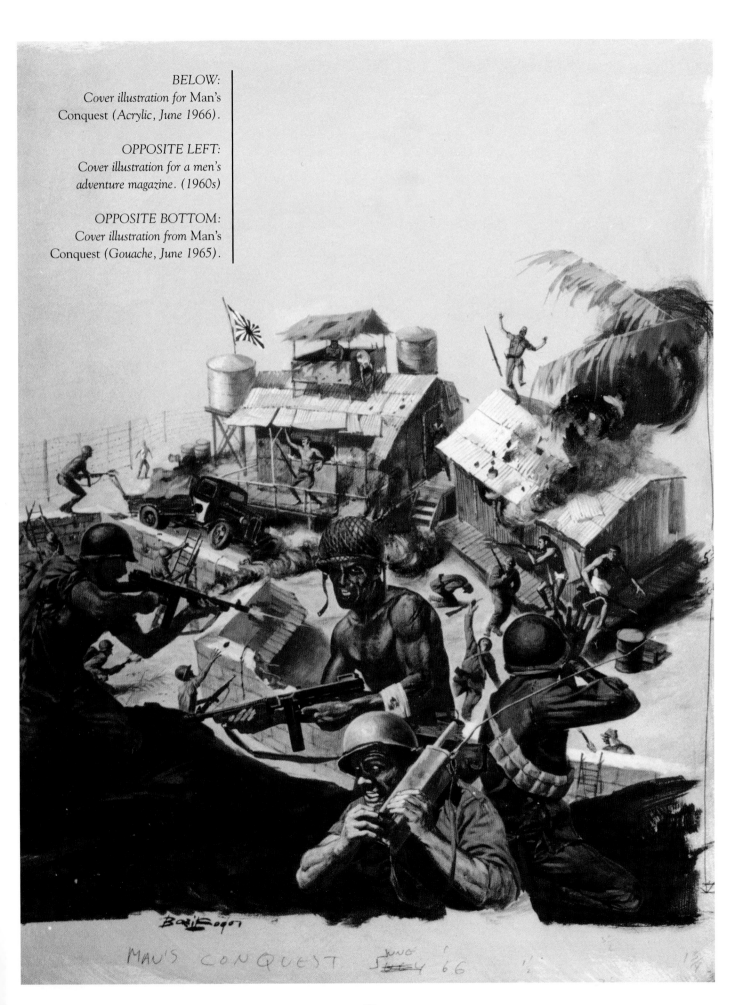

BELOW:
Cover illustration for Man's
Conquest (Acrylic, June 1966).

OPPOSITE LEFT:
Cover illustration for a men's
adventure magazine. (1960s)

OPPOSITE BOTTOM:
Cover illustration from Man's
Conquest (Gouache, June 1965).

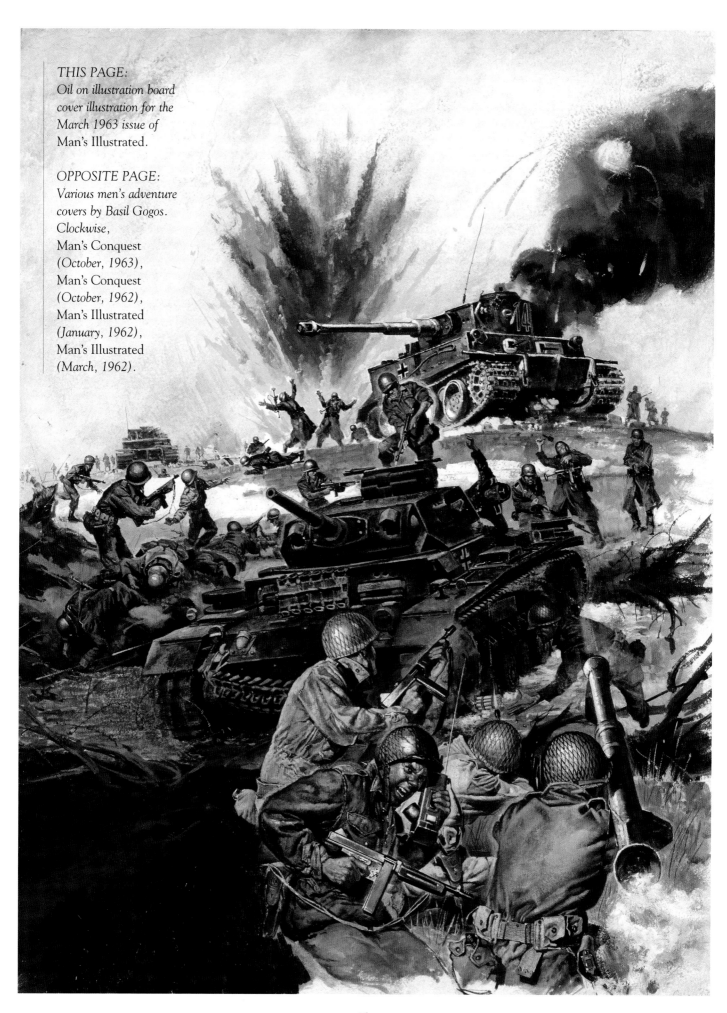

THIS PAGE:
Oil on illustration board cover illustration for the March 1963 issue of Man's Illustrated.

OPPOSITE PAGE:
Various men's adventure covers by Basil Gogos. Clockwise,
Man's Conquest *(October, 1963),*
Man's Conquest *(October, 1962),*
Man's Illustrated *(January, 1962),*
Man's Illustrated *(March, 1962).*

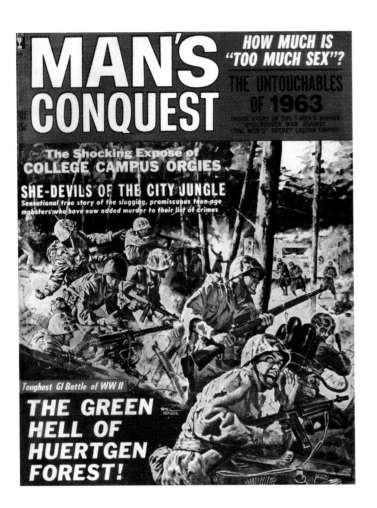

MAN'S CONQUEST

HOW MUCH IS "TOO MUCH SEX"?

THE UNTOUCHABLES OF 1963

The Shocking Expose of
COLLEGE CAMPUS ORGIES

SHE-DEVILS OF THE CITY JUNGLE
Sensational true story of the slugging, promiscuous teen-age mobsters who have now added murder to their list of crimes

Toughest GI Battle of WW II
THE GREEN HELL OF HUERTGEN FOREST!

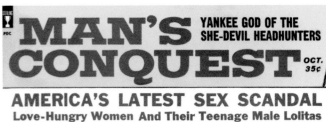
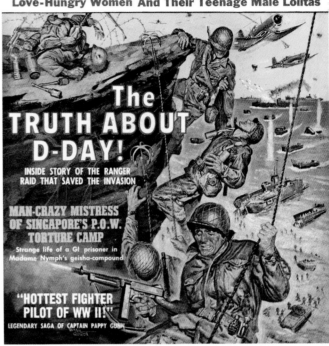

MAN'S CONQUEST

YANKEE GOD OF THE SHE-DEVIL HEADHUNTERS

OCT. 35¢

AMERICA'S LATEST SEX SCANDAL
Love-Hungry Women And Their Teenage Male Lolitas

The TRUTH ABOUT D-DAY!
INSIDE STORY OF THE RANGER RAID THAT SAVED THE INVASION

MAN-CRAZY MISTRESS OF SINGAPORE'S P.O.W. TORTURE CAMP
Strange life of a GI prisoner in Madame Nymph's geisha-compound

"HOTTEST FIGHTER PILOT OF WW II!"
LEGENDARY SAGA OF CAPTAIN PAPPY GUNN

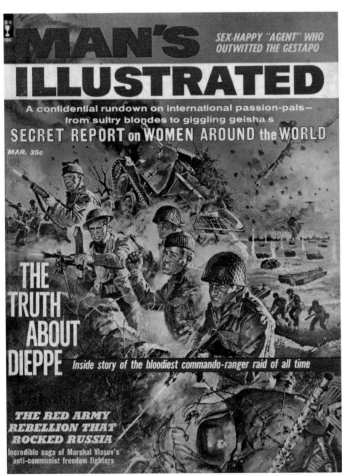

MAN'S ILLUSTRATED

SEX-HAPPY "AGENT" WHO OUTWITTED THE GESTAPO

A confidential rundown on international passion-pals—from sultry blondes to giggling geishas
SECRET REPORT on WOMEN AROUND the WORLD

MAR. 35¢

THE TRUTH ABOUT DIEPPE
Inside story of the bloodiest commando-ranger raid of all time

THE RED ARMY REBELLION THAT ROCKED RUSSIA
Incredible saga of Marshal Vlasov's anti-communist freedom fighters

MAN'S ILLUSTRATED

JAN. 35¢

A Bachelor's Manual on the
ART OF PICKING A PLAYMATE

FREE CHINA'S COMMANDO WAR WITH RED CHINA
Exclusive story of today's savage guerrilla-sabotage battle raging in the Far East

Shocking Expose
Geneva—
SIN TOWN ON THE SKI SLOPES

Gen. MacArthur's Revenge!
BLOODY BATTLE FOR MANILA
Never-before-told saga of the ferocious 90-day slaughter of 20,000 suicide Japs

47

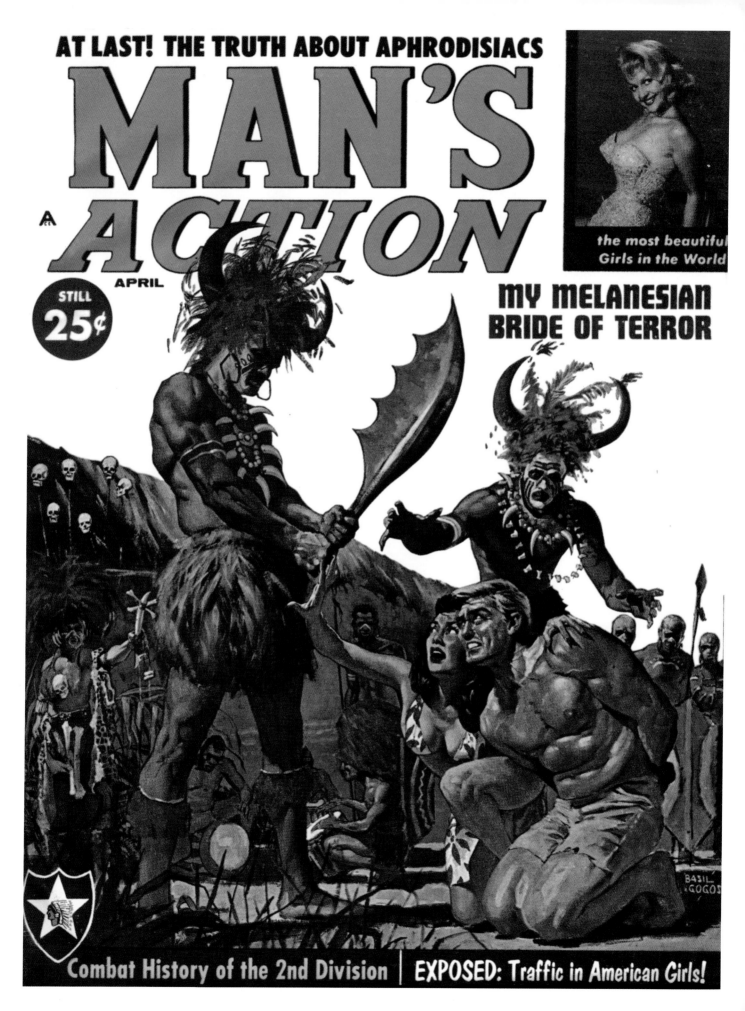

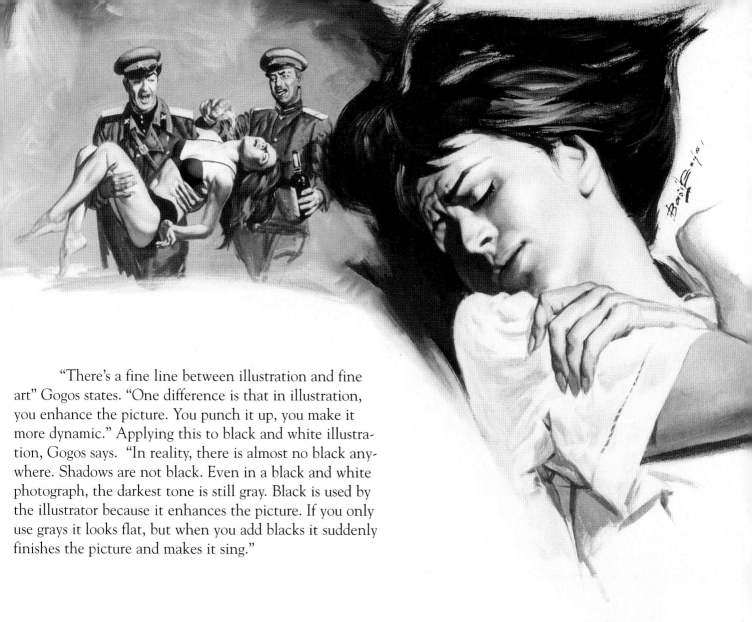

"There's a fine line between illustration and fine art" Gogos states. "One difference is that in illustration, you enhance the picture. You punch it up, you make it more dynamic." Applying this to black and white illustration, Gogos says. "In reality, there is almost no black anywhere. Shadows are not black. Even in a black and white photograph, the darkest tone is still gray. Black is used by the illustrator because it enhances the picture. If you only use grays it looks flat, but when you add blacks it suddenly finishes the picture and makes it sing."

ABOVE:
Men's Adventure magazine illustration in casein (1960s).

LEFT:
Interior illustration for "White Dingo Queen" in Adventure (Casein, October, 1969).

OPPOSITE:
Early illustration for Man's Action (April 1960).

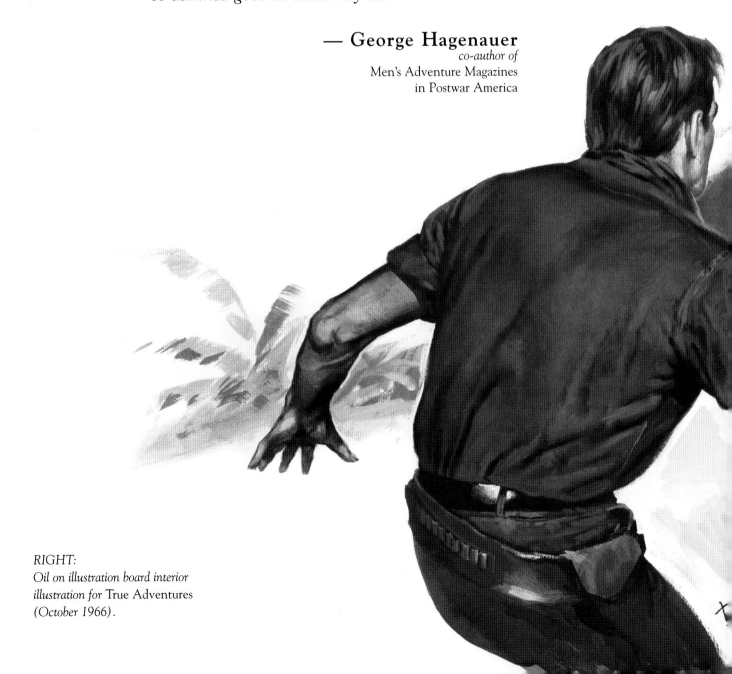

" *Basil Gogos, like many of his era, was underrated because of the type of magazines he worked for. Interviewing and thinking about the guys who grew up as illustrators in the late 1950's, it became very apparent that, born ten years earlier, they would have been major mainstream illustrators as opposed to folks that excelled at monster magazine, men's adventure and paperback illustration. It was all in the timing and role of the photograph in commercial illustration. And so we had a generation of artists like Basil Gogos, who were pushed a genre down from the main market slicks to the pulps. And that is why they were so damned good at what they did.* "

— **George Hagenauer**
co-author of
Men's Adventure Magazines
in Postwar America

RIGHT:
Oil on illustration board interior
illustration for True Adventures
(October 1966).

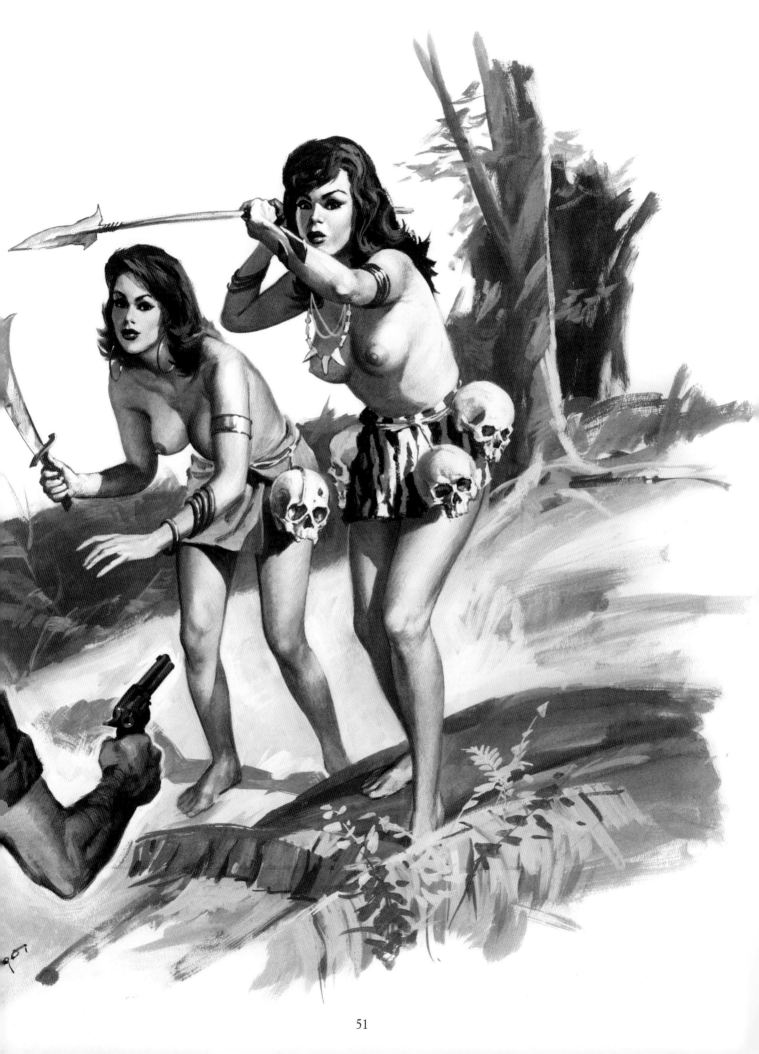

BELOW AND OPPOSITE:
*Interior illustrations for men's
adventure magazines (1960s).*

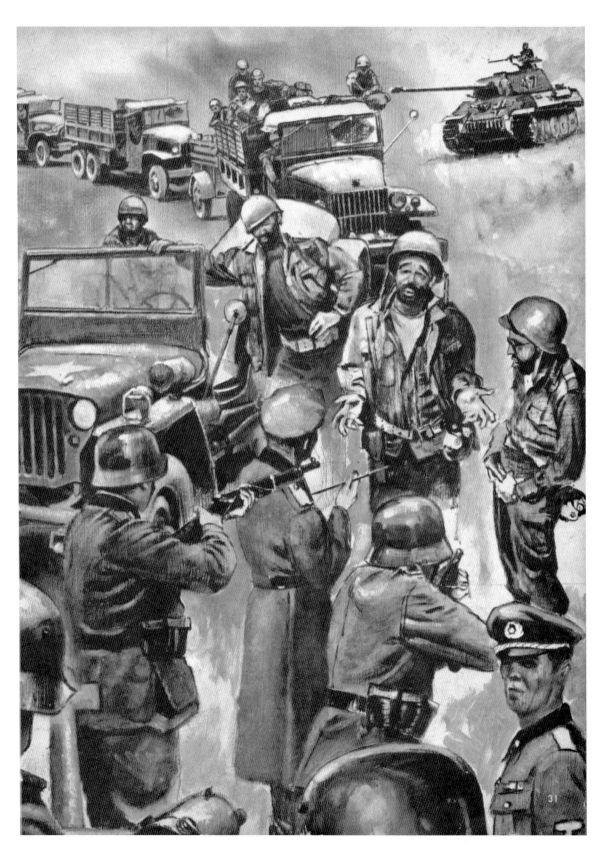

DIVE DEEP AND DIE!

We found the guns and the money was easy. Then greed and lust got the best of Harry as he turned the deep water red with our blood!

WE were almost two hundred feet below the surface of the sea and just emerging from the ripped and torn hull of the merchant vessel S. S. Jacob Isaac when I saw the long leathery-looking tentacle with the many little suction cups that could drain away a man's blood slithering around Jane's pale white shoulders.

I tried to shout—indeed, I did shout—but with my mask pressed tight against my face by the pressure of the water and my lungs full of compressed air from the tank on my back what came out of my mouth was a dim faint burble.

I think Jane heard it. I remember her raising her violent eyes and looking directly at me. She was paddling slowly out of the *(Continued on page 60)*

By Ramsey Nelson

I swear I could hear Jane scream, even in the deep water!

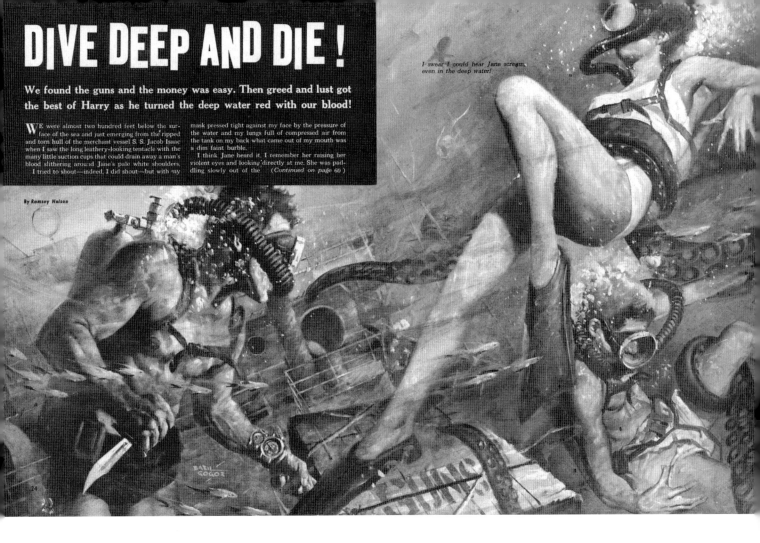

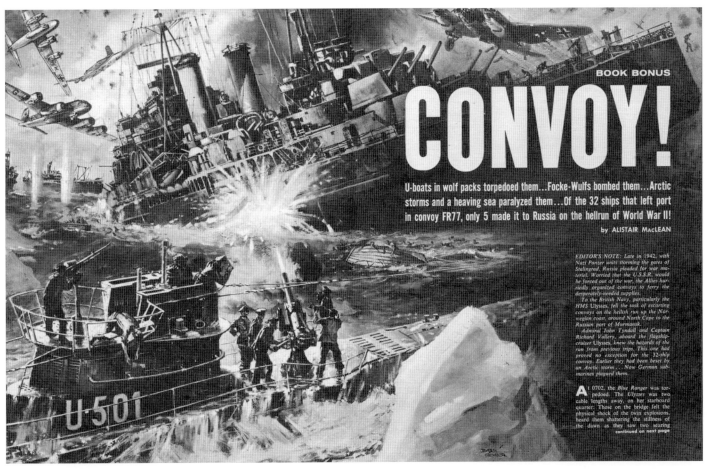

BOOK BONUS

CONVOY!

U-boats in wolf packs torpedoed them...Focke-Wulfs bombed them...Arctic storms and a heaving sea paralyzed them...Of the 32 ships that left port in convoy FR77, only 5 made it to Russia on the hellrun of World War II!

by ALISTAIR MacLEAN

EDITOR'S NOTE: Late in 1942, with Nazi Panzer units storming the gates of Stalingrad, Russia pleaded for war materiel. Worried that the U.S.S.R. would be forced out of the war, the Allies hurriedly organized convoys to ferry the desperately-needed supplies.

To the British Navy, particularly the HMS Ulysses, fell the task of escorting convoys on the hellish run up the Norwegian coast, around North Cape to the Russian port of Murmansk.

Admiral John Tyndall and Captain Richard Vallery, aboard the flagship-cruiser Ulysses, knew the hazards of the run from previous trips. This one had proved no exception for the 32-ship convoy. Earlier they had been beset by an Arctic storm... Now German submarines plagued them.

AT 0702, the *Blue Ranger* was torpedoed. The *Ulysses* was two cable lengths away, on her starboard quarter. Those on the bridge felt the physical shock of the twin explosions, heard them shattering the stillness of the dawn as they saw two searing

continued on next page

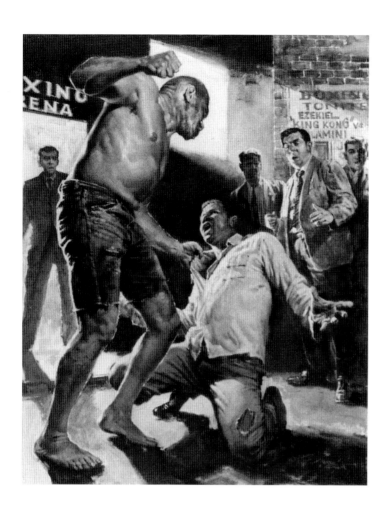

LEFT:
Interior illustration from an unknown men's adventure magazine (1960s).

BELOW RIGHT:
"Get Pretty Boy Floyd" interior illustration in Men *(December 1960).*

BOTTOM LEFT:
"Hong Kong Pickup" from True Adventures *(December, 1966).*

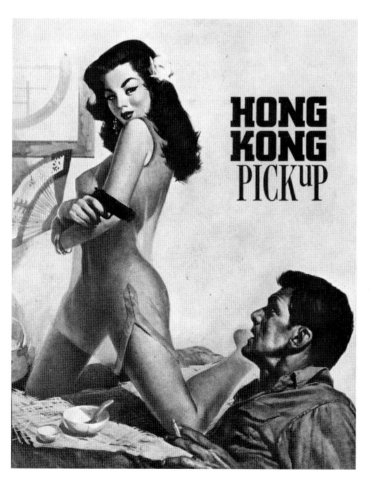

HONG KONG PICKUP

A pathological killer, he made the submachine gun the most
by a gangster. He loved the feel of the heavy gun as it leapee
and jumping violently each time he squeezed the trigger. Which w

"GET PRETT

by DON DWIGGINS

KANSAS CITY's monolithic Union Station basked in
the deceptive calmness and warmth of a bright morn-
ing sun. Commuters hurrying around two inconspicuous
touring cars, parked across from each other on a side
street, glanced up at the hands of the big station clock.
It was exactly 7:15.

In the train shed, passengers were stepping off the Kansas
City Southern special from Fort Smith, Arkansas, by way
of Sallisaw, Oklahoma — home town of the notorious bank
robber, Charles Arthur "Pretty Boy" Floyd.

Outside the station, three men — a notorious gangster
and two deadly torpedoes — lounged in one of the touring

cars, anxiously watch
behind the wheel su
back seat, a signal f
their pay as rub-out

One of the torped
whispered to his part
Boy!"

"Pretty Boy" — ta
in the car and reache
closed around the ha

Five figures moved
gangland assassins.

28

Asked about other New York illustrators he crossed paths with in the adventure magazine business during the 1960s, Gogos replies, "Jimmy Bama, I knew and I knew Tom Lovell, Kunstler and many others. We all met at the same publishers and we would discuss work and talk about the field. I met them all in different publishers' offices."

About other illustrators he admired, Gogos says, "Back then, I liked Robert Fawcett. Bob Peak was doing advertising then, and he was quite good. I also like Frank McCarthy, but as an illustrator I think that Bob Peak was, to me, the most fashionable. I never knew Peak, but he's my favorite illustrator. Frank McCarthy was the King for movie posters. Peak probably did more in the long run, but I think McCarthy was the best. He did a poster for a movie called *The Train* with Burt Lancaster that I loved.

"Of course, I liked Dean Cornwell, who was before my time but, one of my favorites. And there was a friend of mine who was older than I was and in the business a long time, his name was George Gross, and he was so terrific at this type of work. He got work from *Argosy* and better-known magazines. I admired his work, it was very good, and he had been in it for years. We talked a lot, and it was very beneficial for me. There were so many, Vic Prezio was a personal friend. We got to know each other and became good friends. He was very experienced, and quite good!"

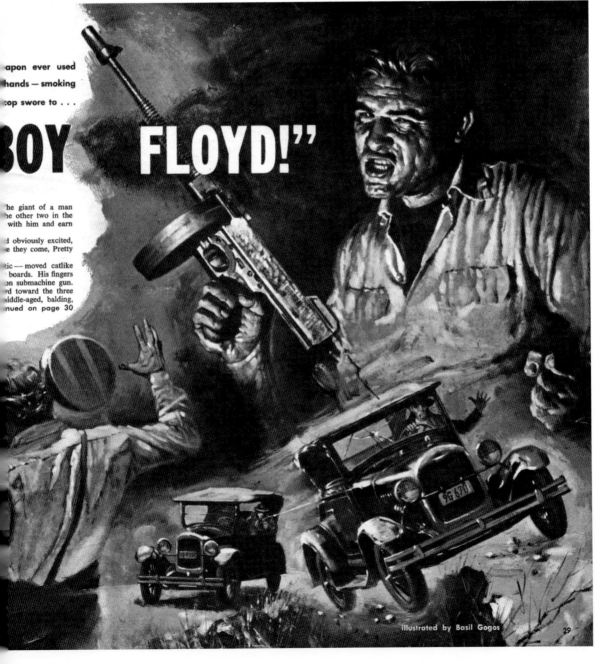

apon ever used
hands — smoking
cop swore to . . .

BOY FLOYD!"

he giant of a man
he other two in the
with him and earn

d obviously excited,
e they come, Pretty

tic — moved catlike
boards. His fingers
on submachine gun.
d toward the three
iiddle-aged, balding,
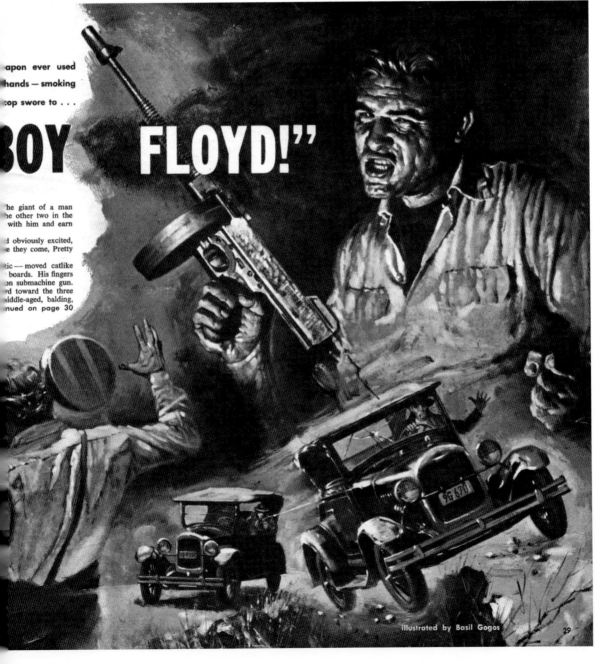

nued on page 30

illustrated by Basil Gogos 29

A model who was very popular among New York illustrators in the 1950s and 1960s was Steve Holland. He may be best known as the model for James Bama's long-running series of Doc Savage paperback covers. Holland was also an actor and was excellent at action poses and expressions.

Gogos recalls, "Steve was a model that everyone used at the time, to the point where an art director said to me, 'Can you choose somebody else? All your heroes look like him!' So I had to use other models, too. Steve was very professional and had an expressive face. He was on all those Doc Savage covers and a lot of westerns, too. He was also Flash Gordon on television. Here's a cute story: He came to pose one day and brought along his five-year-old son. I said to his son, 'Do you know who Flash Gordon is?' He smiled and said, 'My daddy.'"

Asked about his female models, Gogos says, "For a long time, I used one female model named Joan Stein. She was fantastic. I loved using her, and we became friends and she always posed for me as well as a lot of other illustrators. She wasn't a big-time model but she was very pretty and very good at posing for the different characters. Don't forget, we didn't have that much money, and we couldn't go out and get a fashion model who was charging you $100 an hour then. The whole job may have paid $150. And we didn't have the luxury of hiring separate models for each figure in the picture either. I couldn't afford to get more than one woman for each illustration. If there was more than one girl in the picture I had to make them look different—that was a challenge. But it was based on the same model. That's all I could afford. Steve Holland posed for all the men in many of my illustrations, and I had to change his face. But it's experience that you pick up, and it's beautiful. You had every chance to get better by having these challenges."

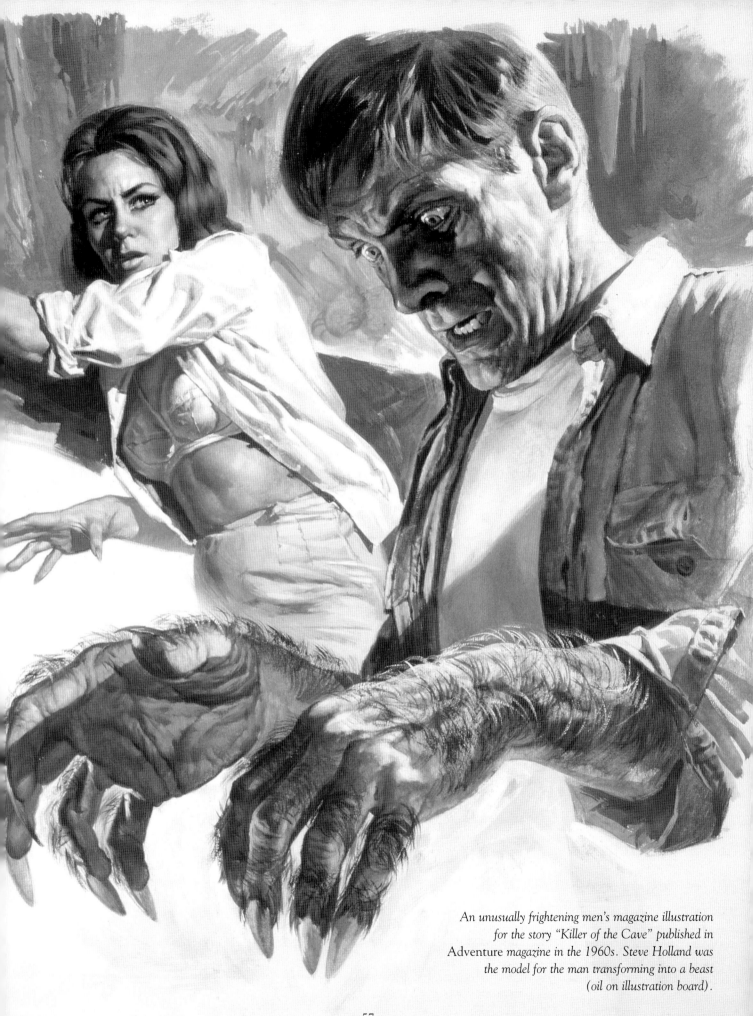

An unusually frightening men's magazine illustration
for the story "Killer of the Cave" published in
Adventure magazine in the 1960s. Steve Holland was
the model for the man transforming into a beast
(oil on illustration board).

THE DEADLY MISSILE CLIMB

THEY WERE four men ascending a mountain, their fate linked together by the yellowed strands of a climb rope. Then Flight Lieutenant Thomas Robertson, leading the special Royal Air Force expedition, felt that rope go taut around his waist; and as he fought off panic and strained to brace himself on the ice-crusted peak, he looked down through the fine haze of wind-blown snow to see a life-and-death struggle unfold.

Airman George Murphy, next man to Robertson, had slipped and plunged feet first and waist deep through the crystal white blanket of the mountain slope. The other two members of this Royal Air Force rescue team had frozen in their tracks, Robertson noted, fearful they, too, would crash through the soft avalanche-prone snow.

Around their boots, the snow already was dislodging and tumbling down the slope with miniature force; and from miles away, like a fearsome warning, came the deep-throated roar of a distant avalanche — the third or fourth the expedition had heard this morning.

Robertson, heart hammering, waited tensely. The winds up here, at 13,000 feet, came with breath-taking force, and he wanted every man rested before they made any attempt to free Murphy. Utterly helpless, Murphy would have to be pulled straight up to avoid setting loose tons of ice and snow. Despite the perilous situation the ruddy-faced airman — only his squinting blue eyes visible through his scarf-mask — winked reassuringly at Robertson.

continued on page 20

MURPHY

illustrated by Basil Gogos

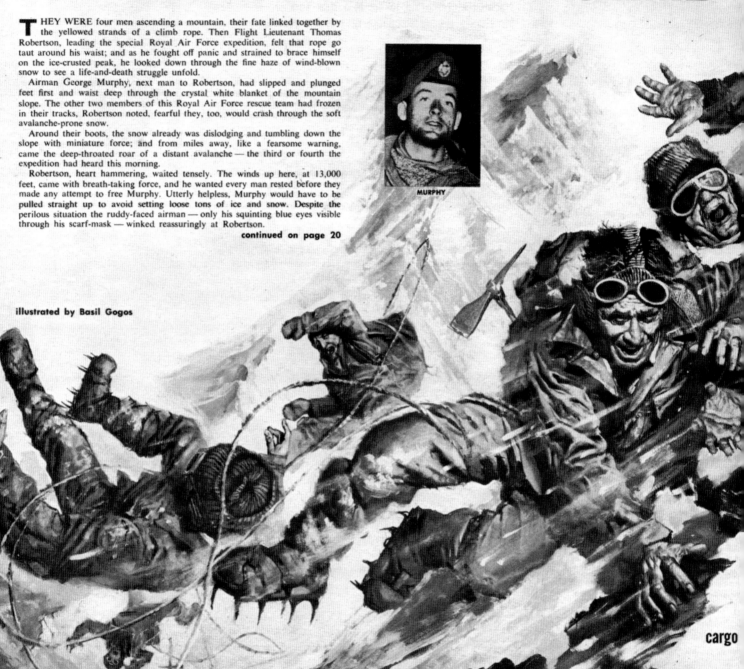

cargo

One of Basil Gogos' frequent models for photo reference was his father, Steve Gogos. "He was my favorite model. And he would fall into the poses. He was a natural actor! He was very helpful. He was a terribly handsome man—very photogenic. He was in his early fifties then and he could change himself to an older fella or a younger fella. And he was always ready to pose whenever I needed him. If I said, 'Pop, will you pose for me?', he never said, 'No, I'm too tired' or 'let's do it tomorrow.' Never. I would dress him up sometimes as a miner or a soldier or what have you and give him props and he would become these characters for the illustration and he was a lovely model."

by JACK RYAN

Crack mountaineers blasted by lashing winds, biting snows and deadly avalanches, they persisted in what the Turks called "the ...le climb." . . . With the world's most valuable ...hey had to beat the Russians up Mt. Suphan!

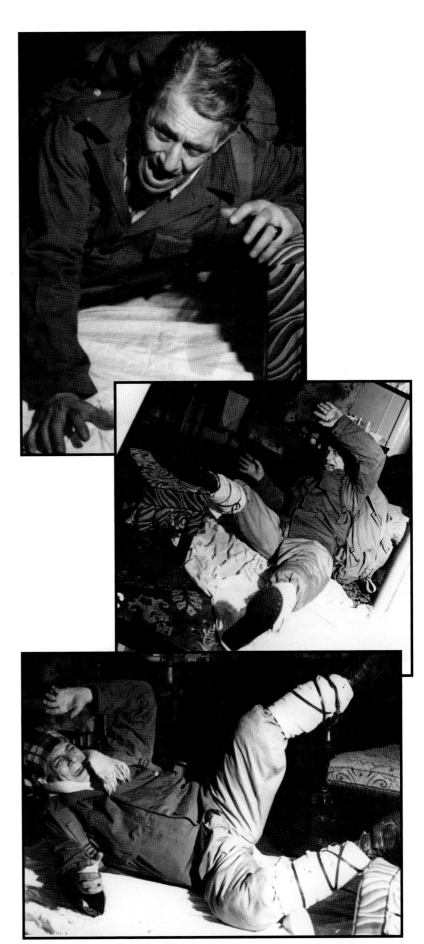

ABOVE: *Double page illustration for "The Deadly Missile Climb," a men's adventure magazine story from the mid-1960s (oil on illustration board).*

RIGHT: *Reference photos for the illustration above showing Basil Gogos' father, Steve Gogos, modeling for all the characters.*

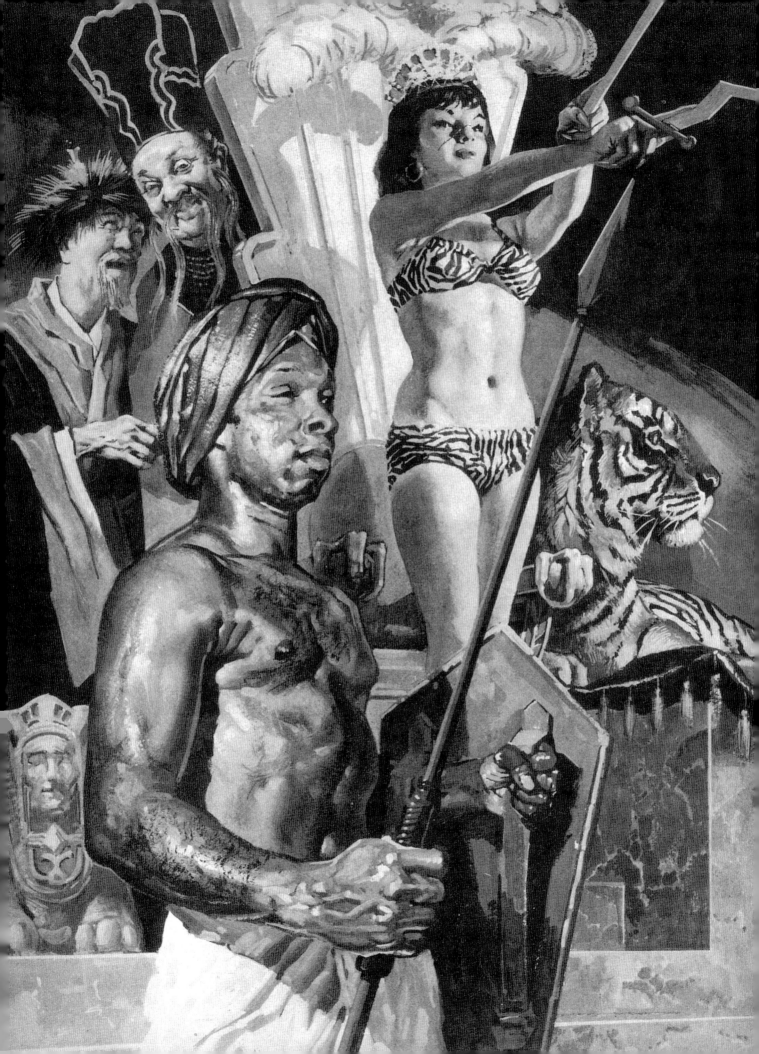

MATE WITH MY DAUGHTER AND DIE

By Myron T. Sorenson

After the queen's daughters were through with me I was doomed . . .

WITH AN OATH the giant black Nubian eunuch planted his foot in the small of my back and shoved. I stumbled forward into the jungle clearing, tripping over the matted roots and falling face down in the muck. My hands were lashed behind my back

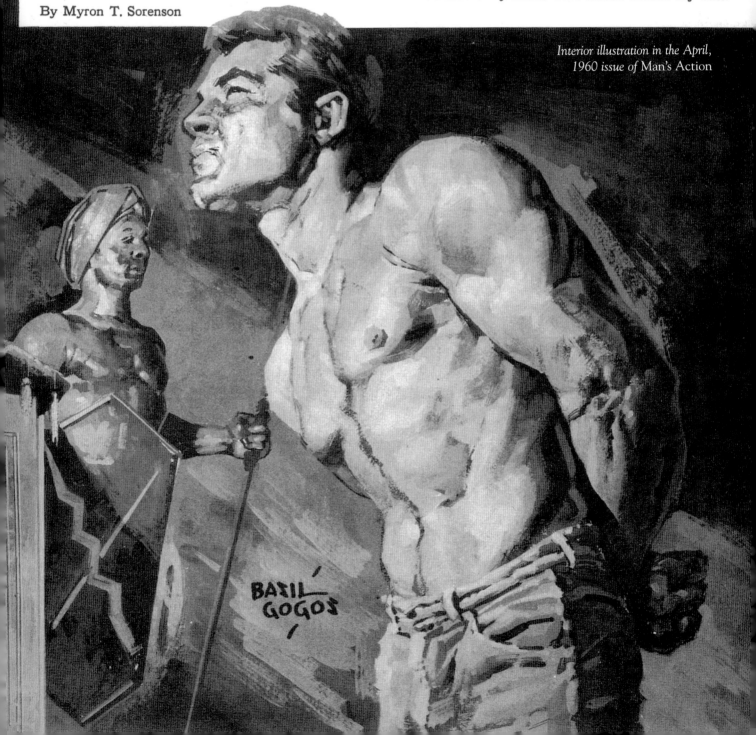

Interior illustration in the April, 1960 issue of Man's Action

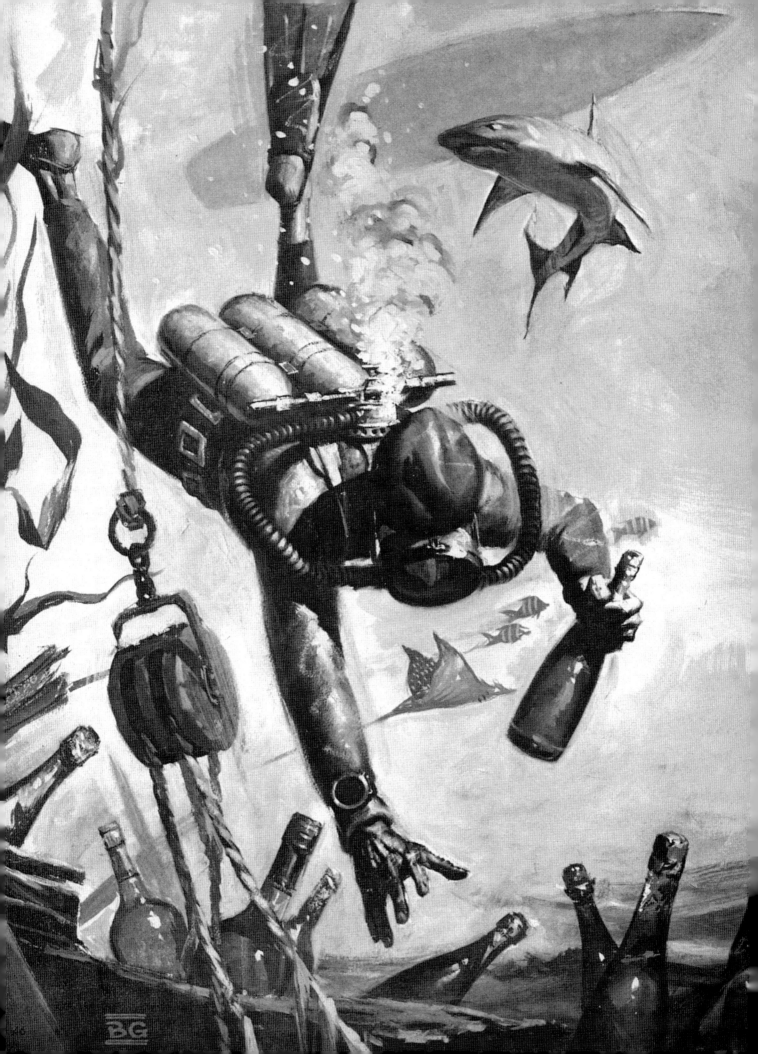

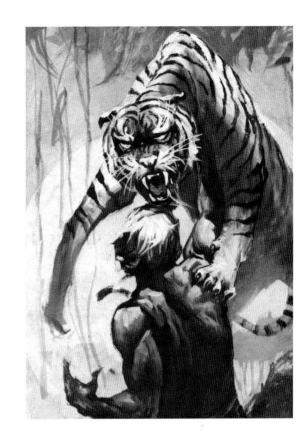

OPPOSITE PAGE: *Interior illustration in June 1965 issue of* True Adventures *(oil on illustration board).*

RIGHT AND BELOW:
Interior illustration for men's adventure magazines of the mid-1960s.

For an illustration involving a pool shark, Gogos used his father as a model. For the photo shoot he recalls, "I took him to a pool hall and he started shooting pool. He was an excellent pool player. And it all came naturally. That was an earlier job, too, but I think it came out very well. I didn't have to add much. The lighting was there and he knew how to hold the cue in a natural way, which you can see the picture. He was a natural, and the lighting was perfect."

Although the covers of most men's adventure magazines were heavily art directed, Gogos sometimes enjoyed more freedom on interior pieces. "For some black and white, single page, illustrations, it got to the point where they said, 'Do whatever you like.' I used to go to the office of the editor and say, 'Look, I'd love to try something,' and he said, 'Go ahead and try it.' I have done a few black and whites where I was totally free. One of them is that tiger that is jumping on a man. That's one example of cutting loose. It was a much freer painting than the typical illustration."

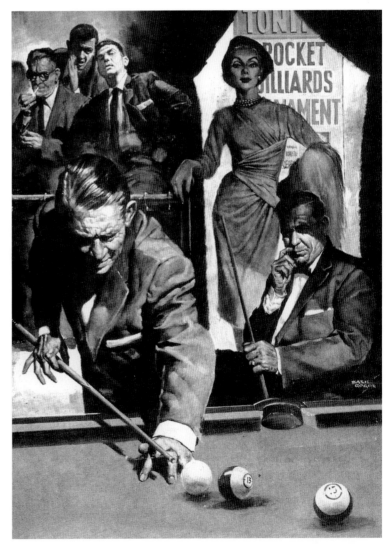

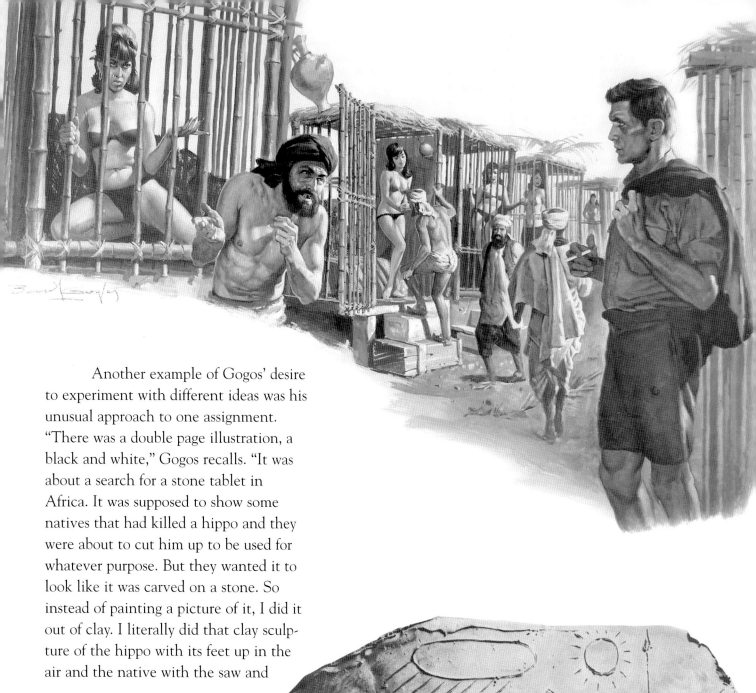

Another example of Gogos' desire to experiment with different ideas was his unusual approach to one assignment. "There was a double page illustration, a black and white," Gogos recalls. "It was about a search for a stone tablet in Africa. It was supposed to show some natives that had killed a hippo and they were about to cut him up to be used for whatever purpose. But they wanted it to look like it was carved on a stone. So instead of painting a picture of it, I did it out of clay. I literally did that clay sculpture of the hippo with its feet up in the air and the native with the saw and

ABOVE:
Interior gouache illustration for
"I saw the Caged Girls of
Bombay" in True Adventures
(December 1965).

RIGHT:
A rare illustration in clay!

OPPOSITE:
Oil on board cover art for
Man's Action *(March 1961).*

strange writings on the wall. I did it in a sort of primitive style, and it looked like a real stone tablet. Because it was a relief, I lit it from one side only to get the most out of it and I photographed it. So instead of a painting of a stone, it's actually a piece of sculpture. I photographed it myself because I wanted to get the best results. And they loved it and they printed it from my photo. That's an example of what can be done when you're allowed to be innovative in commercial work."

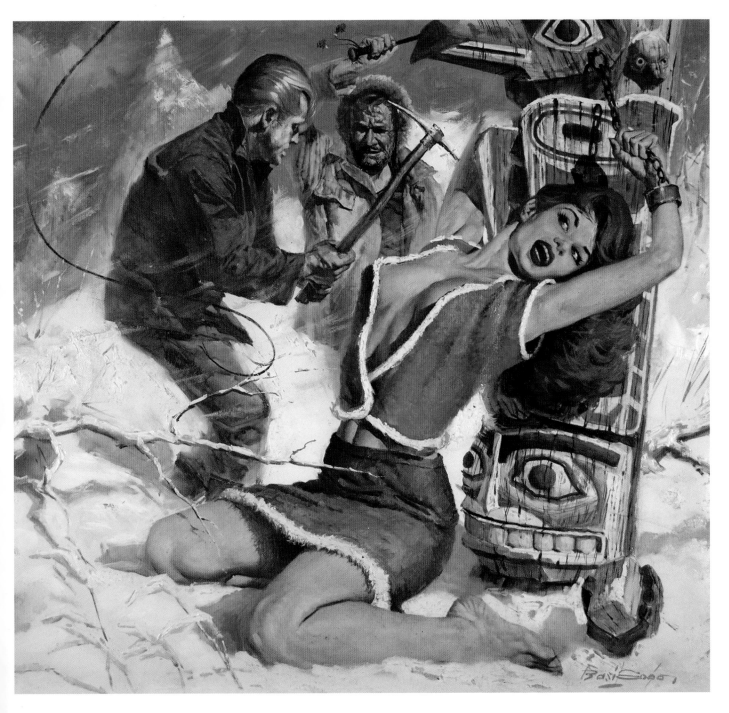

Summing up his men's adventure art, Gogos says, "Early on there were a lot of 'native' things. Natives attacking the hunter with spears, or the hunter and the girl tied up, or you had a native chief with a knife or execution weapon to punish the hunter and silly stuff like that. Then I got into doing war scenes which I also liked. I did dozens of illustrations of World War II battles which could get very tedious when you had to paint so many men and weapons and tanks and planes and everything. But I did some good ones. Then I did scenes of other types of danger and adventure. I liked doing men's adventure scenes. And, once in a while, I loved to do a pretty girl as you have seen."

LEFT:
Paperback sample (casein, 1960s).

OPPOSITE PAGE:
Cover of Adventure *(oil, October, 1965).*

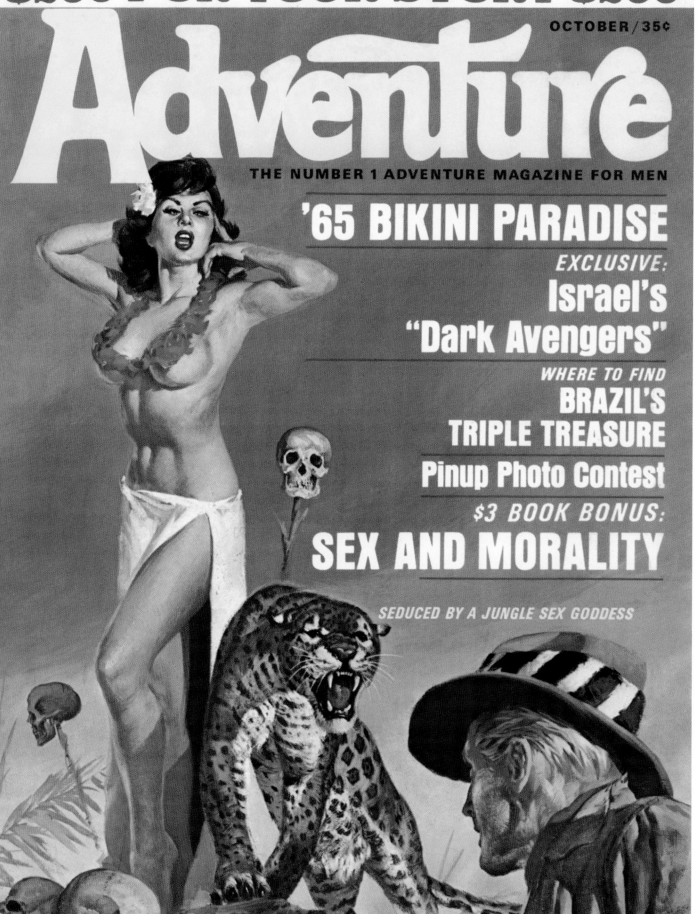

$200 FOR YOUR STORY $200

OCTOBER / 35¢

Adventure

THE NUMBER 1 ADVENTURE MAGAZINE FOR MEN

'65 BIKINI PARADISE

EXCLUSIVE:
Israel's "Dark Avengers"

WHERE TO FIND
BRAZIL'S TRIPLE TREASURE

Pinup Photo Contest

$3 BOOK BONUS:
SEX AND MORALITY

SEDUCED BY A JUNGLE SEX GODDESS

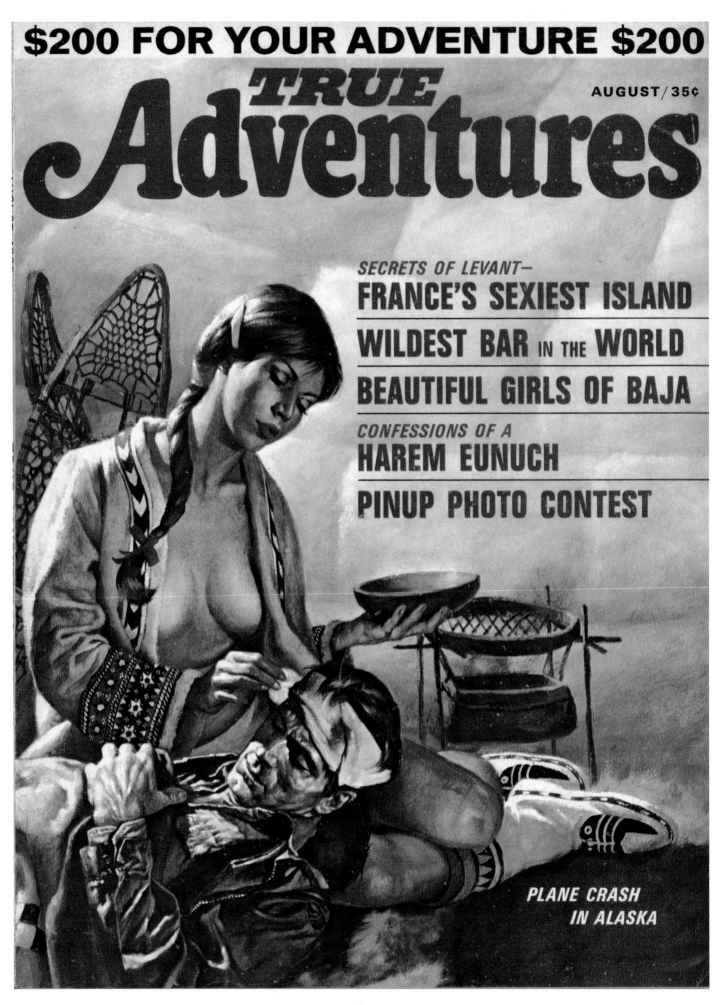

$200 FOR YOUR ADVENTURE $200

TRUE Adventures

AUGUST / 35¢

SECRETS OF LEVANT—
FRANCE'S SEXIEST ISLAND
WILDEST BAR IN THE WORLD
BEAUTIFUL GIRLS OF BAJA
CONFESSIONS OF A
HAREM EUNUCH
PINUP PHOTO CONTEST

*PLANE CRASH
IN ALASKA*

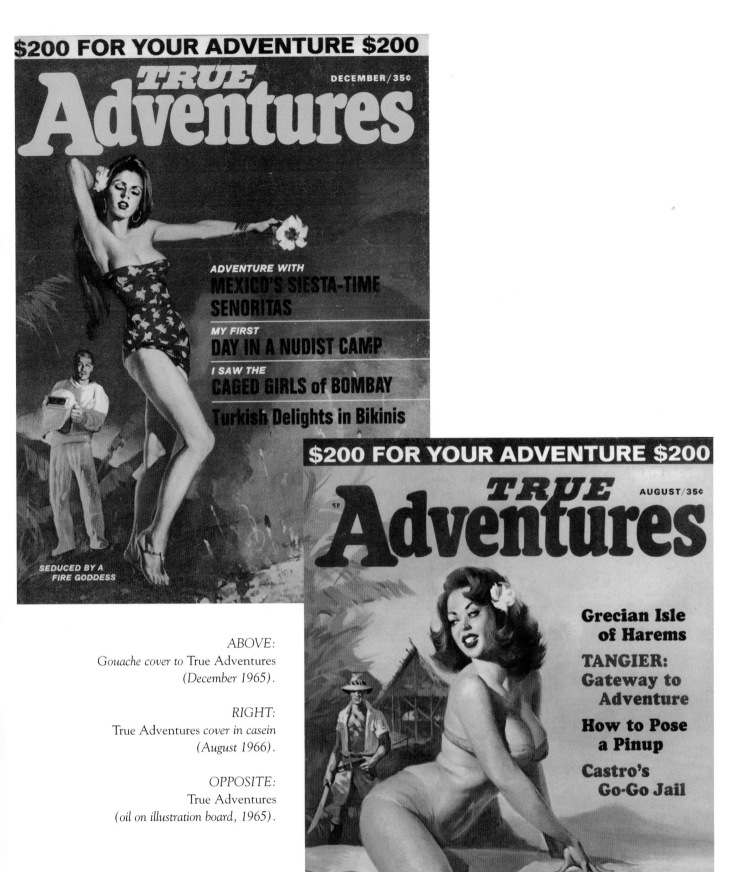

ABOVE:
Gouache cover to True Adventures
(December 1965).

RIGHT:
True Adventures *cover in casein*
(August 1966).

OPPOSITE:
True Adventures
(oil on illustration board, 1965).

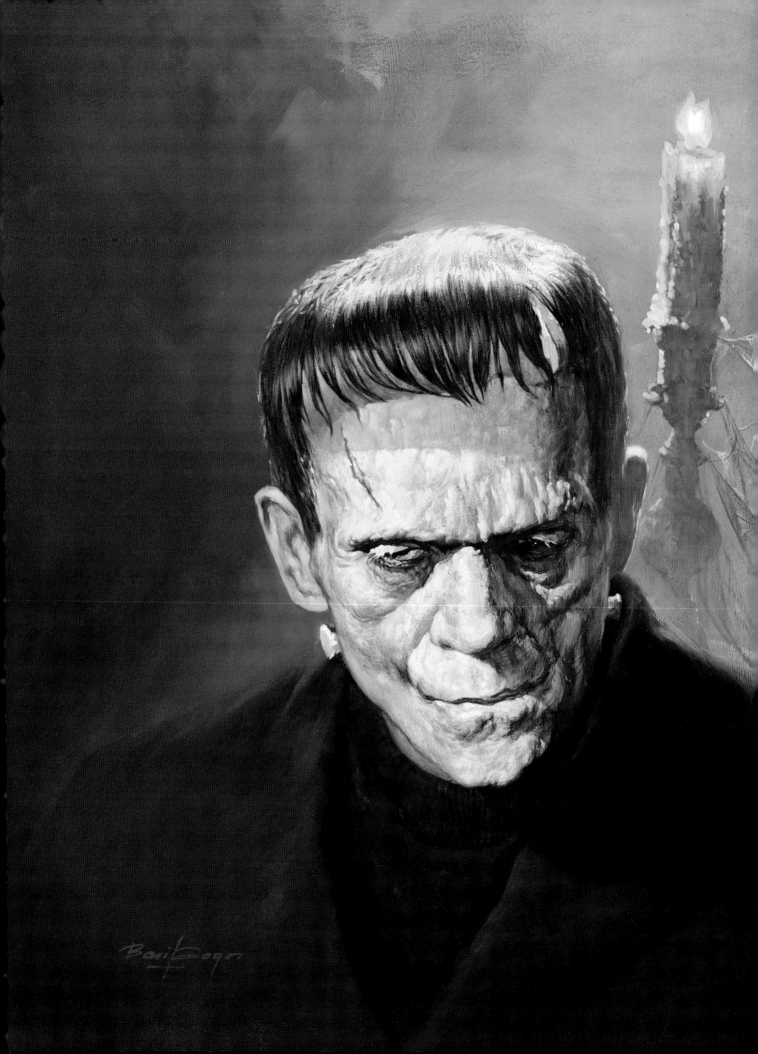

THE KING IS DEAD
Long Live the King

Following his initial run of *Famous Monsters* covers for James Warren, Basil Gogos took a break from monsters to explore other work. Warren turned to other artists who, for the next few years, did their best to fill the void left by the artist who had so quickly established himself as the premier painter of monster magazine cover art. While FM readers were treated to some enjoyable covers by talented illustrators (usually showing at least some Gogos influence), the earlier covers by Basil Gogos soon took on almost legendary status.

Famous Monsters readers longed for Gogos to return to the covers of the magazine and between issues 47 and 53, four of his cover paintings were re-used creating even more new Gogos fans. With an audience eager for Gogos monsters, fate soon stepped in to set the stage for Gogos' re-entrance to the world of monster art.

In February of 1969, word came that Boris Karloff, the most famous actor of the golden age of horror movies, had died in England at the age of 81. Warren and editor Forrest J Ackerman began preparing a special issue of *Famous Monsters* to pay tribute to the late King of Horror. For the cover, their goal was to feature the definitive portrait of Karloff in his most famous role as the misbegotten monster from the original *Frankenstein*. But what artist could do justice to this momentous assignment? Only one. Soon the king of monster magazine art was back to pay homage to the fallen king of horror movies. Though a sad event, the death of Karloff ushered in a new era of Basil Gogos monster art.

BELOW:
Editor Forrest J Ackerman and Basil Gogos with his cover painting for Famous Monsters *56 in the Warren Publishing offices, 1969.*

OPPOSITE:
Gogos' magnificent memorial portrait of Boris Karloff as the Monster from the 1931 classic, Frankenstein *(oils, 1969). Collection of the artist.*

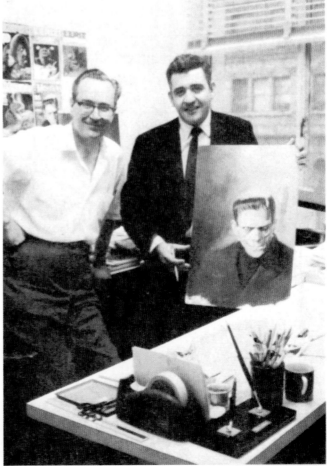

"I thought I'd do it in oil because it had to be a special cover," remembers Gogos. "We all loved Karloff. When he died, I said, 'This has got to be a special cover' and I did it in oil instead of casein or acrylics, or poster colors. I did my best effort, and it came out beautifully. I put the candle behind him, a couple of cobwebs, just to commemorate (his passing), and it was really a beautiful cover."

" *The master artistic hand of my friend Basil Gogos
has immortalized, in paintings, the visages of Boris
Karloff, Bela Lugosi, Vincent Price, Peter Cushing and
numerous others in the pantheon of monsterrific stars.
Basil's marvelous, moody makeovers of movie maniacs,
make him a maven of macabre masterpieces.
He has truly helped to keep horror
fandom and our best fiends ALIVE!* "

— Forrest J Ackerman
*Known as Mr. Science Fiction and Dr. Acula,
original editor of* Famous Monsters of Filmland
and creator of the term "sci-fi."

"Dorian Gray is one of my favorites," states Gogos. "Having used so many colors, sometimes I would ask myself, 'What colors shall I give it now?' I didn't want to repeat what I did on the previous cover. The lighting in that one didn't lend itself to using a lot of colors so I did it looking fairly natural but with a green shadow. If you notice, I sort of liked covering the forehead a little bit with a cast shadow, and that happened on issue 56 with Karloff, too. I threw a cast shadow on the forehead, and that gave me a chance to use an extra color, and I liked the way it looks."

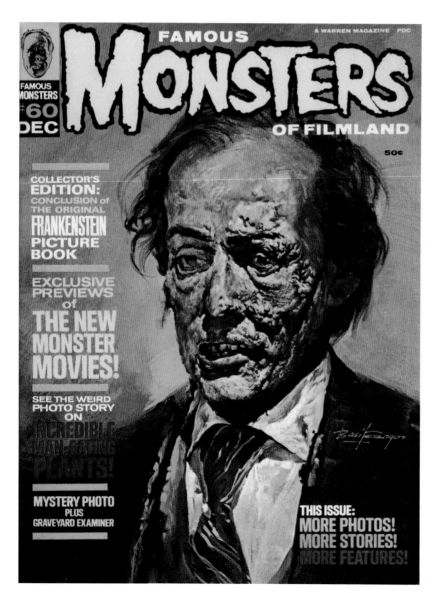

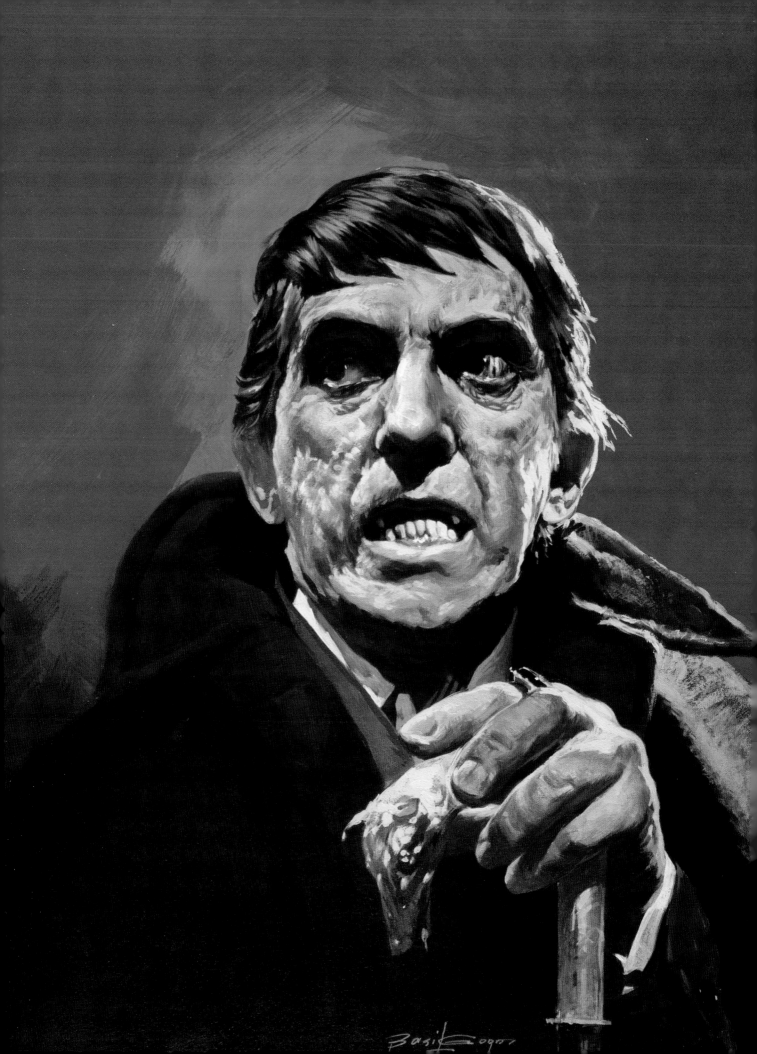

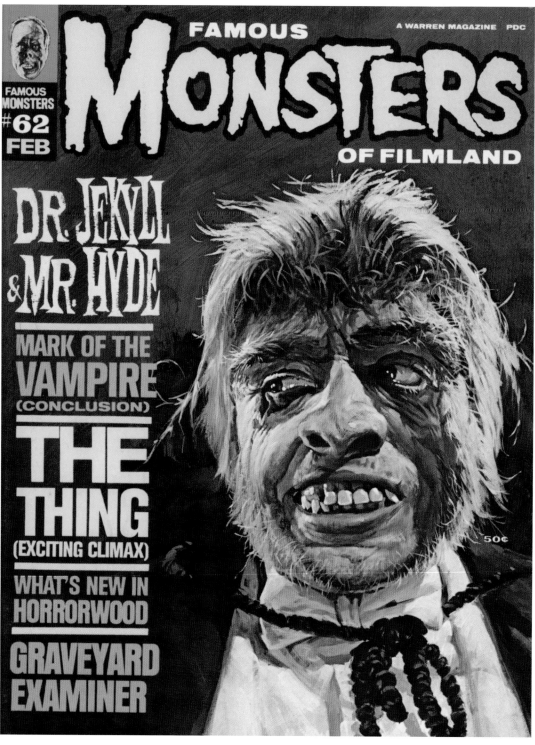

FAMOUS **MONSTERS** OF FILMLAND

A WARREN MAGAZINE PDC

FAMOUS MONSTERS #62 FEB

DR. JEKYLL & MR. HYDE

MARK OF THE VAMPIRE (CONCLUSION)

THE THING (EXCITING CLIMAX)

WHAT'S NEW IN HORRORWOOD

GRAVEYARD EXAMINER

50¢

On his colorful painting of Fredric March as Mr. Hyde, Gogos reflects "I always liked to have a source of information, like a movie still, that has more than one light because it gave me a chance to go from cool to warm, from warm to light, and you have all kinds of attractive opposites to work with. That one has yellowish warmth and reddish midtones in front of the face, and it has an ice blue on the other side. It was really all the vehicle I needed, it was perfect. And it came out very well. I find it to be one of my best jobs."

Remembering his painting of Vincent Price from *House of Wax*, Gogos says, "That was a beautiful painting. I think it really worked. When you do a normal portrait of a man or a woman or a child, you have flesh which is normal, and you can only do so much with it. But when it comes to a monster like that, he's full of pockmarks and burn marks and scars and flesh coming off, and it gives you an opportunity to form every little crater or crevice, that it's a beautiful opportunity to have fun. And I had fun with that one! It took a little longer to do because his face is so distorted and badly treated. But that gives you a chance to, you know, put your fingers in it and really build that face. The more the faces were distorted for these covers, the more I liked it. I enjoy doing normal portraits, but monsters are more fun!"

ABOVE:
Famous Monsters 62. Fredric March in his Academy Award winning role in the 1931 version of Dr.Jekyll and Mr. Hyde (acrylics, 1969).

OPPOSITE:
Vincent Price as the fire-scarred sculptor in House of Wax *for the cover of* Famous Monster 64 *(acrylics, 1970).*

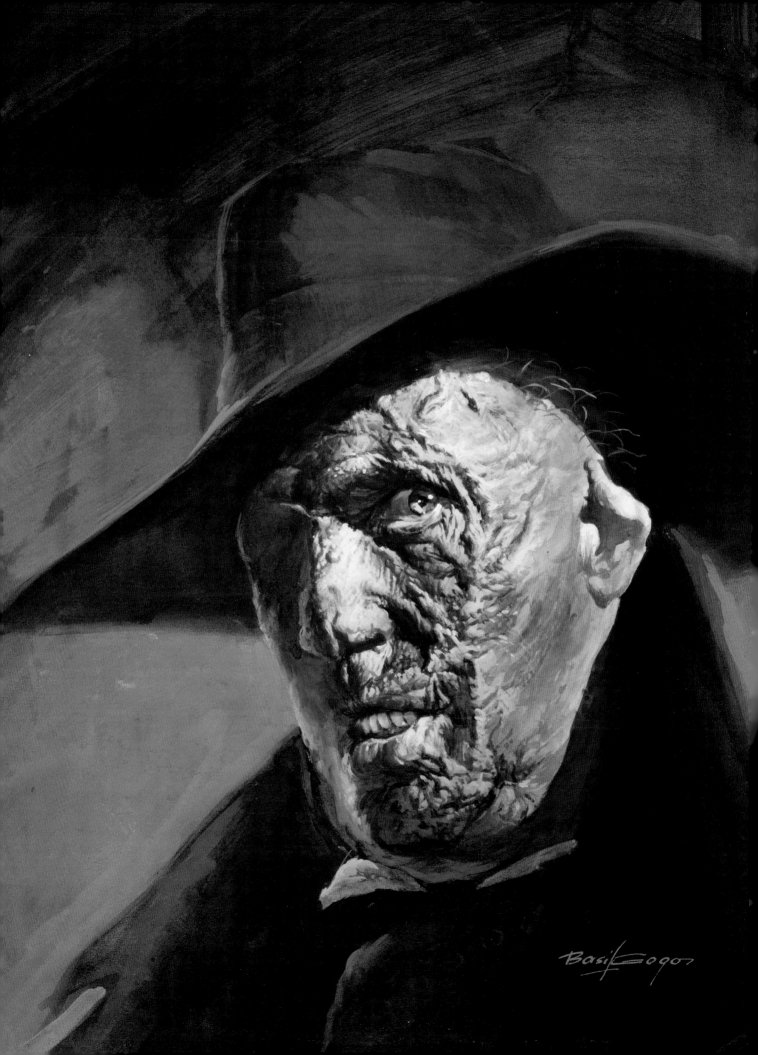

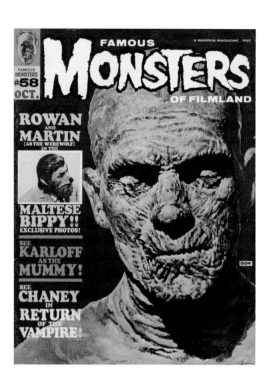

ABOVE:
Famous Monsters 58 featuring Boris Karloff
as The Mummy (oil, 1969).

LEFT:
Cover art for Famous Monsters 83.
High priest George Zucco reveals the secret of
Kharis (Lon Chaney, Jr.) to his successor,
Turhan Bey in The Mummy's Tomb
(oil, 1970).

" I thought
Basil Gogos was
very, very good.
I felt that I never came
close to the quality
of his work. "

— Ron Cobb
Famous Monsters
cover artist and
conceptual artist for
Star Wars *and* Alien
From an interview by Dennis Daniel

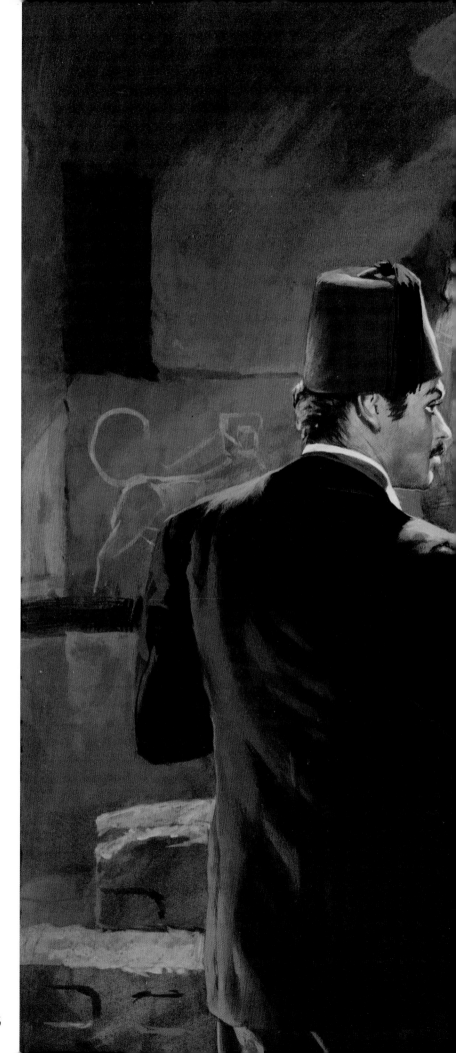

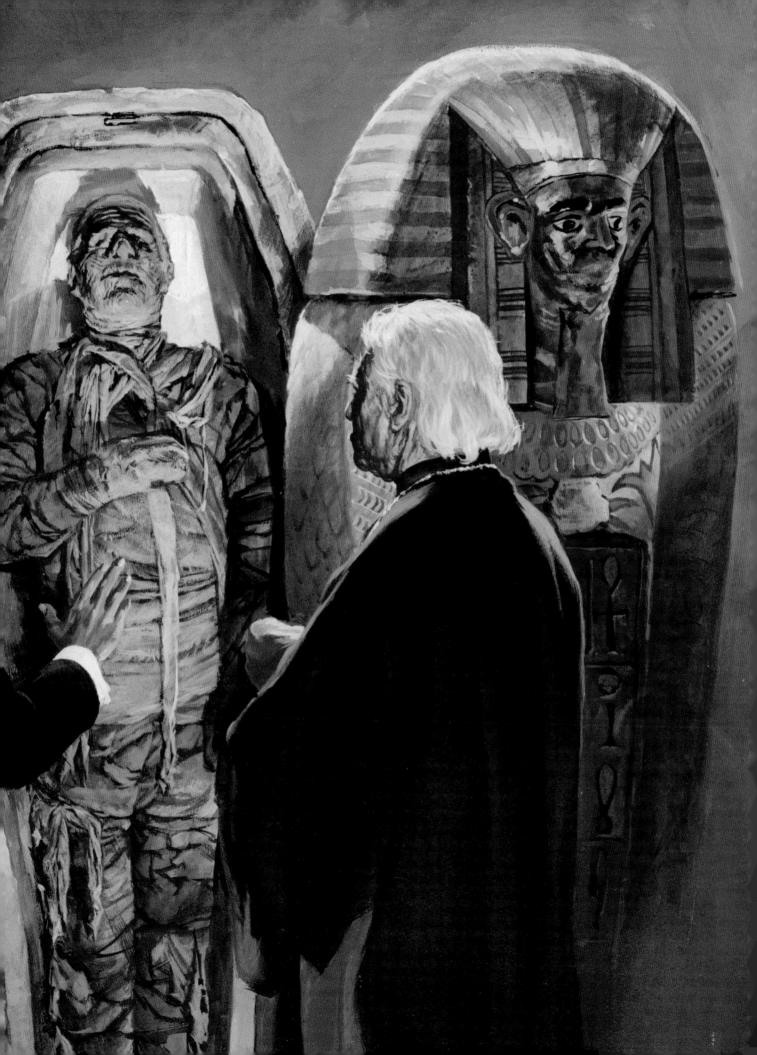

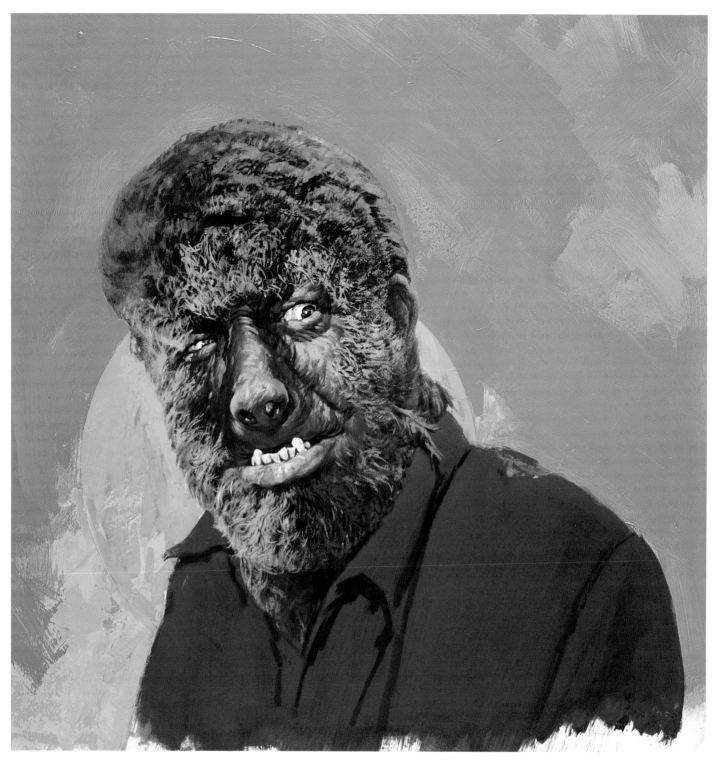

OPPOSITE:
Gogos' first painting of The Creature from the Black Lagoon *for* Famous Monsters 103, *a jigsaw puzzle and a glow-in-the-dark poster giveaway in boxes of Post cereal (acrylic).*

ABOVE:
Lon Chaney, Jr. as the Wolf Man in House of Dracula *for the cover of* Famous Monsters 99 *(acrylic).*

His painting of the Wolf Man for *Famous Monsters* 99 gave Gogos a slight problem. "Jim Warren never liked yellow," he remembers. "I had painted the background yellow, and he said the bright colors made him look like the Easter Bunny! He said, 'Can you do anything for it?' So I took it, and I put the moon behind it to break it up. Turned out to be a good cover because yellow gave me an opportunity to use other colors. But I kept away from yellow after that and Jim couldn't be happier, because he didn't like it."

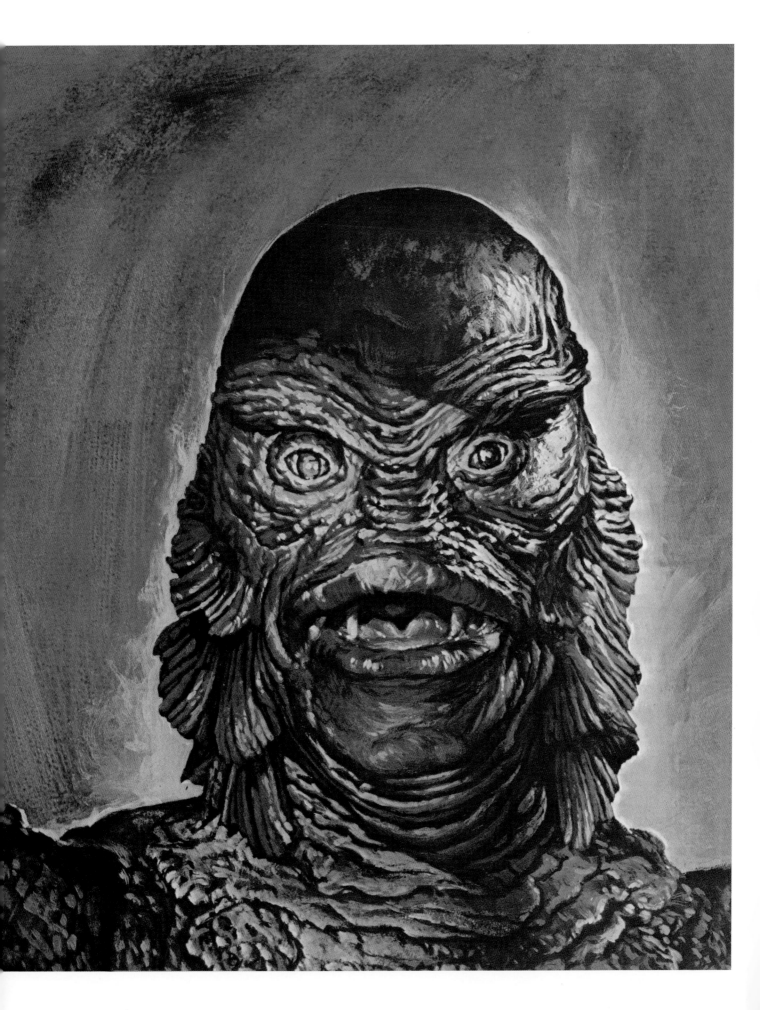

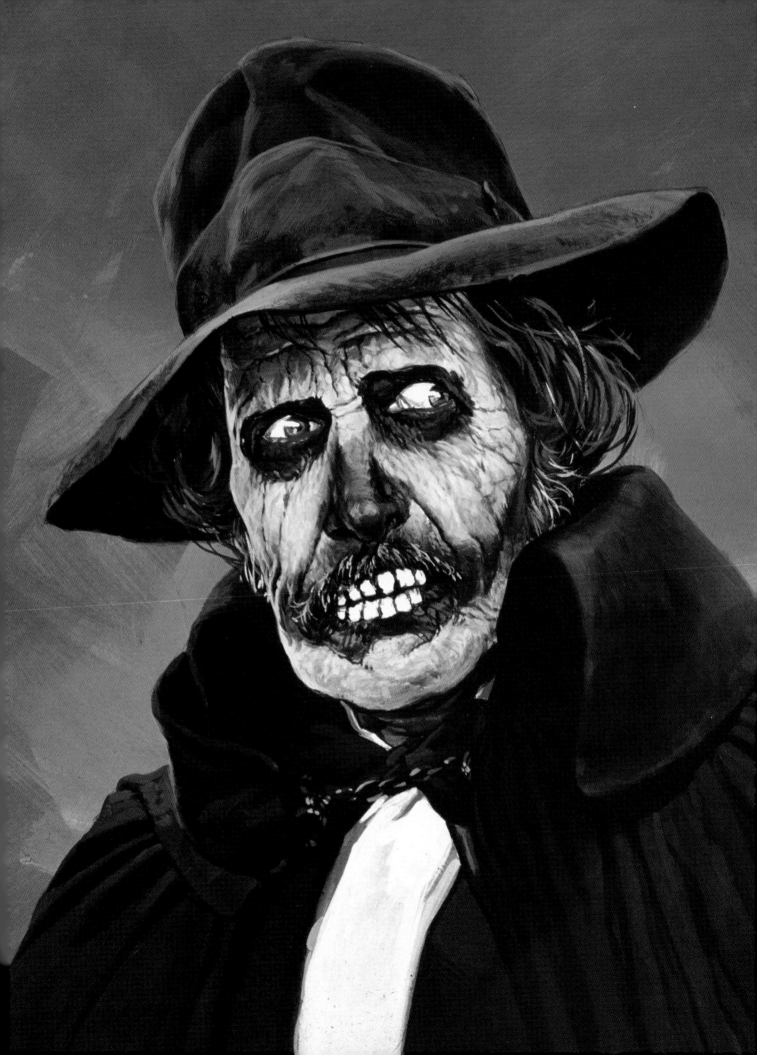

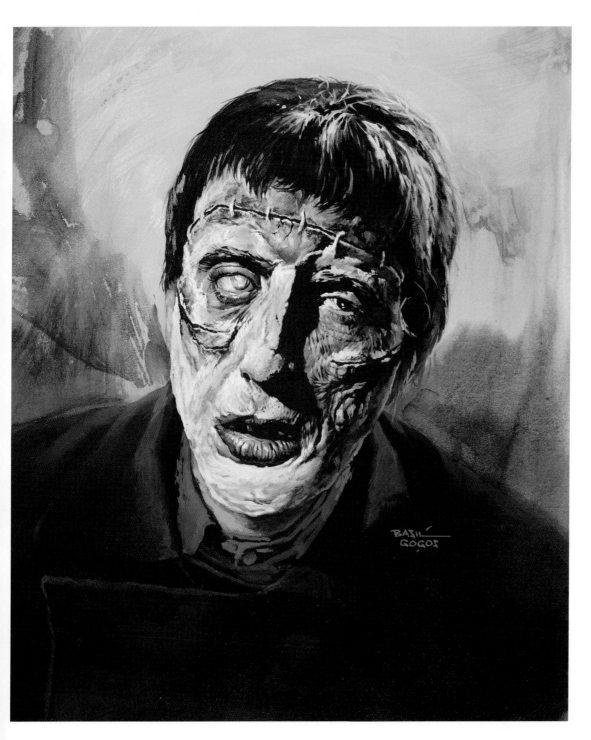

Of his painting of Vincent Price as Dr. Death in *Madhouse*, Gogos recalls, "I loved that greenish-blue hat, and the skull-like face that Price had. It was interesting because in the picture he was playing a horror star wearing horror make-up. It was good because it had bone-like sections, or what seems to be bone, what seemed to be dry flesh but it was over his skin, and he painted the eyes dark. And wrinkles, plenty of wrinkles. Yes, give me wrinkles. [Laughs] It was beautiful. It looks like a touch of death, you know? It's a grayish-bluish dark color that's quite unpleasant, but it makes an attractive cover."

Asked if he minded his work being covered with so much text when printed, Gogos replied, "Jim once said to me, 'Your covers are the only ones where I can put as much type as the New York Times and it won't hurt the painting, that's how powerful the paintings are.' And that made me feel good."

" When I was a kid growing up with little more on my mind than what the next great monster movie was going to be, how soon it might open in the theaters, and what wonders and excitement it might contain, Basil Gogos' work on the covers of Famous Monsters of Filmland was like a magnet to me. He was not merely a great draftsman and a brilliant colorist (unlike many of his competitors in the genre, who were neither), Gogos had the gift of somehow connecting to his subject matter. Not meaning this pejoratively, Gogos always struck me as modern day John Singer Sargent on acid— a true virtuoso whose masterful brush brought that grim procession of the fabulous and the fantastic, the damned and the disfigured to life. And beneath it all was a compelling and masterful talent, far greater than it needed to be for the demands of its largely juvenile audience.

"I know from long personal experience that it's a damn hard thing to make the grotesque beautiful, but somehow Basil Gogos managed it and did it consistently throughout his long and prolific career. When I was a young artist he was among my most treasured role models. If truth be told, at the beginning of my career I wanted nothing more than to be him, to draw and paint the fabulous creatures that inhabited my dreams and filled my young mind with wonder and awe. And although we've never met, he still is, after all these many years, one of my true heroes. "

<div align="right">

— **Vincent Di Fate**
*Award-winning science fiction artist,
past-President of the Society of Illustrators,
author of* Infinite Worlds:
Fantastic Visions of Science Fiction Art.

</div>

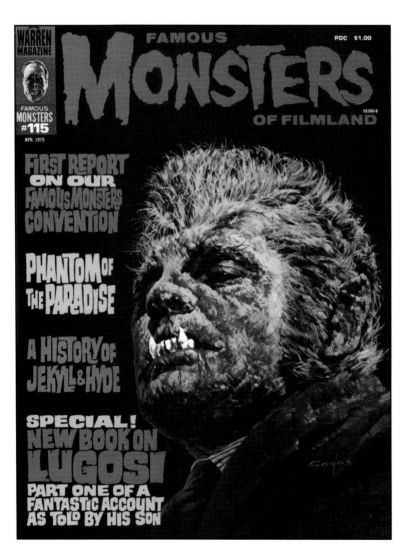

Famous Monsters 108 featured an extreme close-up of the Willis O'Brien's stop-motion figure from the original *King Kong*. Basil Gogos gave the miniature ape an appropriately fierce look.

"King Kong was always nice to paint, because you had the fangs, hair, glaring eyes... I had an opportunity to go crazy with it, and I loved it. I gave it a white background which really makes it stand out."

LEFT:
Famous Monsters 115
featuring Henry Hull in
The Werewolf of London
(acrylic, 1975).

OPPOSITE:
*Close-up of the animation model
from the original* King Kong *for*
Famous Monsters 108
(acrylic, 1974).

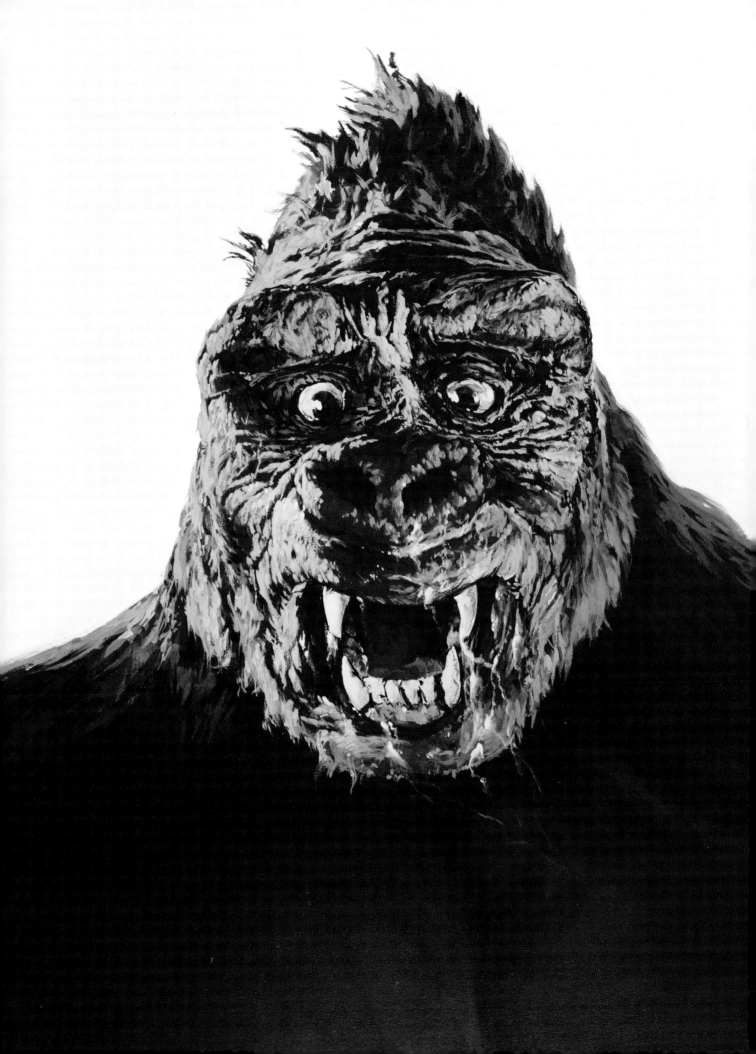

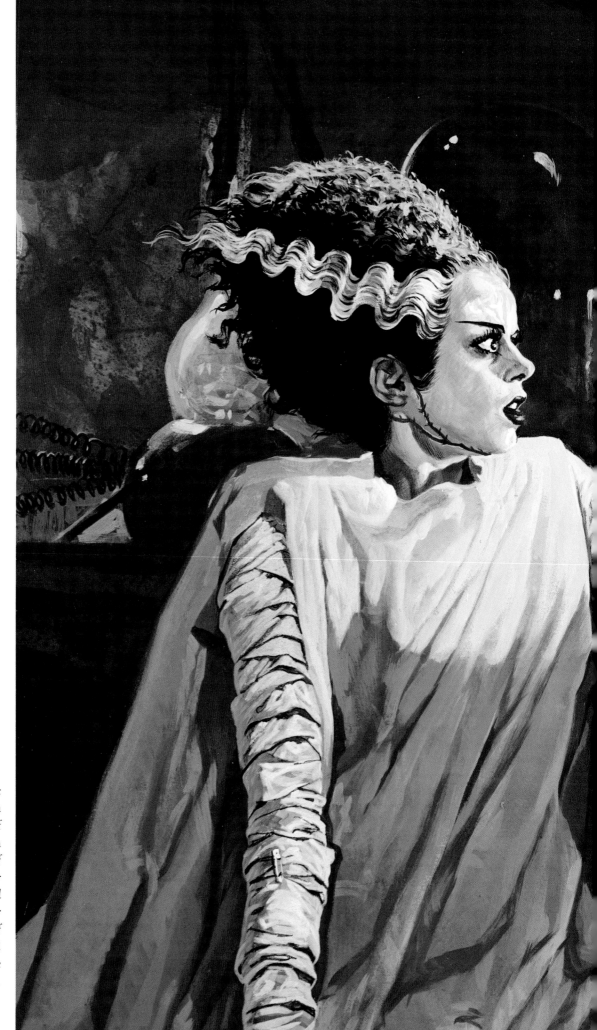

The climactic scene from The Bride of Frankenstein *starring Boris Karloff and Elsa Lanchester as* The Monster *and his mate for the cover of* Famous Monsters 112 *(oil on masonite artist board, 1974).*

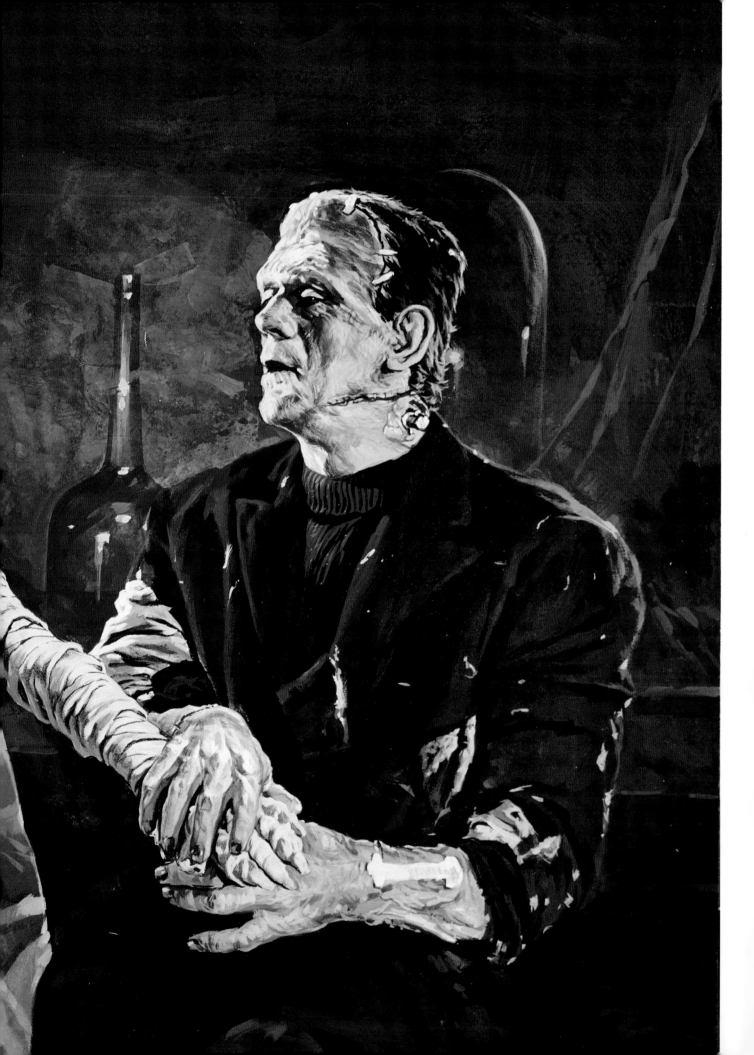

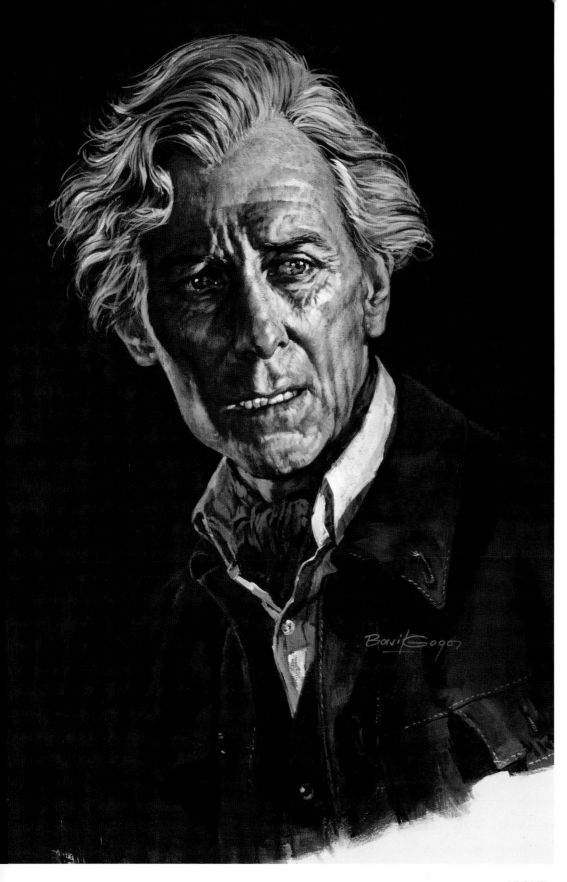

Known for playing monster creators and fighters rather than monsters, Hammer Films star Peter Cushing was so popular with horror fans of the 1960s and 1970s that he could appear on a monster magazine cover looking perfectly normal and still evoke images from classic horror. Basil Gogos captured Cushing's heroic side as Dracula's nemesis, Van Helsing for the cover of *Famous Monsters 130*. Not long before doing the painting, Gogos had met Peter Cushing at the *Famous Monsters Convention* in New York in November of 1975. Gogos recalls his impression of the actor. "The gentleman was very dapper. He had a walking stick, gloves and spats. His diction and way of speaking belonged with everything he wore. He was quite a gentleman."

ABOVE:
Peter Cushing as a modern descendant of Professor Van Helsing in one of the last films in Hammer Films' Dracula series, Dracula A D. 1972 *for the cover of* Famous Monsters 130 *(oil, 1976).*

OPPOSITE:
Portrait of Louis Hayward in The Son of Dr. Jekyll *for the cover of* Famous Monsters 134 *(acrylic, 1977).*

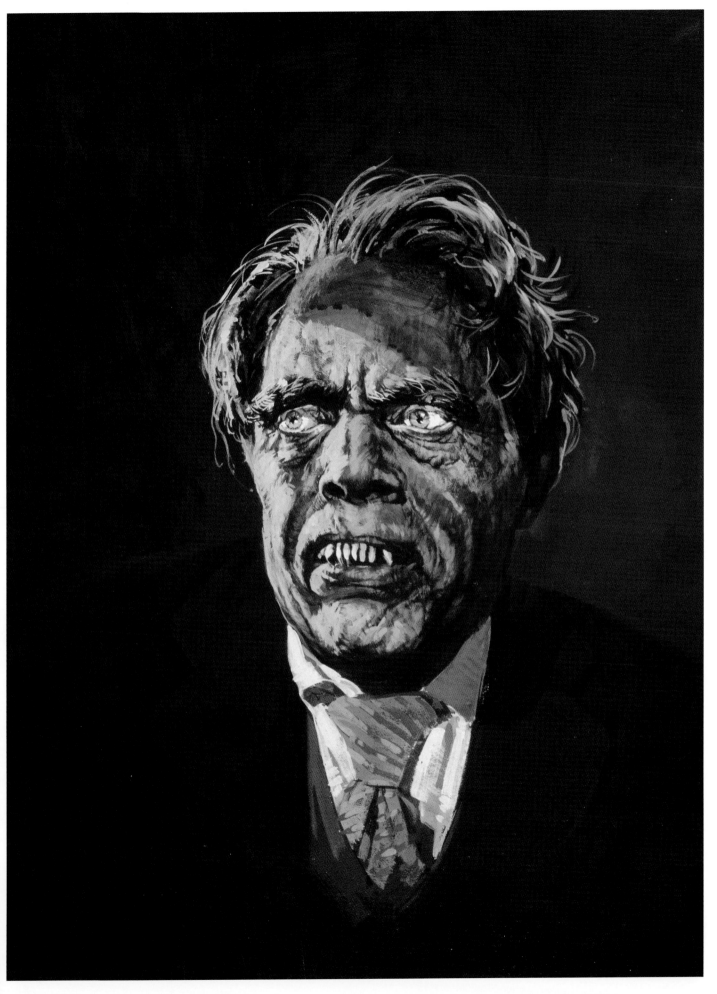

" Although I had the pleasure of painting many covers for Famous Monsters of Filmland, there is only one Basil Gogos. The boldness of his style and his extraordinary use of color, combined with his realism, created some of the most memorable images in monster magazine history. His monster covers were a big inspiration to me and I was very proud to follow in his footsteps. My goal was always to equal the quality of his monster paintings, but in my mind, I never quite did. "

— Ken Kelly
Fantasy illustrator and Warren cover artist

RIGHT:
Staying in the horror mag field but departing from his film monster portraits, Gogos provided this atmospheric scene in oils for the cover of Warren's Creepy 39 *(May, 1971 issue).*

OPPOSITE:
1950s movie monster The Hideous Sun Demon *for the cover of Famous Monsters 106 (acrylic, 1974).*

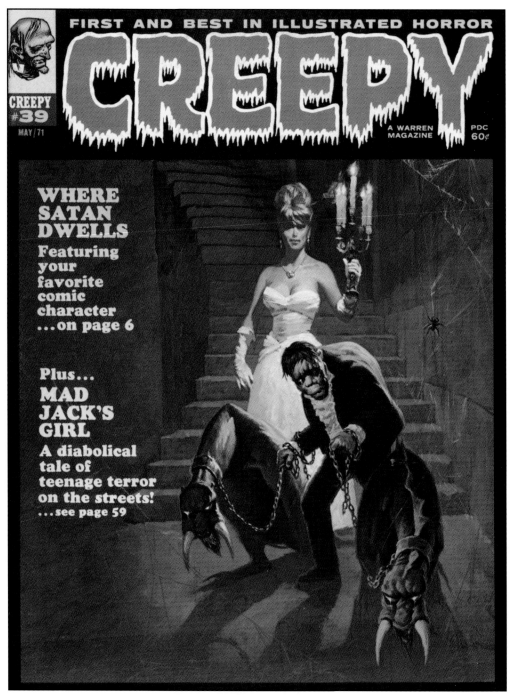

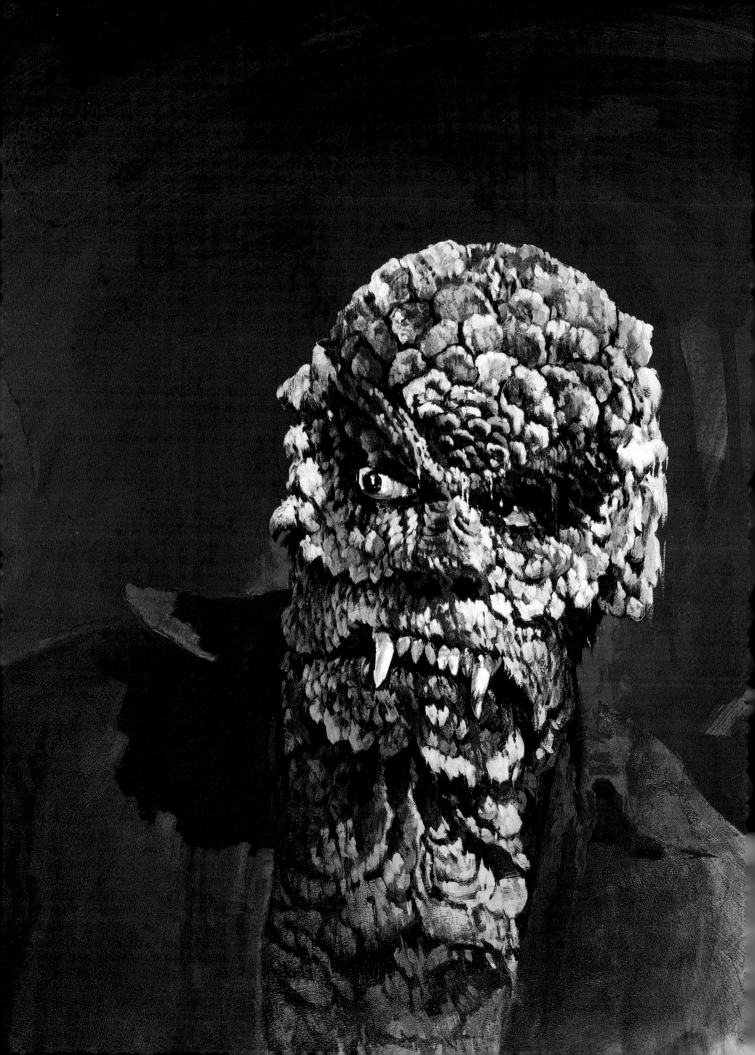

" With his rock solid base of classical skills and training, Basil the Great has conjured all of our favorite monsters and villains to live again in a succulent riot of color and drama. Lucky us! "

— **William Stout**
*Hollywood production designer
and award-winning illustrator*

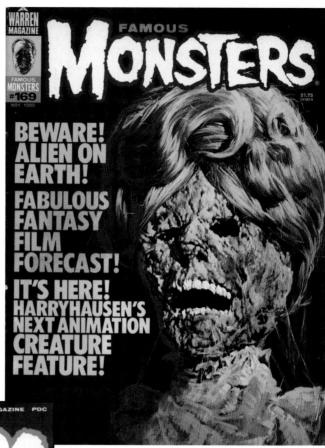

RIGHT:
Famous Monsters 169. *One of Gogos'
last* Famous Monster *covers featured a
shriveled corpse from a Psycho-inspired
movie called,* It! *(acrylic, 1980).*

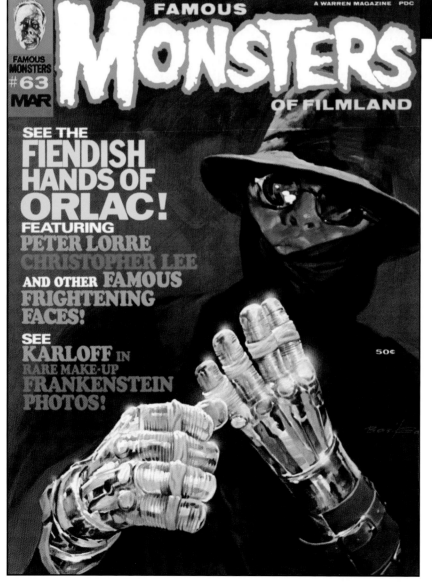

LEFT:
Famous Monsters 63 *featuring Peter
Lorre in a bizarre costume from* Mad Love
(gouache, 1970).

OPPOSITE:
*The one-sheet poster for the U.S. release
of* Godzilla vs The Bionic Monster *featuring the metallic menace, Mechagodzilla.
This art also appeared on the cover of*
Famous Monsters 135 *(acrylic, 1977).*

Fans have always commented on how realistic Peter Lorre's gleaming metal hands look in the *Famous Monsters Mad Love* cover. Gogos reveals the secret. "I had started to use the airbrush which, to me, is a finishing tool, not a tool to work with. I had just learned the airbrush and it was an opportunity to put the glare into the metal—the shine which was very attractive." A few years later, Gogos again made subtle use of the airbrush to add a few finishing touches to Godzilla's latest sparring partner, Mechagodzilla for *Famous Monsters 135.*

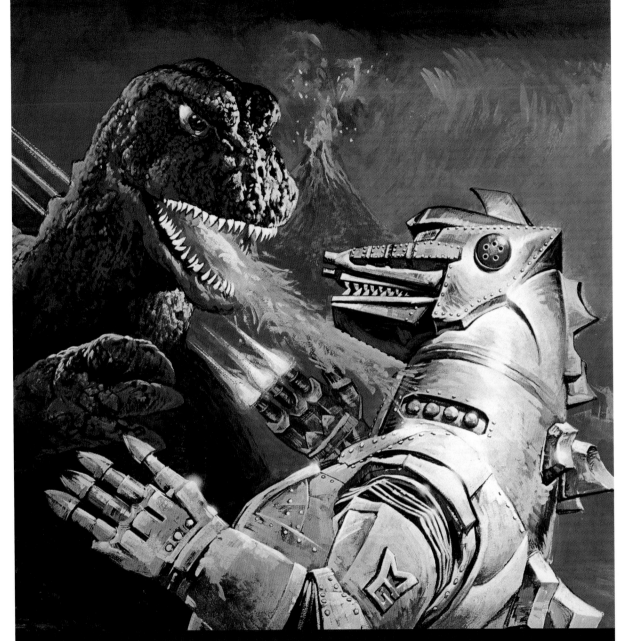

THE NEW MONSTER SCENE
Monster Mags: The Next Generation
By Stephen D. Smith

BELOW:
Monsterscene 3. *Christopher Lee in the 1957 Hammer Film,* Horror of Dracula *(acrylic, 1994).*

RIGHT:
Gogos' first original monster magazine cover art in over ten years. Lon Chaney in London After Midnight. *Originally published on* Monsterscene 2 *(acrylic, 1994).*

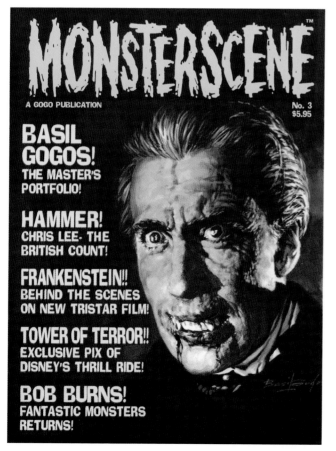

I grew up in a home where art was everything. My mother, a successful graphic designer, was also an excellent painter and print maker when she had the time. I have no recollection of a time in my life when art, and art appreciation, didn't play an important role in my life. I recall our move from Tulsa, Oklahoma to Chicago in 1968. My mother was able to introduce my sister and me to works by Monet, Caillebotte, Cassatt, and other master impressionists courtesy of the Art Institute of Chicago. Now understand, as a seven-year-old, I didn't give a rip about any of this. Chicago for me was all about monsters. No longer did I have to endure the late night horror movies on Tulsa television, sans host.

In Chicago, I had Svengoolie, host of *Screaming Yellow Theater* and the even more sophisticated *Creature Features*. But movies were an art form that my mother respected, so they were never turned off in any fit of moral judgment. As I got older, my love for monster movies grew thanks to Uncle Forry and *Famous Monsters of Filmland*. My favorite cover: issue 56. The artist credited for that piece, Basil Gogos, would later become the reason I would still buy issues of *FM* as I got older. I learned to appreciate sequential storytelling through the pages of *Creepy*, *Eerie*, and later *Vampirella*. Yet my mother's influence kept me close to fine art and for that I owe her an eternal debt of gratitude.

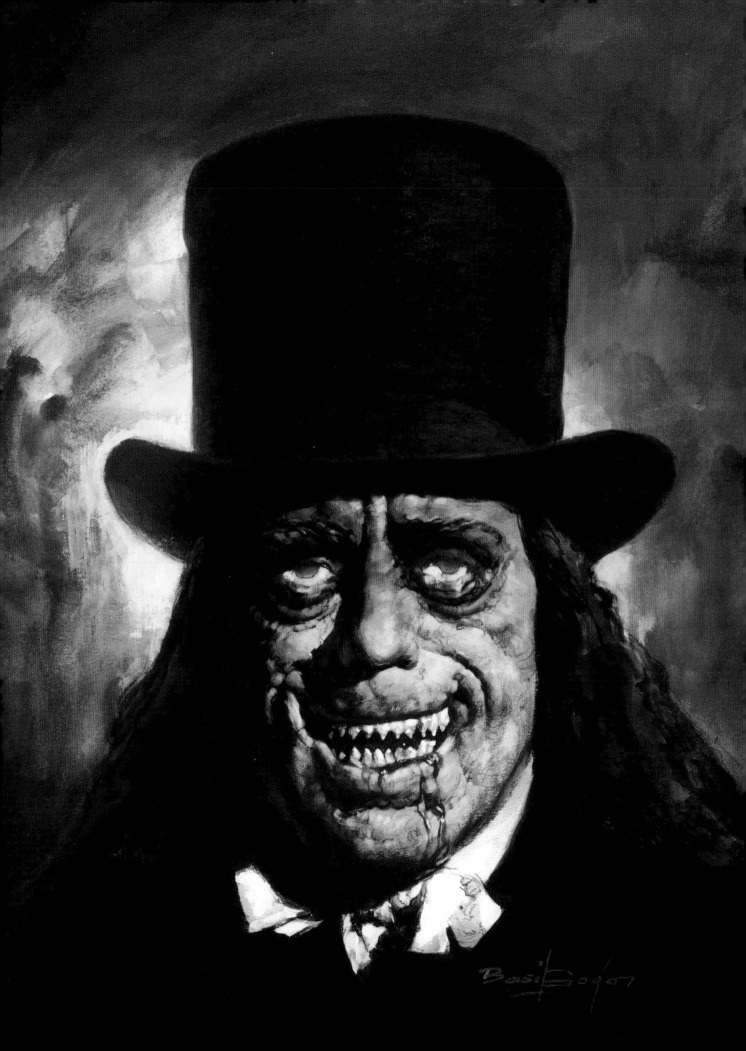

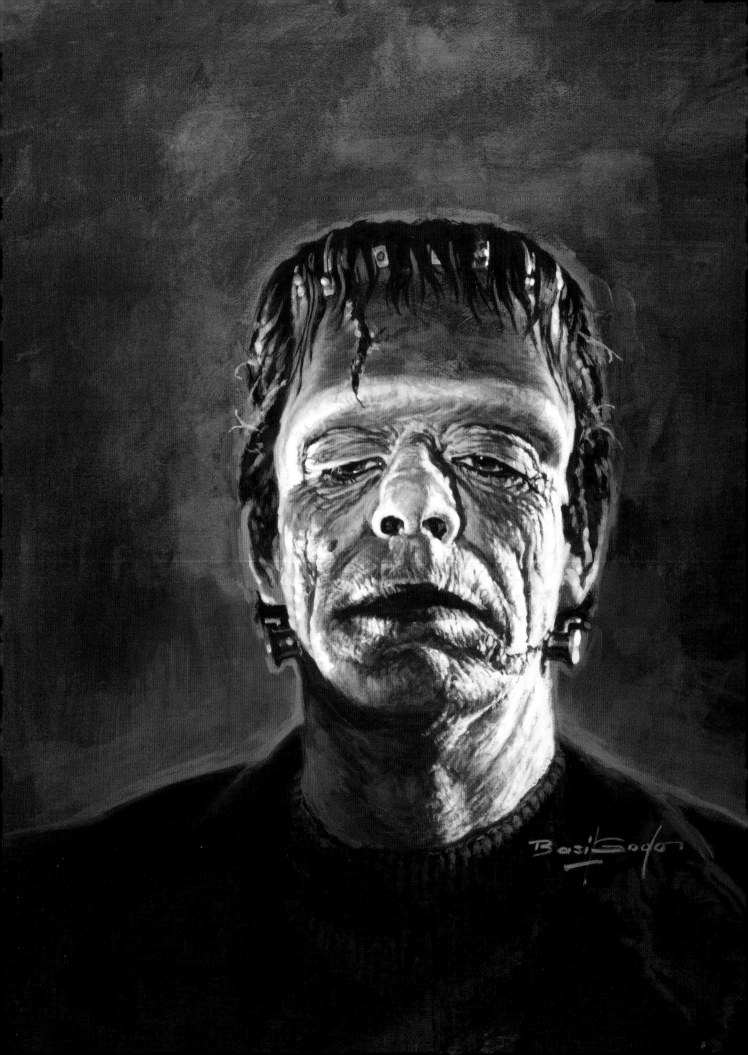

Throughout high school, I tore ads out of magazines if they featured illustrations by Bob Peak or Robert Heindel. I didn't know who these guys were, but man, could they paint; just like that Gogos guy who did the covers of *Famous Monsters*. As I got older, I would make a decision whether or not to buy *Famous Monsters* based on the cover art. If it wasn't a Gogos, it stayed on the store shelf.

By the time college rolled around, I was studying to be an illustrator under comic legend-to-be Mark Nelson, the artist who would revolutionize the look of comics with his original Aliens comic series from Dark Horse Comics. Actually, that series was years away when I studied under Mark, a professor who wouldn't think twice about showing a Munch painting followed by a Wally Wood panel in the same slide carousel if the theme, lighting, or perspective somehow related. It was he who made me know I was not alone in my appreciation of comics, of commercial art. It was he who assured me it was okay to like art that moved me, not because it moved someone else. It may seem silly, but let me tell you, when you go from following trendy 1980s artists like Patrick Nagel and even American classics like Norman Rockwell to embracing Modigliani when no one else is, it gets lonely.

I met Moebius, an internationally renowned comic artist, in a gallery in Santa Monica in July of 1987. Moebius was the founding artist of the French comics magazine *Metal Hurlant*, which came to America in 1977 as I was beginning my junior year of high school. Moebius' work on strips like *The Airtight Garage* showed me that delicate lines could be used as powerfully as could explosive word balloons in a classic Jack Kirby strip. Needless to say, I felt privileged to meet this great artist.

In 1988, the same month my son was born, I met Peter Max at a gallery opening in Chicago. I happened to mention my love of pop culture and comics, and suddenly we were best friends much to the annoyance of the gallery owner who had invested much in pretentious catered food and was banking on the sale of some of the pricier works to uninformed yet very tan older couples in their golf course attire and deep pockets. It was a moment I won't forget, having taped Max's posters to my wall as a child when other kids were taping up posters of David Cassidy and Susan Dey. A

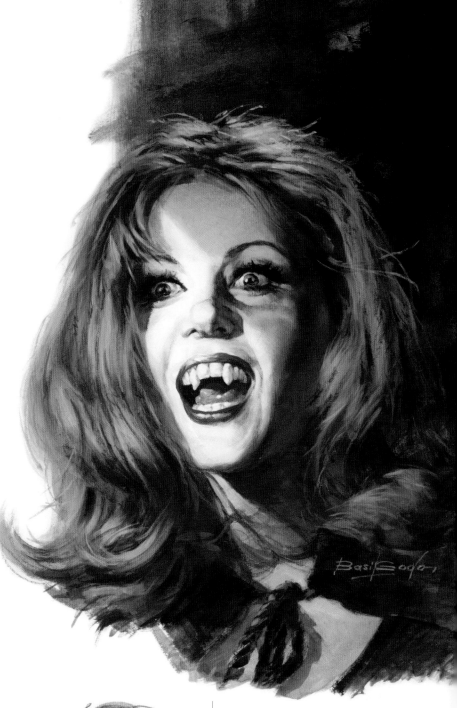

ABOVE:
Ingrid Pitt as the beautiful Carmilla in The Vampire Lovers *for the cover of* Monsterscene 8 *(acrylic, 1996).*

LEFT:
A preliminary sketch for Monsterscene 8 *before a different pose was chosen.*

OPPOSITE:
Glenn Strange as the Monster in Abbott and Costello Meet Frankenstein *for the cover of* Monsterscene 9 *(acrylic, 1996).*

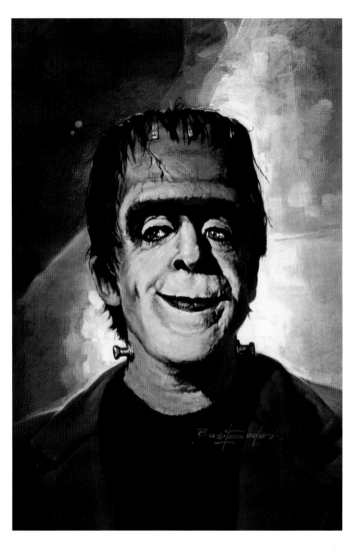

ABOVE:
The classic monster make-up takes on an almost clown-like quality on Fred Gwynne as Herman Munster for the cover of Monsterscene 11 *(acrylic, 1998).*

RIGHT:
Vincent Price in one of his best later roles as the title character in the campy 1971 AIP film, The Abominable Dr. Phibes *painted for the cover of* Monsterscene 10 *(acrylic, 1997).*

print inscribed to my son hangs in my home as a memento of that great day.

So there I was, in my late twenties at a *Chiller Theatre* convention somewhere in New Jersey (where you can't make a single left turn) back in 1992. I was there to unveil my latest hair-brained scheme, *Monsterscene*, a new monster magazine my friend Chris Ecker and I planned to dominate the world with. After all, magazine publishing is very lucrative—*really*. But the crowd really did like the magazine complete with its amateurish logo and hand-tinted photo cover of Elsa Lanchester as the Bride of Frankenstein. Call it karma, fate, just plain ol' good luck, whatever. But down the aisle from me, just a few tables away, Basil Gogos was there. The legend was at *Chiller*. I had to give him a copy of the magazine.

Moebius was cool for a French guy. Peter Max was the kind of guy who I think wanted to get away from all of the stuffiness and go have a beer and talk about comics, but Basil Gogos... Basil Gogos was setting up his black and white prints of Frederick March from *Dr. Jekyll and Mr. Hyde*, and his print of Chaney, Sr., from *London After Midnight*. Basil Gogos, an artist whose work I had admired as a boy, was there behind a table shaking my hand as he looked suspiciously over my debut issue of *Monsterscene*.

"You need me on your covers," Basil told me.

No kidding! I thought as I nodded with a goofy smile, not unlike Ralphie in *A Christmas Story* as Santa suggested a football as a great gift. But we talked. It was an honor. Before the end of the weekend, I assured Basil that if the next issue of *Monsterscene* ever came out, I'd figure out a way to have him on my cover. The whole trip back to Chicago was filled with thoughts and questions of how I could possibly afford to get Basil Gogos, a legend from my youth, onto my magazine.

But a year and a half later, with my new publishing partner Bill Harrison on board, *Monsterscene 2* debuted at the *Chiller Theatre* show, sporting a Basil Gogos painting of Lon Chaney from *London After Midnight*. That was May of 1994, a moment I have often referred to as the beginning of the Gogos renaissance. Over the next four years we published a meager nine more issues, but of those nine, Gogos' art appeared on seven of them. I still regret not using the Karloff Frankenstein image from the Topps card as the cover for issue 4, but we were trying hard to have original pieces on each cover. The compromise under a tight deadline is a collage of Gogos' cards. Sorry for that one Basil!

Throughout the run of *Monsterscene*, Basil published his own line of fine art lithographs that now grace the walls of countless monster collectors throughout the world. He also worked with the Karloff, Lugosi, and Chaney estates to pitch a series of movie monster stamps to the U.S. Postal Service, creating a stunning series of double portraits that would go unused. I'll never understand why the postal service chose the very talented Thomas Blackshear, whose work in the religious market is breathtaking, to create monsters so obviously influenced by Gogos, when Basil himself was available. But it's not like his talent went unnoticed. He was commissioned to create album covers for bands

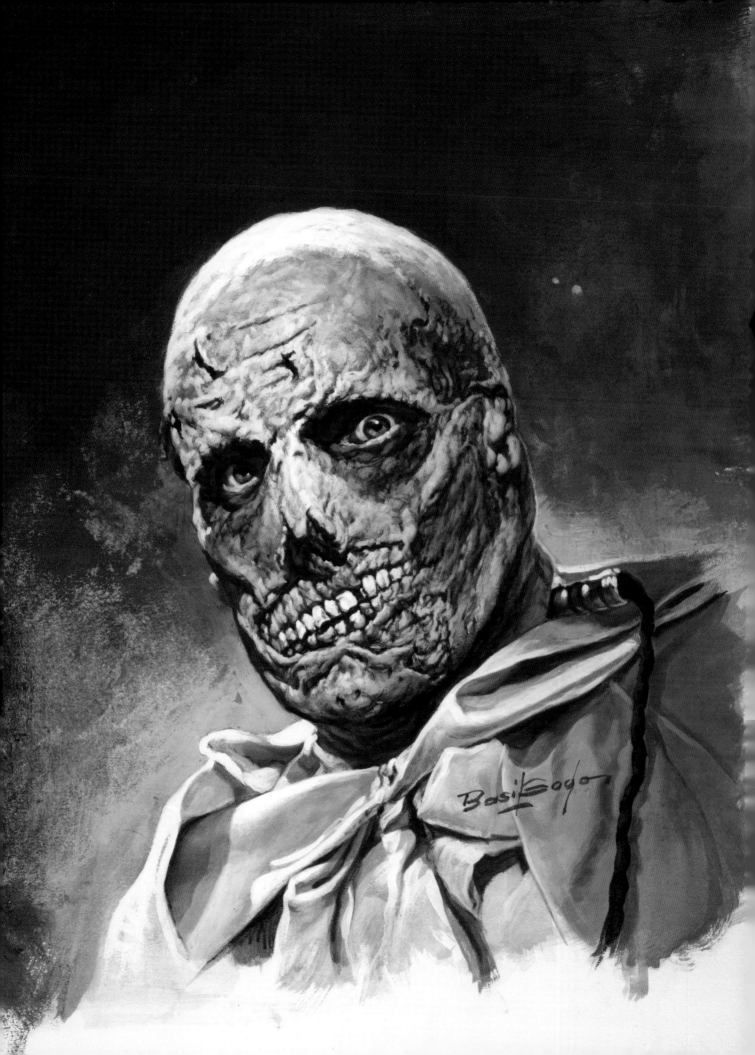

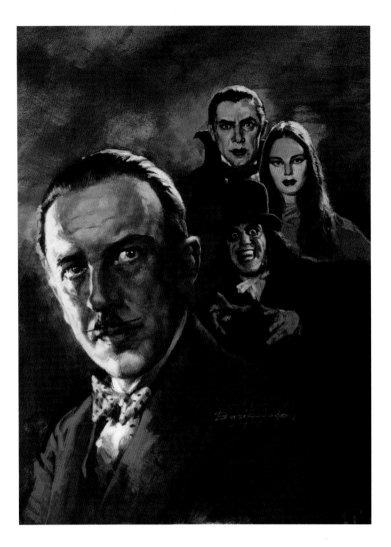

whose members had grown up on his art. The cover of Rob Zombie's *Hellbilly Deluxe* is a quintessential Gogos monsterpiece. His covers for several of the Misfits' albums make me envious that I don't have my portrait painted by Basil. Jerry Only, the bassist and frontman for Misfits, has three!

I realize that my writing, still loose and perhaps seeming to be without focus after all these years, might have thrown you readers, but my point, padded by good memories, is that I met Basil Gogos at a monster convention, not an art gallery, where his work belongs. But that's because Basil Gogos paints monsters and galleries just don't get it. When fans of *Monsterscene* approach me even today, they don't identify an issue by a great video review or a feature on Universal's Dracula films. They identify the issue by the art on the cover, and with all due respect to my good friends Jeff Preston and Dave Dorman, whose paintings appear on issues 5 and 7 respectively, those aren't typically the ones that are discussed. It's Gogos' interpretation of Ingrid Pitt that her husband wanted so badly to buy from Basil. It is the Glenn Strange Frankenstein on issue 9. But it's when you look at the cover to the sixth issue, the portrait of Tod Browning, that one realizes Basil Gogos is a brilliant portrait artist, and it just so happened that his subjects were often monsters.

In 1997 I was approached by the organizers of Fanex, a wonderful horror convention in Baltimore, to present Basil Gogos with a lifetime achievement award. As I stood up on the stage, Basil, his longtime companion Linda, and *Monsterscene*'s co-publisher Bill Harrison, sat together. Bill knew what was going down but Basil and Linda didn't. I shared much of the same history I have just shared with you, and then I called Basil up to be recognized. That night meant a great deal to Basil. The standing ovation by fans and an amazing cast of Hammer horror stars touched him deeply.

Please indulge me as I say a few words to this great man and incredible artist: Basil, you are the best monster artist ever. Period. You are, in addition, a brilliant painter worthy of the finest galleries in the world. I salute you and hope you treasure this book, because those who have assembled it did it out of respect and admiration for you. Thank you for gracing *Monsterscene* with the best covers I could have ever hoped for.

—Your friend and fan, Steve.

LEFT:
Cover art for Monsterscene 6. *Director Tod Browning is haunted by some of his characters. Bela Lugosi and Carroll Borland as Count Mora and his daughter Luna in* Mark of the Vampire *and Lon Chaney in Browning's earlier version of the same story,* London After Midnight *(acrylic, 1995).*

OPPOSITE:
Gogos captures Christopher Lee in all his fury as the vampire count for a new generation in the 1958 Hammer production, Horror of Dracula. *First published on* Monsterscene 3 *(acrylic 1994).*

Steve Smith
Chicago
September 2005

Steve Smith was the editor and co-publisher of Monsterscene magazine from 1992 through 1998. He is currently a screenwriter and entertainment developer.

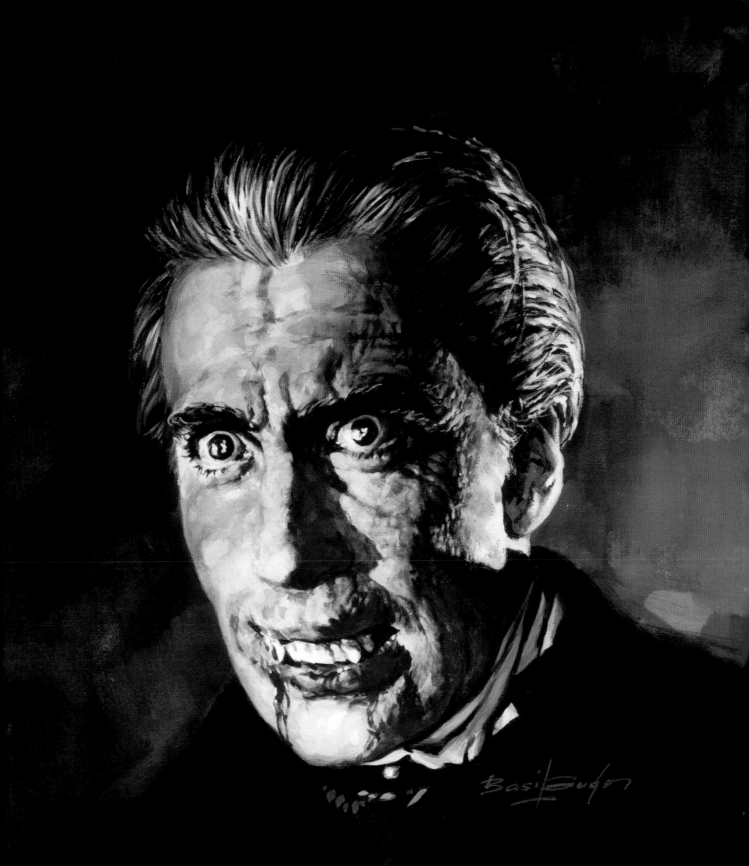

Basil Gogos

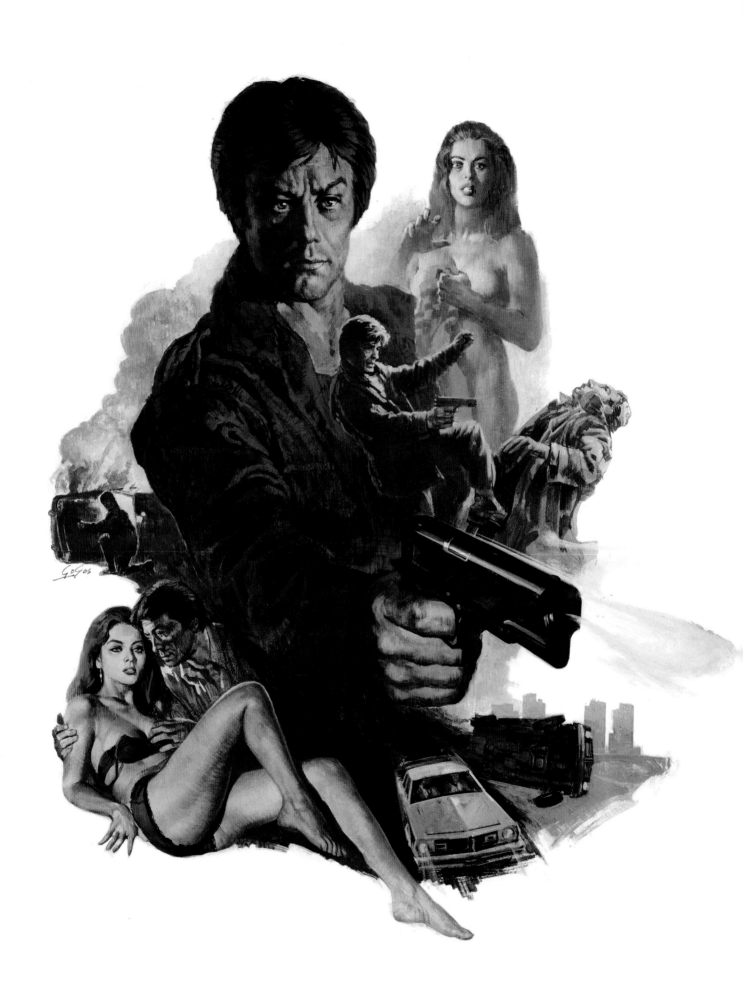

FROM FILM TO FINE ART
Movies, Advertising & Personal Works

In the mid-1970s Basil Gogos left the magazine illustration field. With the changing market and his personal desire to concentrate on fine art, the decision seemed like a natural one.

Gogos explains his reasons for making the change: "Illustration was, for one thing, dying out. For another, I still had the love for fine arts and I felt like working in illustration was sort of, if I may use the word, 'poisoning' my love for fine arts. Not only love, but my opportunity to do fine arts, because invariably it would pour into it and influence my fine art. So I decided to quit illustrating in hopes that it would keep my fine arts untouched by commercialism."

However, Gogos still needed to make a living so he looked for different ways to market his talents. He soon found what seemed like an ideal job at the New York office of United Artists as an illustrative photo retoucher for motion picture ads. "I thought if I retouched, rather than illustrated, it would hurt my fine arts less, so I became a retoucher," explains Gogos. "I learned on the job and it proved to be a very well-paying job. I mainly retouched photos for the black-and-white movie ads that would appear in newspapers."

BELOW: Preliminary version of the poster art for The Spook Who Sat by the Door. *(acrylic, 1973).*

OPPOSITE: Poster art for the U.S. release of a film starring French superstar Alain Delon (acrylics, 1970s).

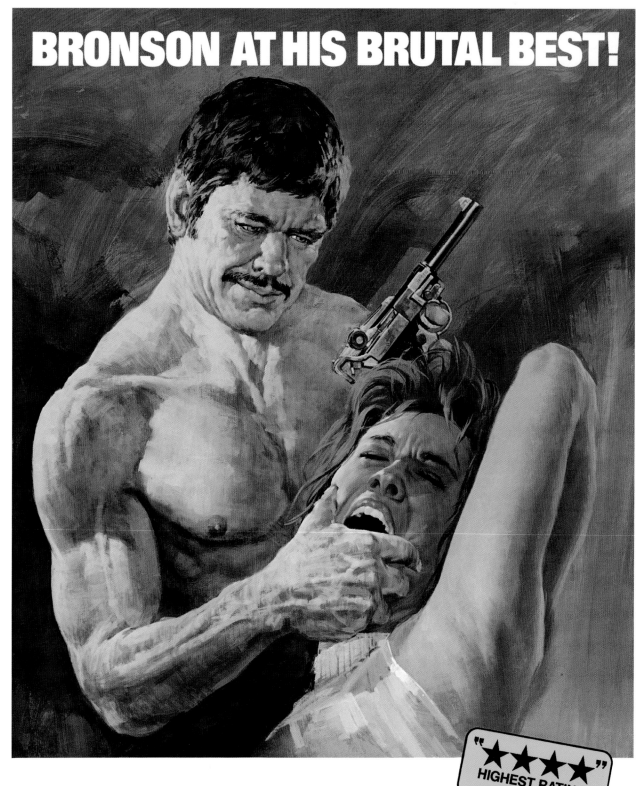

BRONSON AT HIS BRUTAL BEST!

"★★★★"
HIGHEST RATING!
—New York Daily News

Charles Bronson
"Rider on the Rain"

JOSEPH E. LEVINE presents An AVCO EMBASSY Film A SERGE SILBERMAN Production starring CHARLES BRONSON
MARLENE JOBERT in "RIDER ON THE RAIN" Story and Screenplay by SEBASTIEN JAPRISOT · with GABRIELE TINTI
JILL IRELAND · ANNIE CORDY and with the participation of CORINNE MARCHAND · Produced by SERGE SILBERMAN
Directed by RENE CLÉMENT · Prints by MOVIELAB · COLOR **PG** PARENTAL GUIDANCE SUGGESTED SOME MATERIAL MAY NOT BE SUITABLE FOR PRE-TEENAGERS AN AVCO EMBASSY RELEASE

Gogos continues, "The point was to create an image that didn't exist. For instance, for one ad Jerry Lewis was supposed to have rubber legs. Of course, he doesn't have rubber legs, so what I did was blow up the photograph of Jerry Lewis with extra paper at the bottom, and I painted the rubber legs, shoes, everything. Then I combined the two and retouched it into one piece of art, and eventually, he looked like he had rubber legs! The things they would do with Photoshop today, I was doing with paint. I became one of the best retouchers in the northeast, for the newspaper ads. I got the best jobs to do because they liked the fact that I was an 'illustrative' retoucher. The other retouchers could retouch, very professionally, but they could not paint photographically. I was able to do that."

In addition to the black and white ads, Gogos occasionally painted the poster art for movies, including foreign films which UA was distributing in the U.S. He did poster art for the Japanese cult classic Infra Man and an Italian-made Charles Bronson movie released here as Rider on the Rain. Gogos recalls, "That's one of my best posters. I was told that if you didn't paint that vein Bronson has on his right arm biceps in, he wouldn't approve it. He wanted that vein. In any event, I'm very proud of that one, it was quite a painting. And everybody loved it."

ABOVE RIGHT:
Promotional art for Raiders of the Living Dead *used as cover art on the DVD edition (acrylic, 1986).*

BELOW RIGHT:
Celebrating the DVD release of The Sci-Fi Boys *which features a Gogos cover. (l to r) Basil Gogos, Peter Jackson (director of* King Kong *and* Lord of the Rings*), Rick Baker, Bob Burns, Forrest J Ackerman and* The Sci-Fi Boys *director Paul Davids.*

OPPOSITE:
One-sheet poster for Rider on the Rain *starring Charles Bronson (casein, 1974).*

PAGE 96:
One-sheet poster for the cult classic Infra-Man *(acrylic 1975).*

PAGE 97:
A Tuskan Raider from Star Wars *which appeared on a Topps Star Wars Trading card. (acrylic 1978).*

From design to finished product: For movie posters like the one for the Italian-made comedy, *This Time I'll Make You Rich*, Gogos first created a color "comp" (comprehensive layout). Loosely painted, it established the composition and color scheme for approval. The final illustration was done closely following the approved design (acrylic, 1975).

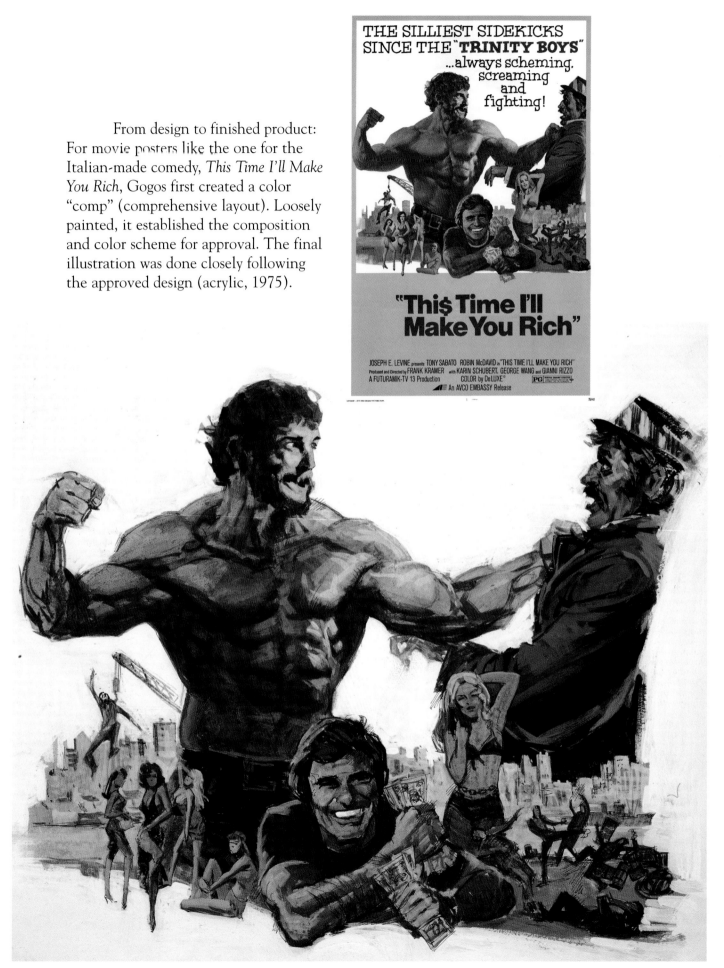

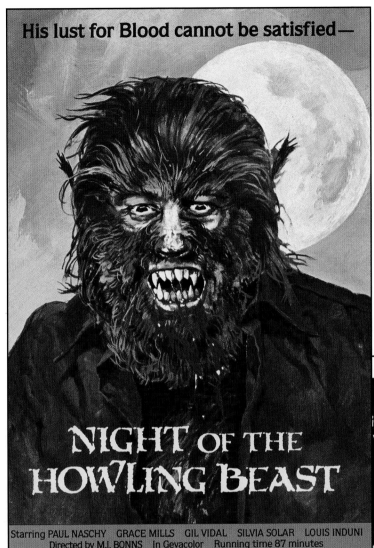

His lust for Blood cannot be satisfied—

NIGHT OF THE
HOWLING BEAST

Starring PAUL NASCHY GRACE MILLS GIL VIDAL SILVIA SOLAR LOUIS INDUNI
Directed by M.I. BONNS In Gevacolor Running time 87 minutes
An INDEPENDENT-INTERNATIONAL Pictures Corp. Release **R** RESTRICTED
© copyright MCMLXXXIV Independent-International Pictures Corp.

Sam Sherman, who had been an editor at Warren when Gogos began doing covers there, later became a film producer forming Independent-International Pictures Corporation which produced and released many low-budget films. Sherman occasionally asked his old friends from his Warren days, like Gogos and Gray Morrow, to do promotional art for films his company was releasing. Gogos did illustrations for several of Sherman's products like the U.S. release of *House of Psychotic Women* and the video release of *Night of the Howling Beast*, both starring Spain's leading horror star of the '70s, Paul Naschy. Sherman's *Raider's of the Living Dead* was recently released on DVD with Gogos' art on the cover.

ABOVE:
Video poster art for
Night of the Howling Beast
starring Spanish horror superstar Paul Naschy
(acrylic, 1970s).

Right:
One-sheet for the U.S. release of
House of Psychotic Women,
also starring Paul Naschy
(acrylics, 1970s).

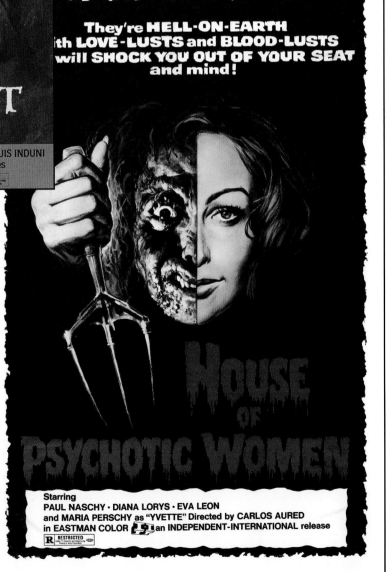

They're HELL-ON-EARTH
with LOVE-LUSTS and BLOOD-LUSTS
will SHOCK YOU OUT OF YOUR SEAT
and mind!

HOUSE
OF
PSYCHOTIC WOMEN

Starring
PAUL NASCHY · DIANA LORYS · EVA LEON
and MARIA PERSCHY as "YVETTE" Directed by CARLOS AURED
in EASTMAN COLOR an INDEPENDENT-INTERNATIONAL release
R RESTRICTED

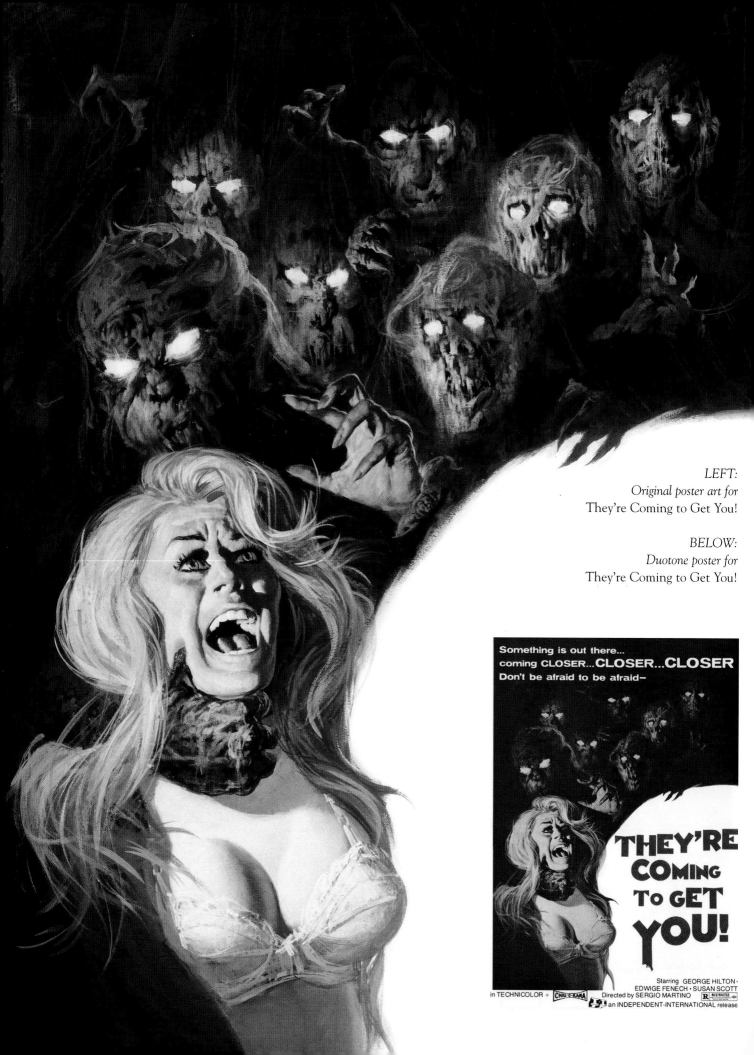

LEFT:
Original poster art for
They're Coming to Get You!

BELOW:
Duotone poster for
They're Coming to Get You!

After several years of working on movie ads, Gogos made another career change. "Eventually, the movie companies moved out of New York, and went to the West Coast so there was no movie work here," Gogos recalls. "I looked around, and I decided to try the advertising world. First, I went to work for a studio as a sketch man, and a magic marker artist, which was the thing of the day. That, too, I had to learn on the job, just like airbrushing, and in no time at all, I got the hang of it. Then I went to an agency with my samples, and they hired me. It was a very large agency, one of the largest, and soon after that, I became Senior Sketch Artist doing storyboards and presentation art. For the first time, instead of having to do one piece of work every week or two, I suddenly had to do thirty and forty frames a day! There wasn't even time to look at reference, I just kept drawing. And I stayed with them for thirteen years."

RIGHT AND ABOVE: marker samples. (1980s)

David Grove
'98

LEFT: *Humphrey Bogart (pencil, 1998).*

BELOW: *Portrait of Marlon Brando on the cover of Wildest Westerns 6 (1961).*

BELOW LEFT: *Recent photo of J. David Spurlock, Basil Gogos & Kerry Gammill.*

OPPOSITE PAGE: *Portrait of Robert Mitchum done when Gogos was 18 (pastels).*

FOLLOWING PAGE: *Portrait of Peter Cushing (charcoal, 2003). Collection of J. David Spurlock*

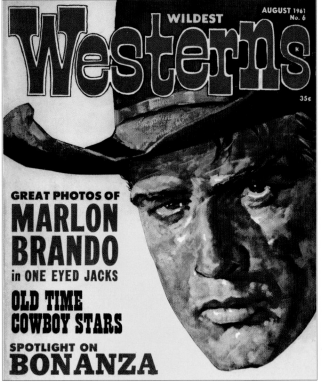

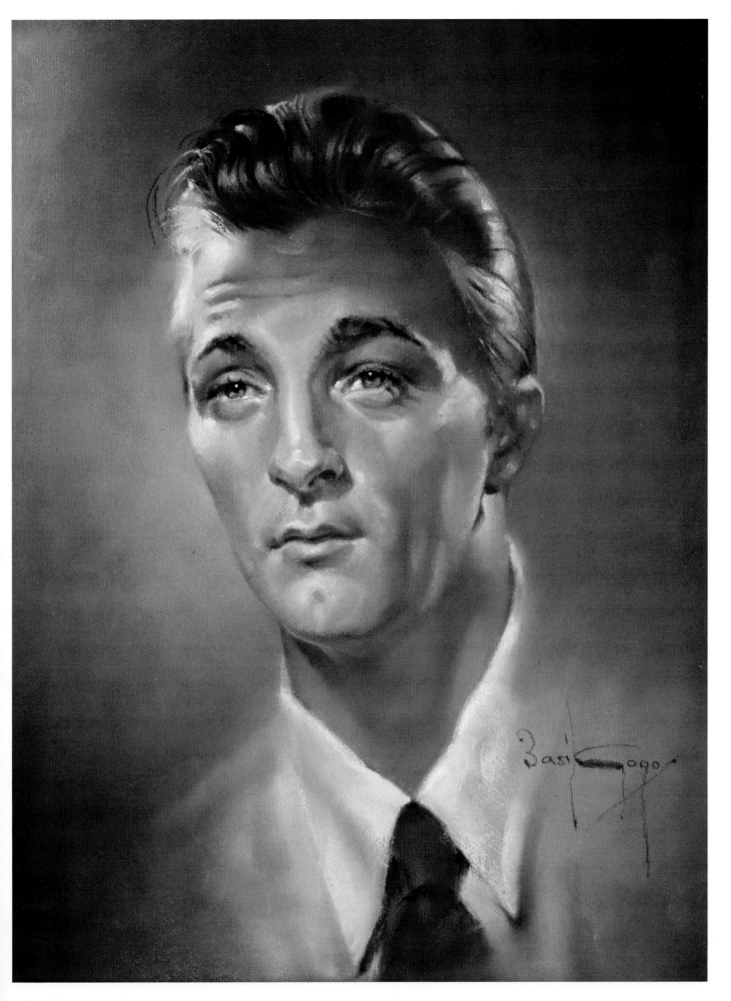

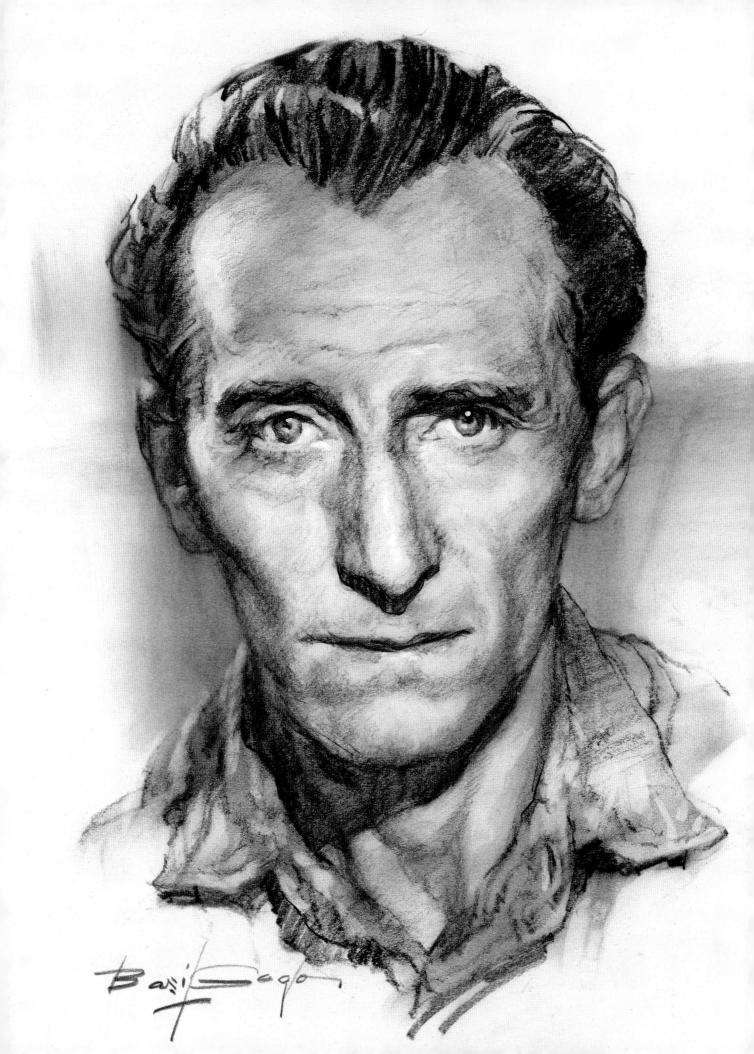

Drawing from Life

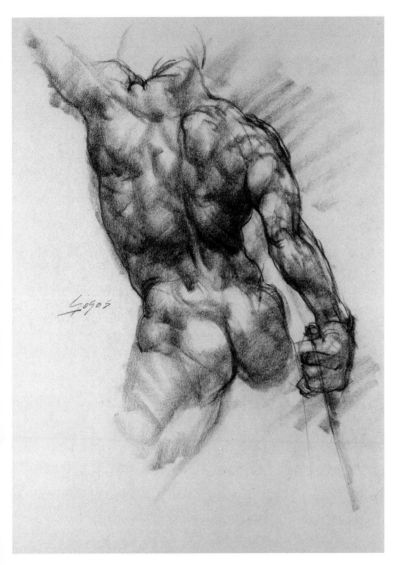

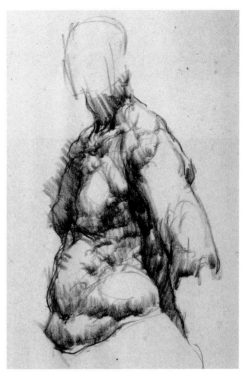

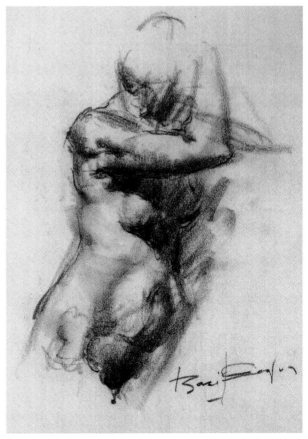

After years of working in illustration and advertising, Gogos feared his professional skills were interfering with his ability to produce the work he loved most; drawing and painting from life. He felt it was time to reevaluate where he was artistically and where he wanted to be. In order to reconnect with his original fine art goals, he made the somewhat surprising decision to enroll in art classes.

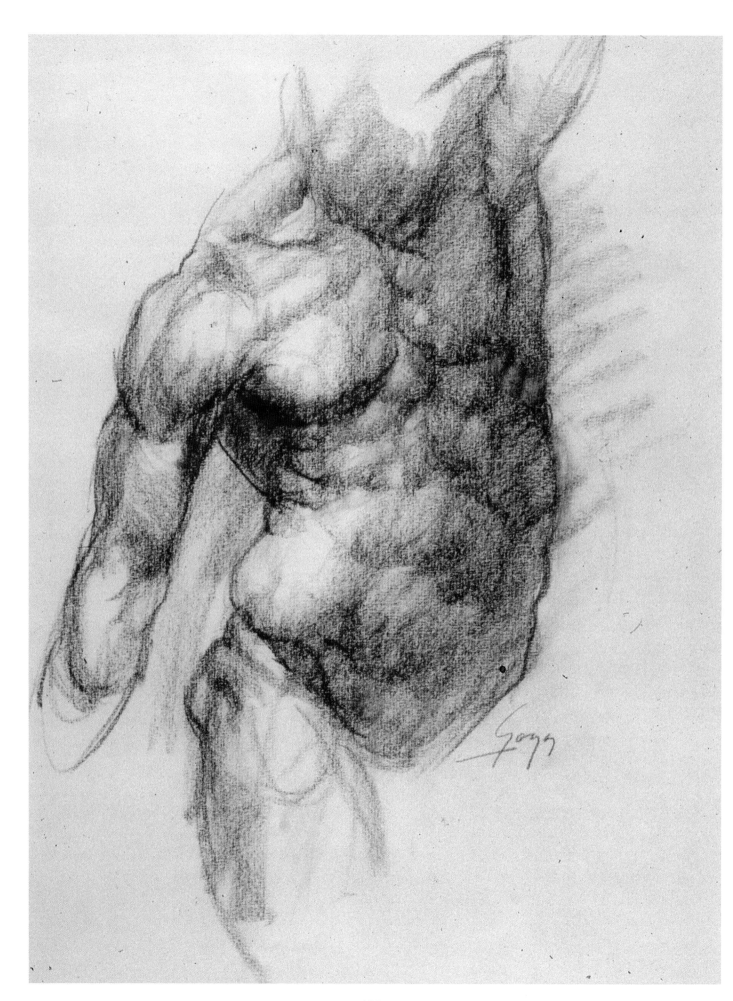

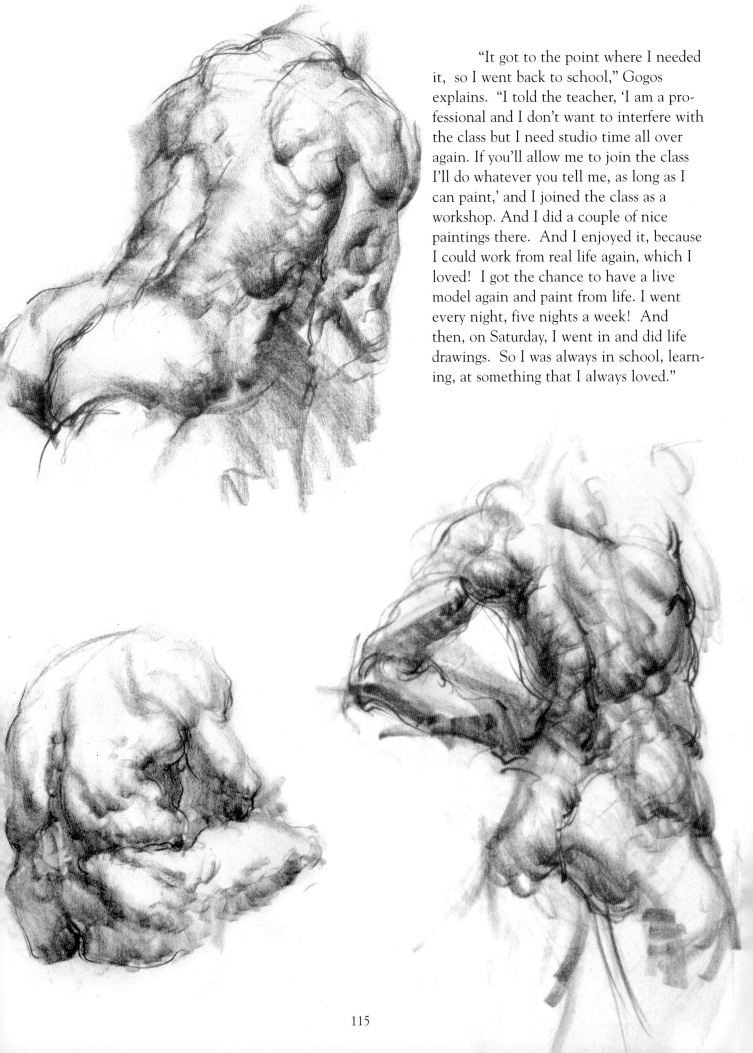

"It got to the point where I needed it, so I went back to school," Gogos explains. "I told the teacher, 'I am a professional and I don't want to interfere with the class but I need studio time all over again. If you'll allow me to join the class I'll do whatever you tell me, as long as I can paint,' and I joined the class as a workshop. And I did a couple of nice paintings there. And I enjoyed it, because I could work from real life again, which I loved! I got the chance to have a live model again and paint from life. I went every night, five nights a week! And then, on Saturday, I went in and did life drawings. So I was always in school, learning, at something that I always loved."

115

RETURN OF THE KING
The Gogos Renaissance

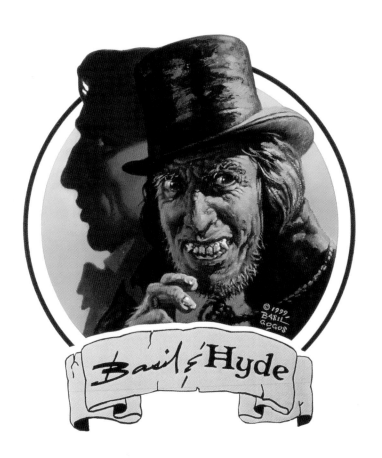

The original *Famous Monsters of Filmland* ceased publication in 1983. For most horror fans, it had not been the same since the late '70s when it shifted its focus to the new post-*Star Wars* blockbuster films, using mostly photos from current films on the covers and pushing the beloved old monsters to the background.

LEFT:
An illustration for Jekyll and Hyde's restaurant. Gogos was his own model for this piece (acrylic, 1999).

BELOW:
Gogos painted five new monster portraits as title cards for Topps' set of Universal Monsters trading cards released in 1994.

OPPOSITE:
Boris Karloff as Imhotep in the 1932 classic, The Mummy (acrylic, 1994).

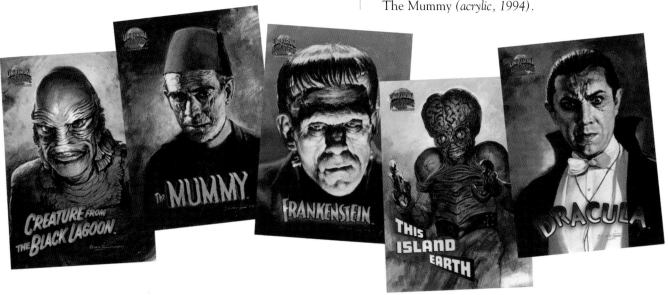

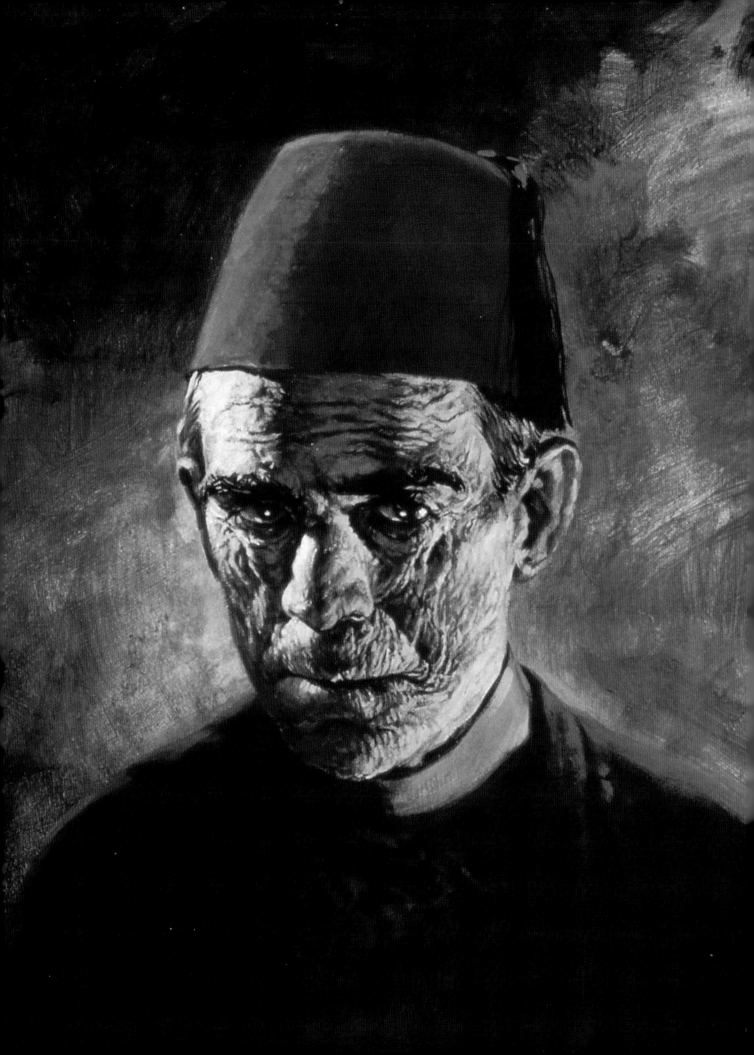

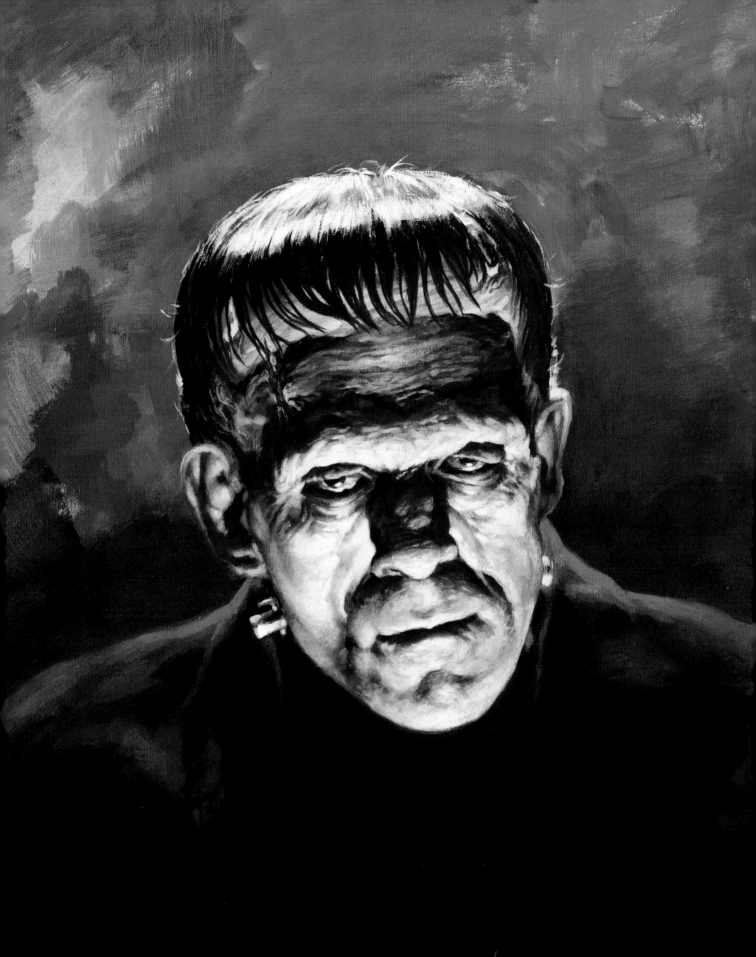

The vintage horror films were being shown with less frequency and seemed in danger of being forgotten. But as fans tired of the effects-heavy sci-fi epics and hockey masked killers, they began to miss their old friends.

By the 1990s, older fans who were part of the "Monster Kid" generation that had grown up watching horror films on late-night TV and reading monster magazines were now nostalgic for the feelings they experienced in those days.

As a result, during the mid-1990s there was a resurgence of interest in classic horror films. Younger fans were seeing the vintage horror films for the first time on cable TV and home video. New classic monster publications and products began to appear and monster fan gatherings were growing.

When Basil Gogos, who was now a legend among monster fans and collectors, agreed to appear as a guest at a monster fan gathering in 1993, the fans were more than ready for his return.

Gogos' longtime companion, Linda, who is also a painter, knew little of the impact of Basil's commercial work until she accompanied him to the event. "I did two new black-and-white prints and Linda thought I was crazy," recalls Gogos. "Fans went crazy buying them. It was quite beautiful how people were taken by them. I was very moved. It was so beautiful it brought me back into it again."

With Gogos back in circulation and with his skills for capturing the essence of the classic monsters just as in tune as ever, new offers began to come his way, many from old *Famous Monsters* readers who were now publishers or editors or even rock stars.

Topps cards commissioned Gogos to paint five new monster portraits for a set of monster trading cards and he began to produce cover art for the excellent new magazine, *Monsterscene*. Gogos was back where he belonged.

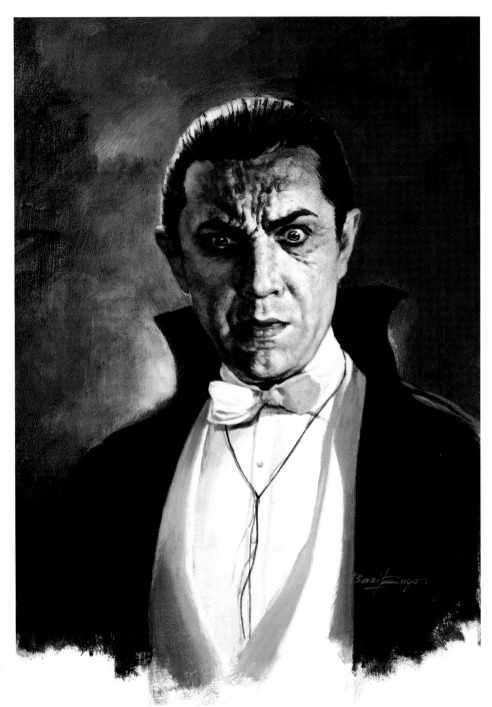

ABOVE:
Bela Lugosi in his greatest role as the undead count in the 1931 classic, Dracula *painted for the Topps Universal Monsters Illustrated card series (acrylic, 1994).*

OPPOSITE PAGE:
Boris Karloff as The Monster in the original Frankenstein *painted for the Topps Universal Monsters Illustrated card series (acrylic, 1994).*

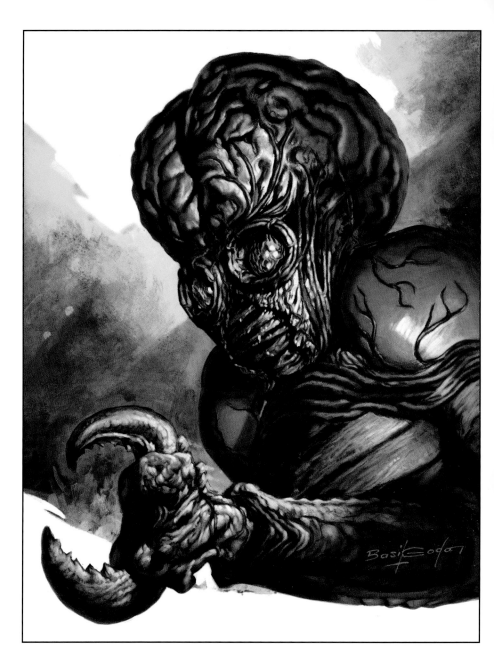

RIGHT:
*The Metaluna Mutant from the
1950s sci-fi classic* This Island
Earth *(acrylics, 1996)*

BELOW:
*The beautiful art deco robot from
Fritz Lang's futuristic masterpiece,*
Metropolis *(charcoal, 1995).*

OPPOSITE, TOP:
*Basil Gogos is menaced by the Gill
Man himself. Ben Chapman, the
man inside the suit in* The
Creature from the Black
Lagoon, *poses with Gogos at a
horror convention.*

OPPOSITE PAGE, BOTTOM:
*The Creature from the Black
Lagoon (acrylics, 1996).*

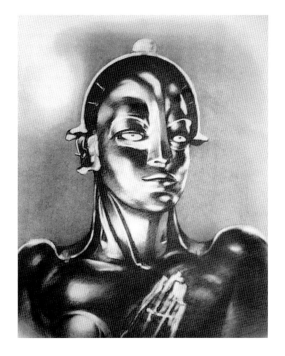

Now knowing that the old horror fans were still out there and eager for more Gogos monsters, Basil produced a series of limited edition art prints from new paintings of popular film monsters, including the Metaluna Mutant from the 1950s sci-fi classic, *This Island Earth*. For this one Gogos decided it was better not to add his usual multicolored lighting effect. "It's very busy with the big brain and the veins. I studied him very well and placed every vein exactly where it actually was. I couldn't add a yellow to it because I had yellow in the background. He's pretty colorful already. It was one of those things where it was so busy it couldn't take any more color."

Gogos also produced a series of black and white drawings of silent horror film characters including several of Lon Chaney's greatest creations. Prints of these pieces are still available on the Basil Gogos website, *www.basilgogos.com.*

One of Gogos' favorite classic monsters is the Creature from the Black Lagoon. "Creatively, the Creature is a great monster," Gogos observes. "I remember in the movie, trumpets blasted every time he would come out of the water and it really scared you."

However, the Creature is not an easy subject to paint, as Gogos explains. "He's full of scales and bumps and gills and stuff. Painting him was tedious, but I enjoyed it because it gave me a chance to have good, strong darks and lights from all over the place. Someone I knew at an advertising agency once called me to find out what color the Creature really was and none of us knew because we saw it in black and white. I used colors that I made up, picturing a fish and an amphibian, something that lives in the water and on land. I also saw a mother of pearl on it, and by throwing different color lights on it, it gave me a chance to do something rather radical with it. And I really enjoyed doing it!"

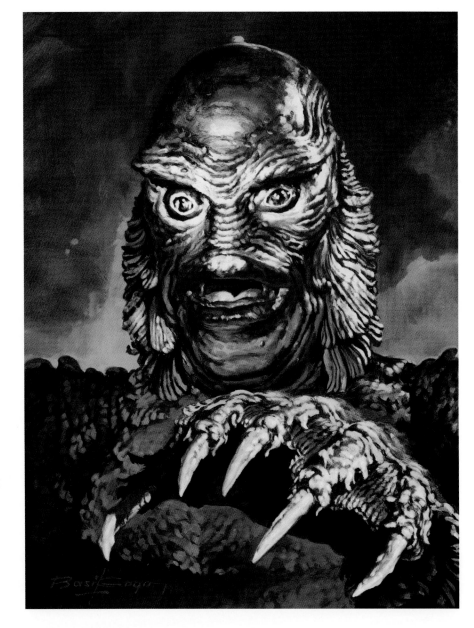

ICONS OF HORROR
Tributes to Classic Monster Movie Stars

Part of what has made the classic movie monsters so appealing to generations of horror fans is the special quality of the actors behind the make-up. Our favorite creepy characters would not be the same without the talented men beneath the make-up and their peculiar gifts. While painting a face and striving to bring out the thoughts and emotions behind it, an artist feels he has come to know his subject intimately. Over the years, Basil Gogos has developed a special appreciation for the classic horror film stars and feels very close to them.

Bela Lugosi

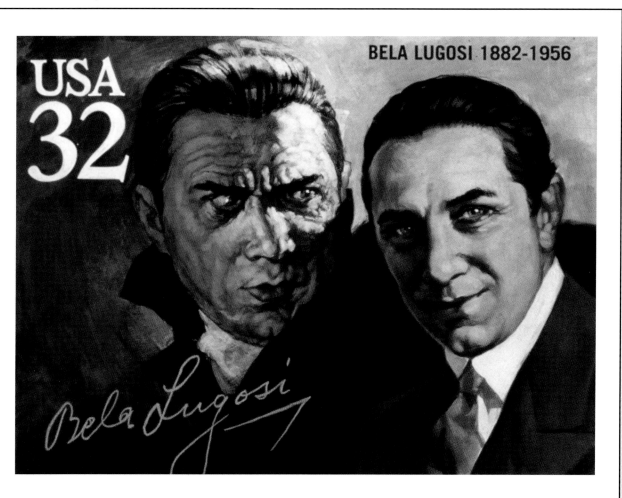

Boris Karloff

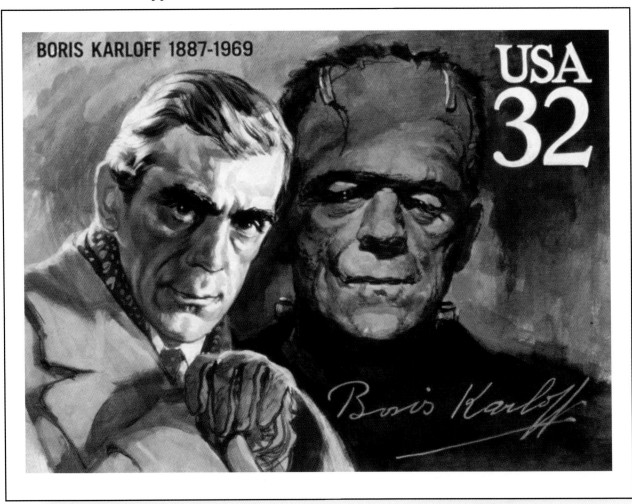

BORIS KARLOFF 1887-1969

USA 32

Boris Karloff

" *One does not just look at Basil Gogos' work, one is mesmerized by it.
His choice of subject, his dynamic use of color, the energy and emotion which leap
from his canvases capture the attention of even the most casual passerby. One need not
be a fan of the genre to be enthralled by his genius. Basil Gogos has done more than
any other artist to pay tribute to the Classic Horror characters and to the men who
portrayed them. For this, their families and their fans are extremely grateful.
Thank you, Basil...* "

— Sara Karloff

" *Basil Gogos' paintings masterfully capture the essence
of the classic horror characters. When I enjoy Basil Gogos'
paintings of my father, I am taken back to those days when
Hollywood horror was born. The family is grateful that Basil
has chosen to preserve for posterity Dad's unique personality.* "

— Bela G. Lugosi

LEFT and ABOVE:
Concept art for postage
stamps honoring Boris
Karloff and Bela Lugosi
showing the actors as they
appeared out of make-up in
the early 1930s and as their
most famous screen creations,
Count Dracula and the
Frankenstein Monster.

> *"Many of us have been captivated by the wonderful style of Basil Gogos. He has been a tremendous inspiration to me as he has brought to life our favorite monsters with his skillful and unique use of color."*
>
> **— Thomas Blackshear**
>
> *Renowned painter of Star Trek, King Kong and various postage stamp series.*

When the families of Boris Karloff, Bela Lugosi and Lon Chaney, Sr. and Jr. asked Gogos to lend his talents to a special cause, he was delighted. In the mid-1990s, horror star descendants Sara Karloff, Bela Lugosi, Jr. and Ron Chaney joined forces in a campaign to honor the classic horror actors and their famous screen characters with their own series of U.S. postage stamps. To aid in this effort, Gogos painted several images to draw attention to the effort and the pieces were also used to present the idea to the United States Postal Service and show various concepts for the design.

The campaign proved successful with the Classic Movie Monster stamps being issued in October of 1997, though changes included, the actors not appearing out of make-up and Postal-Service-approved artist (and Gogos enthusiast), Thomas Blackshear providing the final art.

Lon Chaney

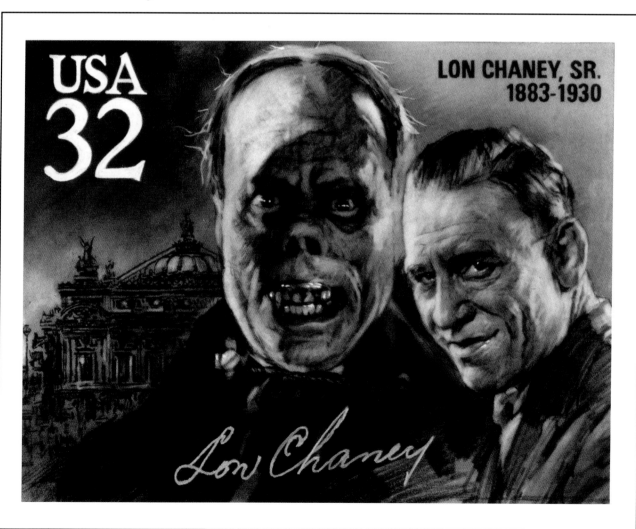

Lon Chaney, Jr.

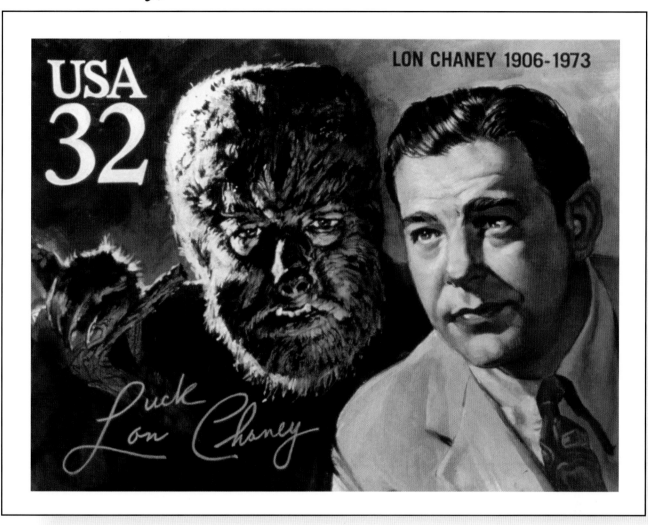

USA 32

LON CHANEY 1906-1973

*Luck
Lon Chaney*

Chaney Entertainment, Inc., is run by Ron Chaney, grandson of Lon Chaney, Jr. and great-grandson of Lon Chaney, Sr. Like Sara Karloff and Bela Lugosi, Jr., Ron is also a big fan of Basil Gogos' art and has enjoyed the relationship they have had with projects such as Basil's art prints of Chaney Sr. characters and the campaign to give the horror stars their own series of U.S. postage stamps. He credits Gogos' promotional paintings with helping the stamp project get the attention of thousands of fans who supported the effort and made it a reality.

Ron's latest projects are the completion of a book begun by his grandfather called *A Century of Chaneys*, and a campaign to award his grandfather, Chaney, Jr., with a star on the Hollywood Walk of Fame. Basil Gogos would like to personally request that all his fans support this effort.

For more information, visit www.lonchaney.com.

ABOVE:
Concept art for the Lon Chaney, Jr. postage stamp showing the star without make-up and as his most famous monster character, The Wolf Man (1995).

OPPOSITE PAGE:
Concept art for the Lon Chaney, Sr. postage stamp showing the natural face of the Man of a Thousand Faces alongside one of his most famous ones, The Phantom of the Opera (1995).

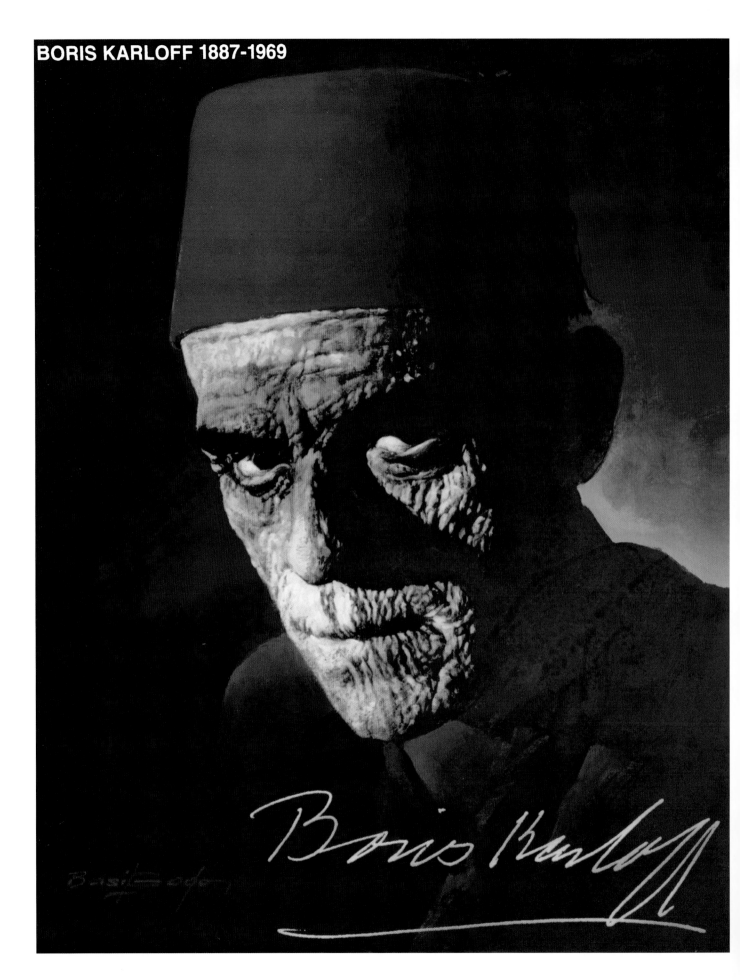

"In all my years as a professional painter, and they are many, I have excelled most in one area, that of the film monster genre. I have met some of the actors who portrayed film monsters, but much to my regret, I never met the supreme Karloff. A superb facial structure with nicely chiseled planes, deeply sunken eye sockets, high cheek bones, and with one side of his jaw bone deeper than the other—pure drama. I must have painted him a dozen times. I respected Karloff as an actor, and at the same time loved him, as by all accounts a good man, even though he stole Christmas. So long, dear friend, you are missed."

— Basil Gogos

A horror icon of a different sort, Zacherley helped introduce a generation to the classic monsters as the nation's foremost TV horror host. He has been the subject of at least three Basil Gogos paintings including one *Famous Monsters* cover, an 80th birthday tribute issue of *Chiller Theatre* magazine and the cover of the first issue of the new comic book, *Zacherley's Midnight Terrors.*

" It's great to be able to say something in favor of old Basil. That big portfolio that he has is just astonishing to see. He did that wonderful picture of me that was on Famous Monsters *magazine years ago. He certainly has a knack for these portraits, he just does everything. If you're seeing this collection of his work, you're a lucky person. I'm glad he's still around.."*

— John Zacherle

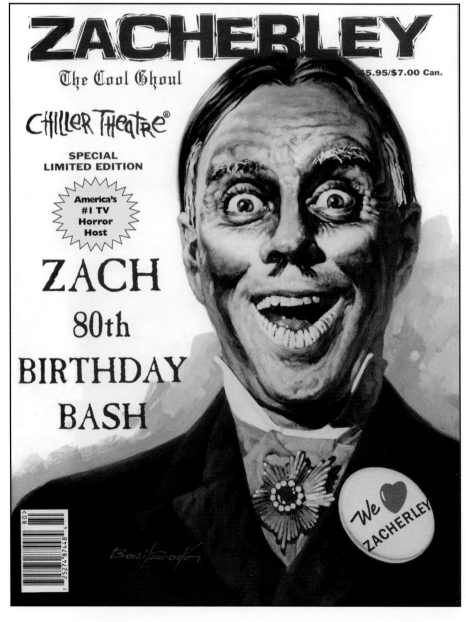

127

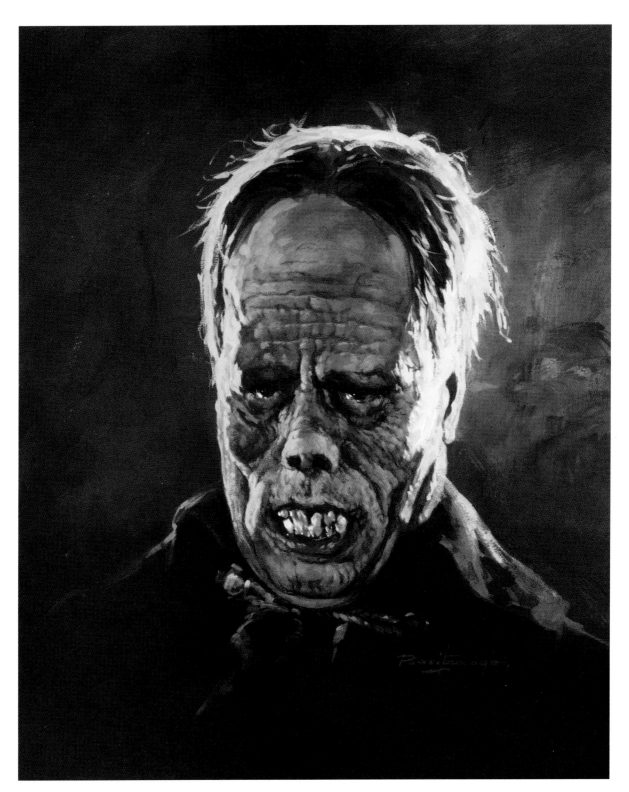

"Basil's work is magnificent! His unique style and beautiful use of color has captured both my great-grandfather and grand father's likeness brilliantly. But beyond the amazing realism of the image he creates, he manages to continually express emotion in his work. The various characters he has depicted of the Chaney's reflect a multitude of emotions within, such as fear, anger, pain, pity, remorse and sorrow. Basil, thank you for giving and sharing your art with so many. Bravo!!!"

— Ron Chaney

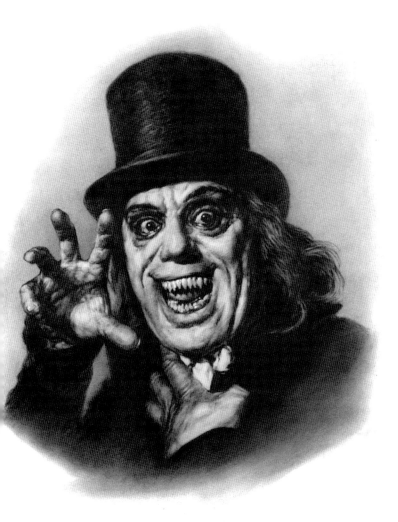

Lon Chaney, Sr. has been a frequent subject of Gogos' paintings over the years. His stark, colorful portraits of Chaney as the Phantom of the Opera and the saw-toothed vampire from *London After Midnight*, which appeared on the early issues of *Famous Monsters* magazine, are among his most memorable works.

When asked about Lon Chaney, Gogos replies, "He was quite original. I enjoyed illustrating his various make-ups. I appreciated the effort he took in his roles and I like the movies very much. All of them were good. His performance as the *Hunchback of Notre Dame* is full of pathos and compassion."

Gogos enjoys films from the silent era, partly because of the look of the film itself. "There was a sense of drama you got out of the nitrate film. It was very much like an old glass negative photograph. It's just beautiful. And you get tonal values that you don't get with newer film."

Of the *Phantom of the Opera* painting (acrylic 1994), Basil says, "That one was interesting because I chose a blurred picture, purposely, to work from to see how much of myself I could put into it. And it came out like a real portrait, a classical portrait. I love it because it's more painterly. Everything was not there for me so I had to use my imagination and enhance it. It's like fine art and I love it."

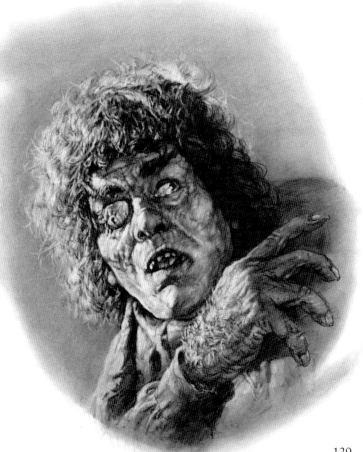

TOP:

Lon Chaney as the Vampire in the lost film, London After Midnight *(1927). Chaney used wire rings around his eyes to achieve a hypnotic stare and false teeth with wires at the edges which held his mouth in a fiendish perpetual grin (prismacolor 1994).*

LEFT:

Chaney in his first monstrous role as the disfigured bellringer, Quasimodo in 1923's The Hunchback of Notre Dame *(prismacolor 1994).*

CHARCOAL CHILLERS
Horror Noir Portraits

Although most famous for the kaleidoscopic colors he gives his monster paintings, Gogos is just as adept at capturing the strange beauty of classic film creatures in sinister shades of gray.

Gogos explains, "For black and white, you think in terms of light and shadow. Both color and black and white art are based on form and value. Dark against light, white against black, black against gray... contrasting values.

"You generally start with shadows. For horror portraits, you want a lot of dramatic shadows. Once you put all your values in, at a given point you have your artistic statement made. The finish is just a matter of tightening up or rendering. Even in a color piece, all your good statements are made in the light and shadow and color is just an additional step, just a matter of adding hues."

On the following pages we present a gallery of studies in light and shadow from the hand of the master.

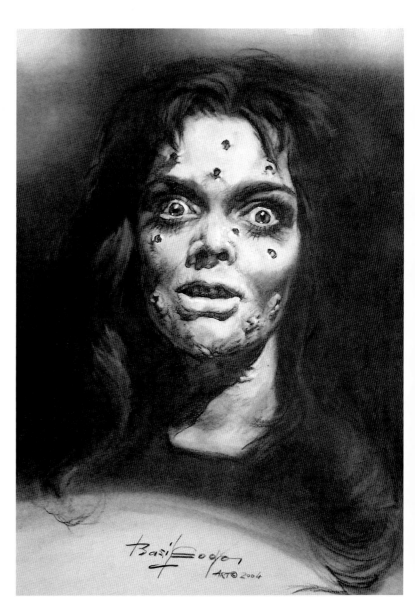

LEFT:
The haunting face of Barbara Steele from her most famous horror role, the 1960 Mario Bava classic, Black Sunday.

OPPOSITE PAGE:
The frightening title character from the supernatural thriller, Curse of the Demon.

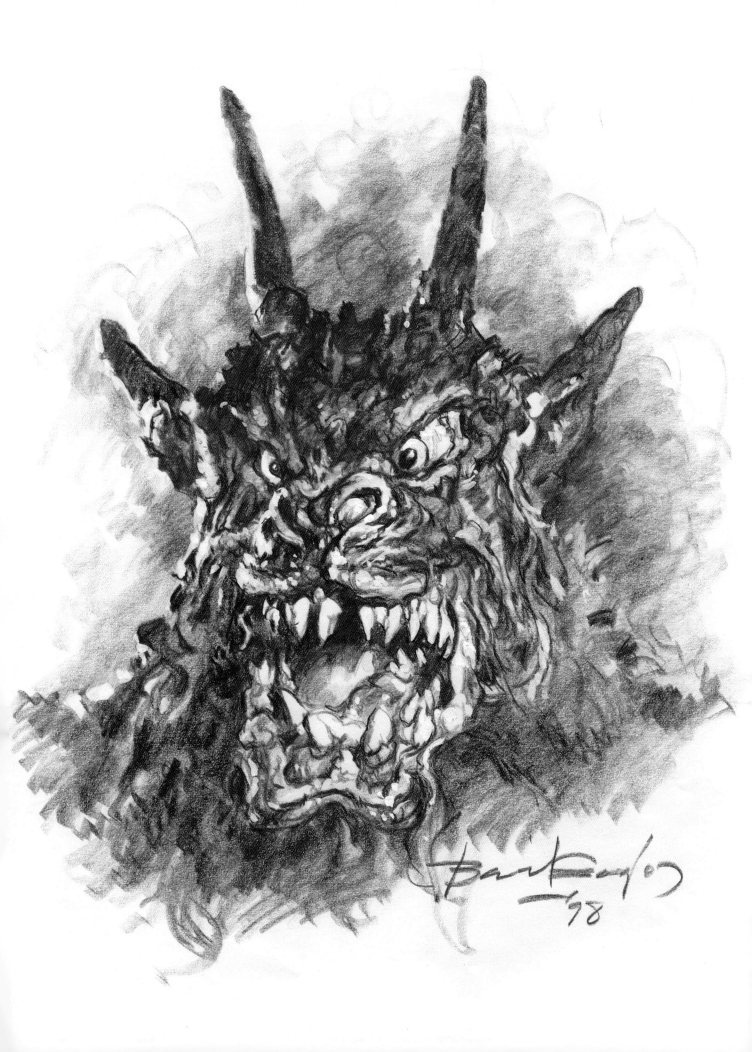

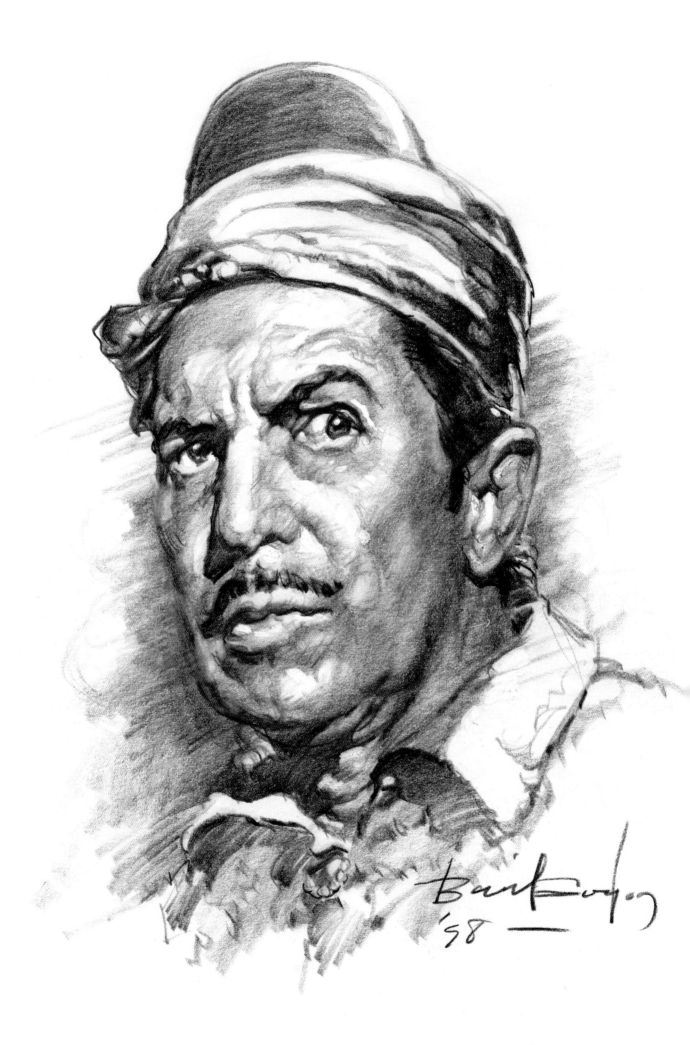

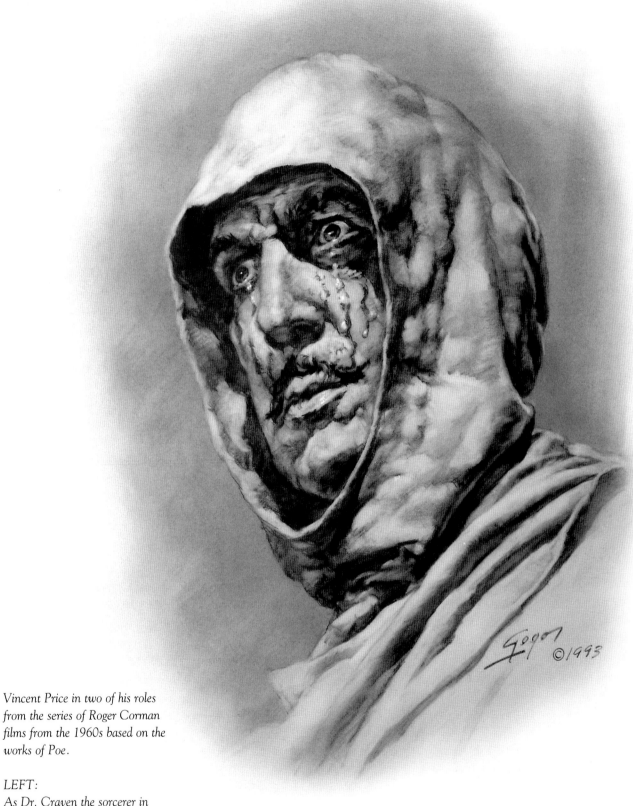

Vincent Price in two of his roles
from the series of Roger Corman
films from the 1960s based on the
works of Poe.

LEFT:
As Dr. Craven the sorcerer in
The Raven.

ABOVE:
Playing Death itself in The
Masque of the Red Death.

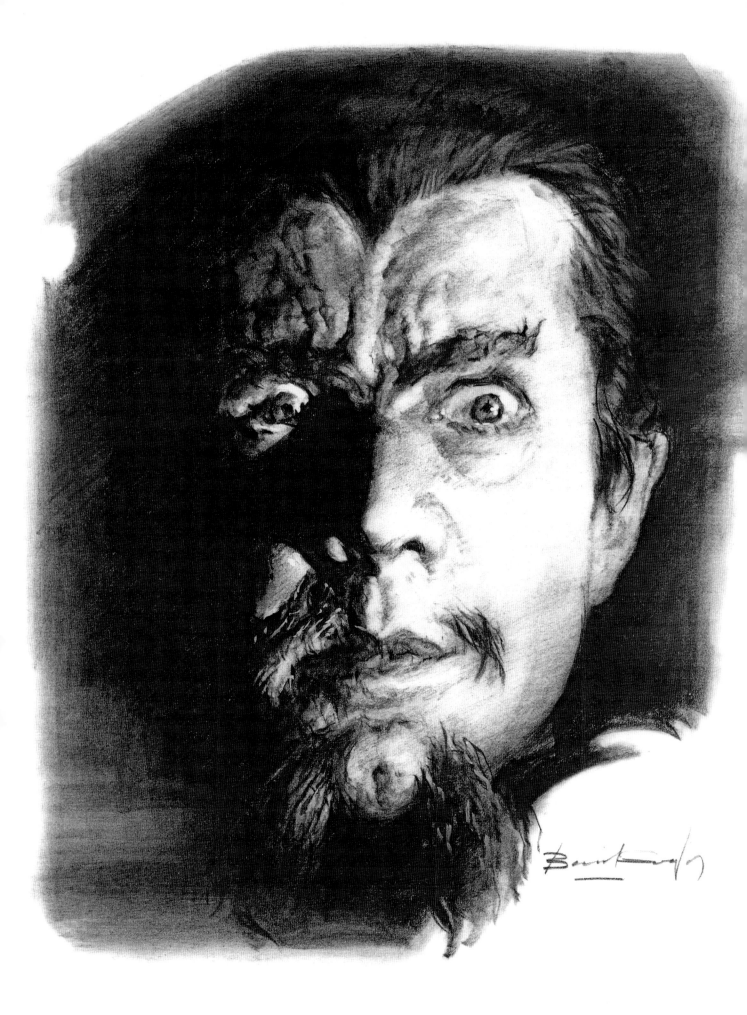

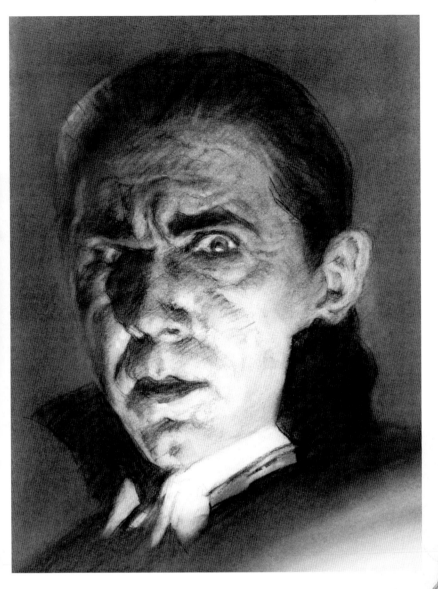

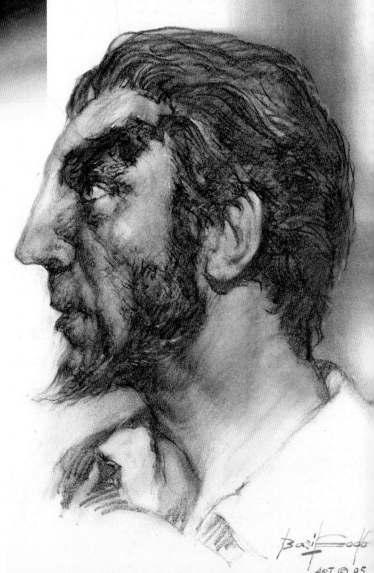

The fascinating face of Bela Lugosi.

LEFT:
At his most mesmerizing as voodoo master
'Murder' Legendre in the eerie
1932 classic, White Zombie.

ABOVE:
In the role that made him world famous
and launched the golden age of
sound horror films, the 1931, Dracula.

RIGHT:
Lugosi's distinctive profile was altered
for this test make-up for his role as
the "Sayer of the Law" in the still-powerful
1932 film, The Island of Lost Souls.

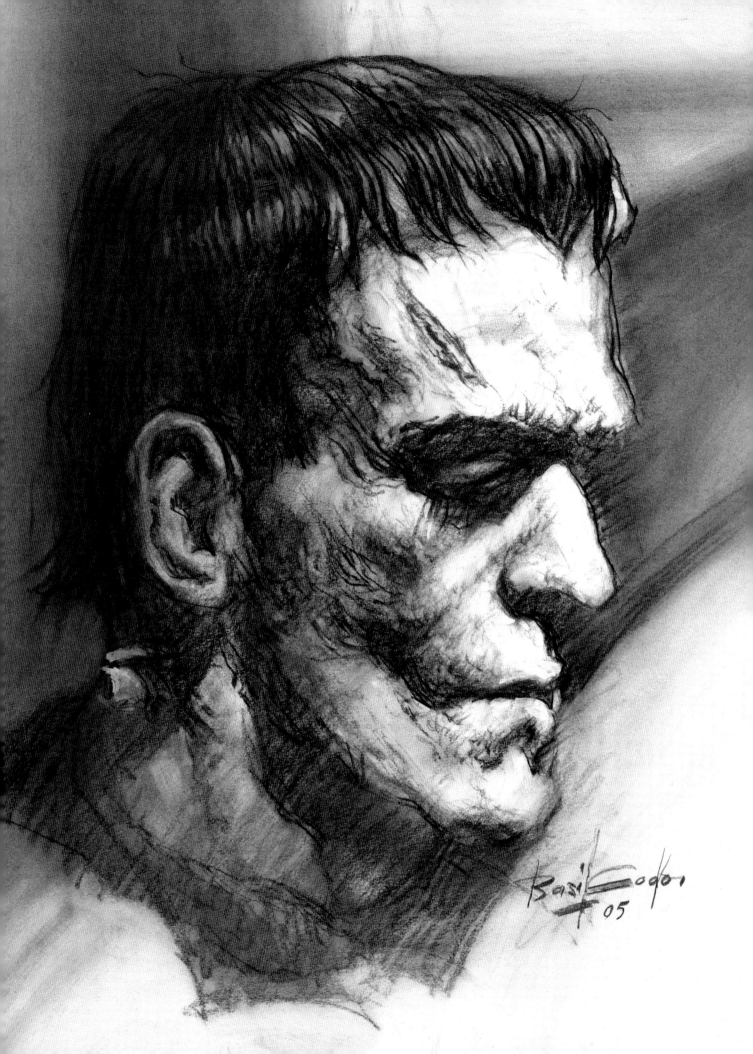

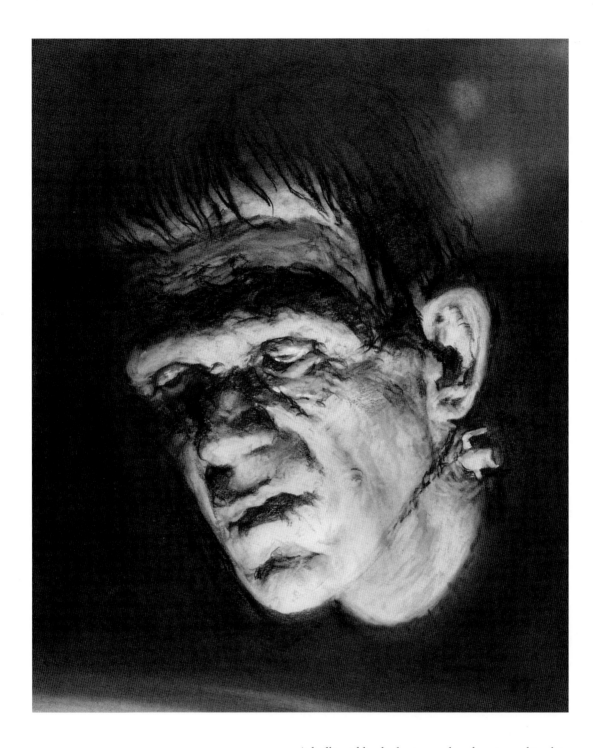

A brilliant blend of actor and make-up combined to create the most iconic screen monster of all time. Two charcoal studies of Boris Karloff as the inarticulate monster in the original 1931 Frankenstein. Make-up by the great Jack Pierce who created the make-up for all of Universal's monsters of the 1930s and 1940s including The Mummy and The Wolf Man.

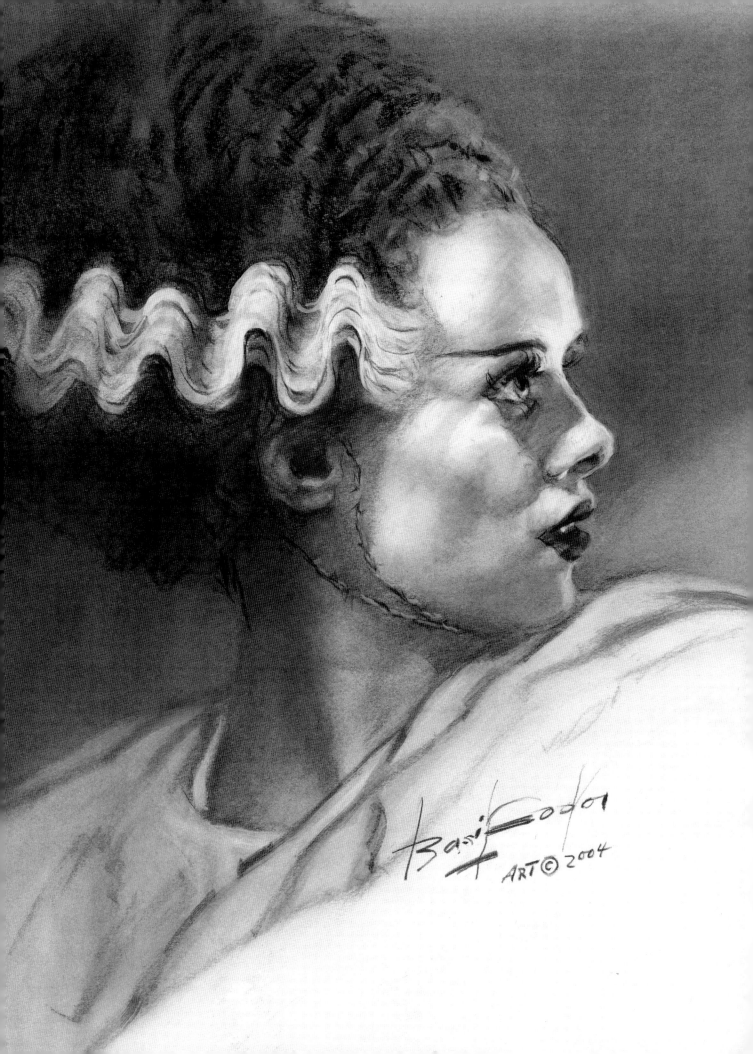

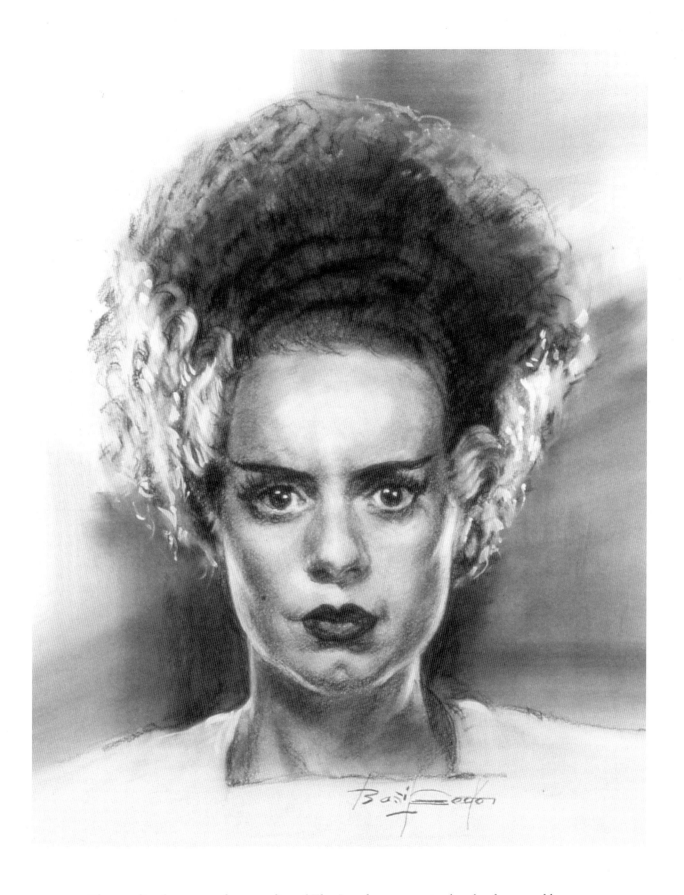

The peculiar features and personality of Elsa Lanchester were perfect for the swan-like female creation in director James Whale's 1935 masterpiece, The Bride of Frankenstein. The hairstyle was inspired by the Egyptian bust of Queen Nefertiti.

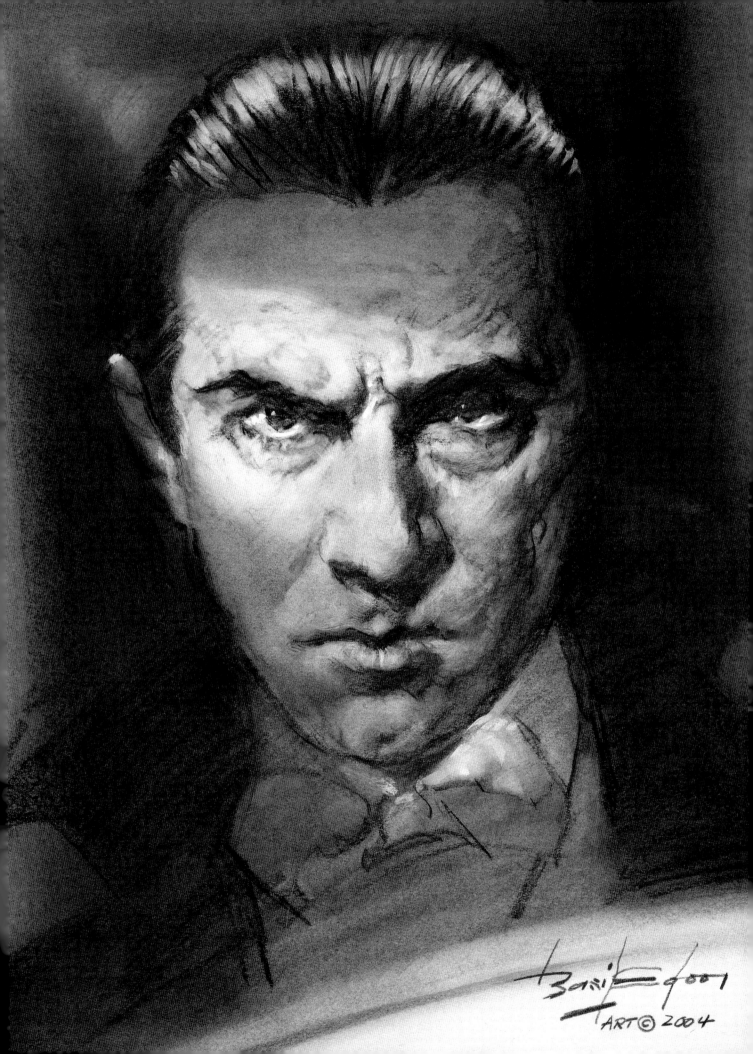

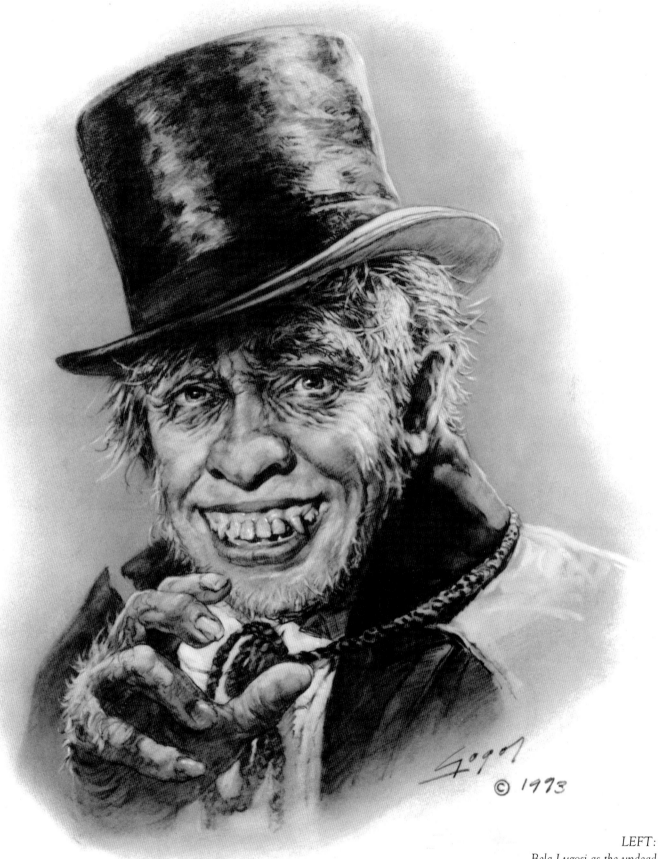

LEFT:
Bela Lugosi as the undead
Transylvanian count in Dracula

ABOVE:
Fredric March as the evil Mr. Hyde in the
1931 version of Dr. Jekyll and Mr. Hyde.

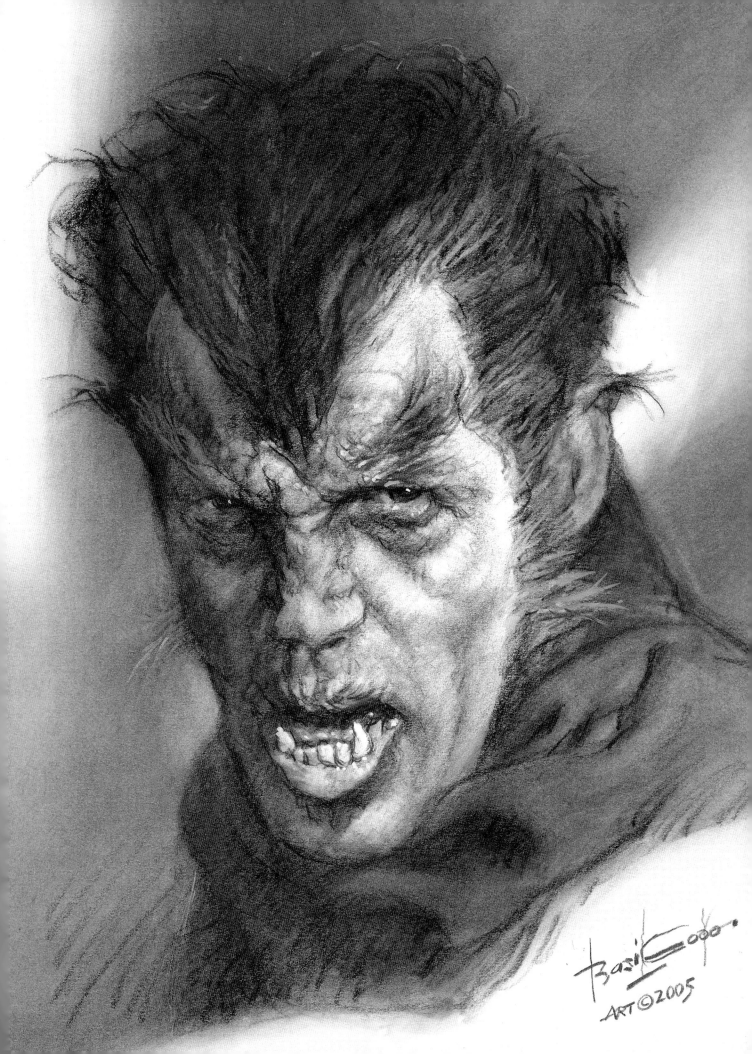

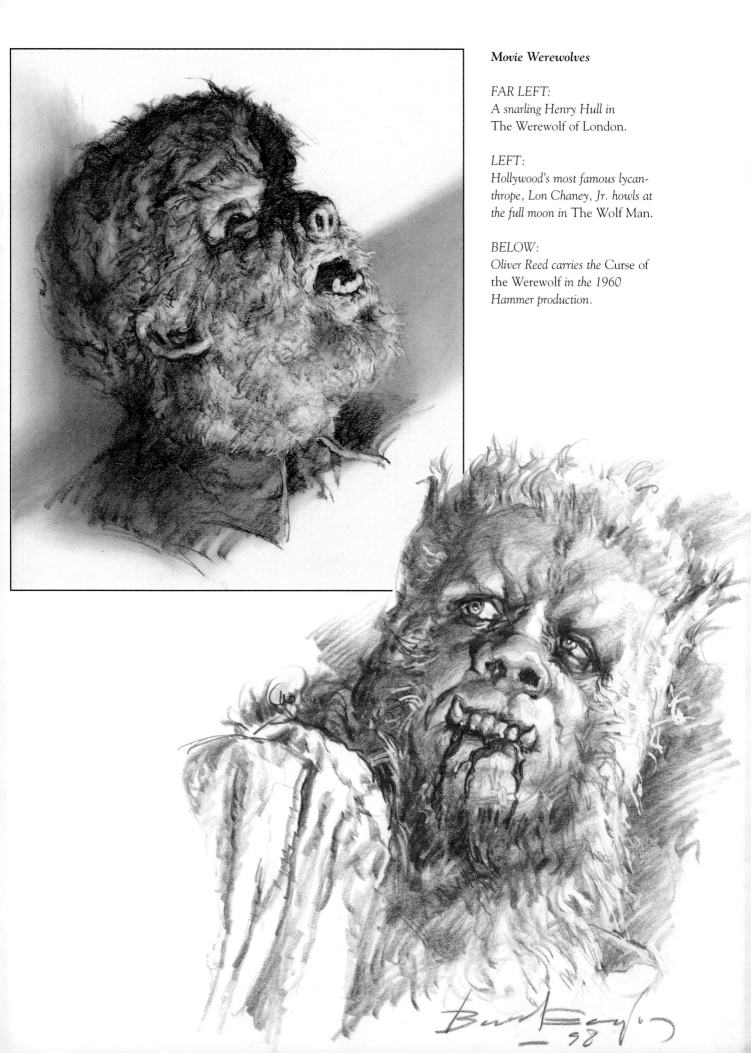

Movie Werewolves

FAR LEFT:
A snarling Henry Hull in
The Werewolf of London.

LEFT:
Hollywood's most famous lycan-
thrope, Lon Chaney, Jr. howls at
the full moon in The Wolf Man.

BELOW:
Oliver Reed carries the Curse of
the Werewolf *in the 1960*
Hammer production.

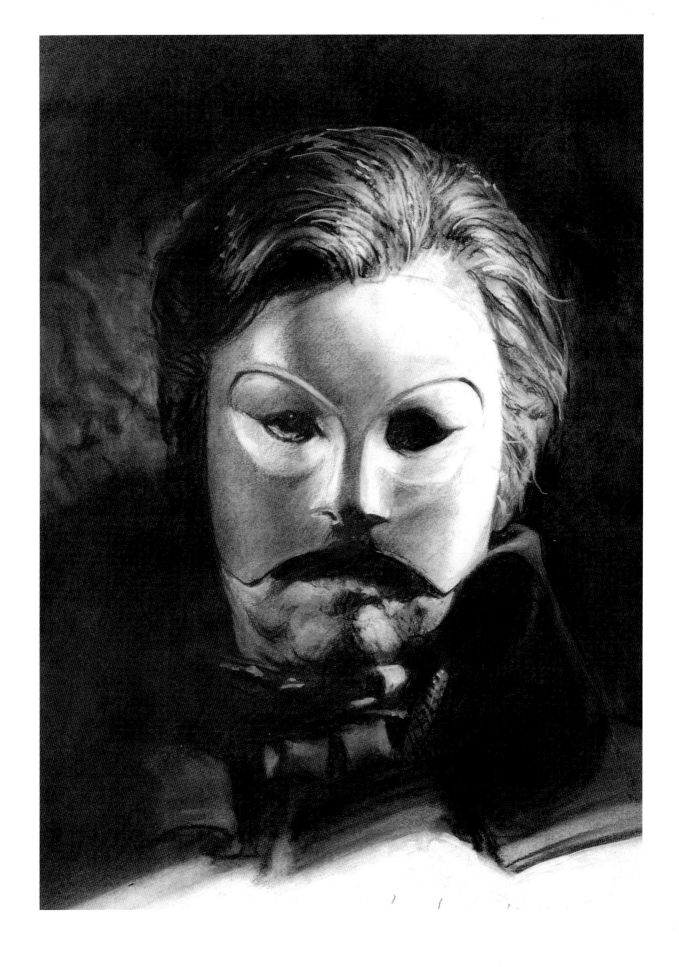

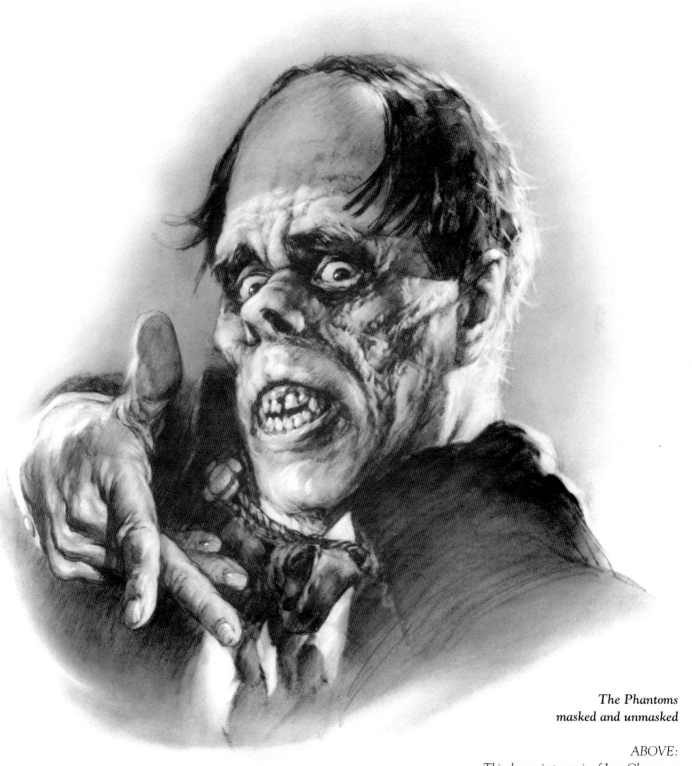

**The Phantoms
masked and unmasked**

ABOVE:
*This dynamic portrait of Lon Chaney as
The Phantom of the Opera was an original creation
based on dozens of character reference studies.*

OPPOSITE PAGE
*Claude Rains as the masked
Phantom in the stylish 1943 version.*

GOGOS ROCKS ON
Heavy Metal Horror

Although it may seem like an odd blend at first, when you think about it, the pairing of Basil Gogos and rock music makes perfect sense. Both offered pure excitement and emotion. And with some of today's rock stars looking more and more like monsters, it's only natural that they would think of Basil Gogos as the ideal artist to capture them in all their monstrous glory.

Gogos remembers how his first CD cover came about: "I got into it by virtue of The Misfits who were the first rock musicians to ask me to do a cover for them. They are horror fans and we had met at several horror conventions and became very good friends. At one of the shows they came over and said, 'We want you to do a CD cover for us.' It was the first time and I was a bit leery, but I said well, let's cut loose and see what develops."

BELOW RIGHT:
Basil Gogos art of the cover of Rob Zombie's Hellbilly Deluxe CD (acrylic, 1998).

BELOW LEFT:
Rock group Electric Frankenstein's Burn Bright, Burn Fast (acrylic, 2005).

OPPOSITE PAGE:
Detail of Gogos' illustration for Burn Bright, Burn Fast, done in a style similar to the frenetic underground and hot rod cartoon art which is the signature of the band's poster art.

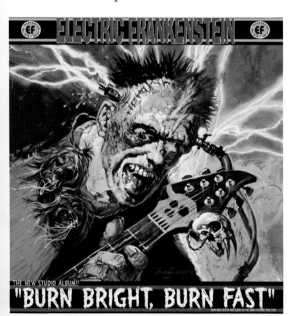

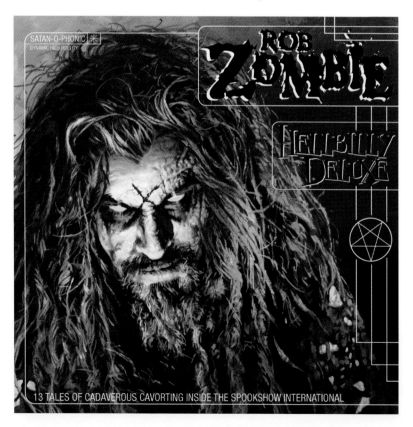

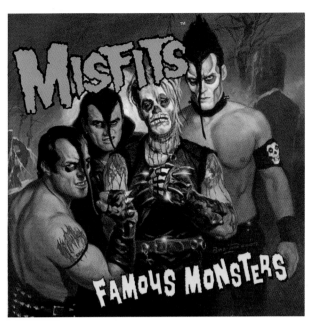

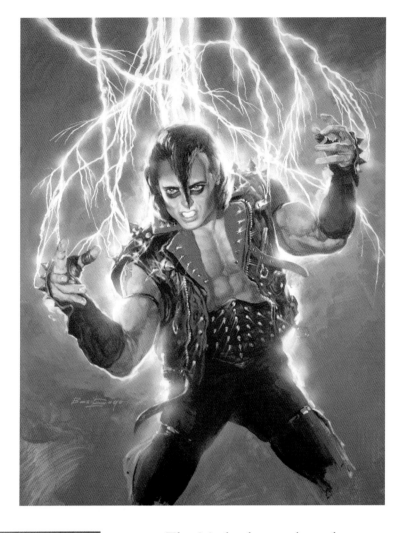

ABOVE:
Gogos' cover for The Misfits' CD appropriately titled,
Famous Monsters. *(acrylic, 1999)*

RIGHT:
A "striking" portrait of Misfits member Jerry Only.

BELOW:
art for the CD Misfits Meet The Nutley Brass.
(acrylic, 2005)

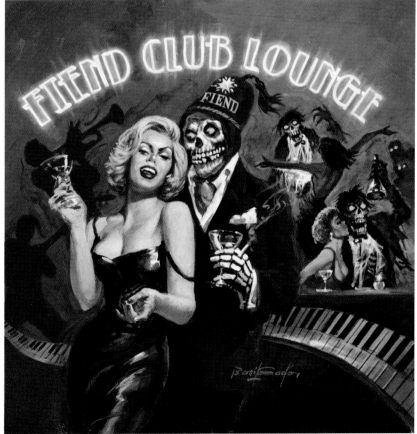

The Misfits have adopted as their trademark a hooded skull-faced villain resembling the character from 1940s serial, *The Crimson Ghost*. The character would have been a good candidate for a monster magazine cover of the 1960s so it was a perfect subject for a Gogos painting.

"The first thing I did for them was a painting that looked like the Crimson Ghost," Gogos recalls, "and then I did one of Jerry Only, a portrait of him in costume with lightning coming down and striking him. It was used as the cover of one of the rock music magazines."

The Misfits even titled one of their CDs *Famous Monsters* and asked Gogos to paint the entire group for the cover. When it was released, Jerry Only told *Cosmik Debris Magazine*, "Basil Gogos was one of the first artists we appreciated, because he did the covers for *Famous Monsters* magazine when we were

kids. So this album is actually our childhood dreams of being on the cover of *Famous Monsters*."

"Rob Zombie liked what I did for The Misfits and, being that he always liked my work, he gave me an assignment to paint the cover for his CD, *Hellbilly Deluxe*. Then I did another one for him for a CD with music from Frankenstein films and one more of his own music. And they were very successful. As a matter of fact, the *Hellbilly Deluxe* CD became a platinum record which is superb. And the record company gave me a citation for being a part of the platinum record.

"Before I knew it I was doing more work for rock stars for their CDs. And I find it to be exciting work. It gets me out of the realm of conventional illustration and seriousness and I have fun doing it."

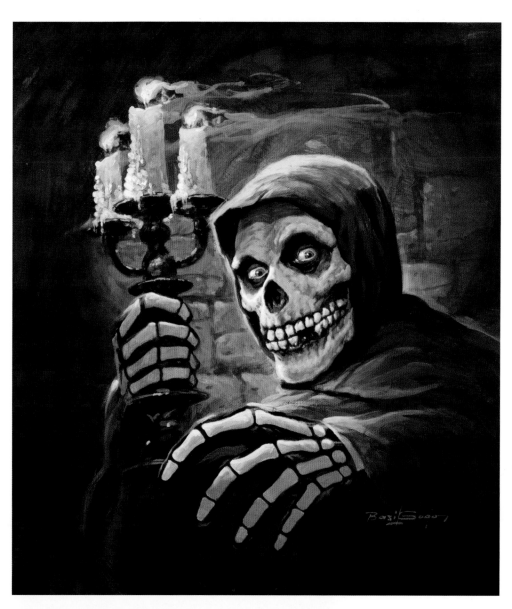

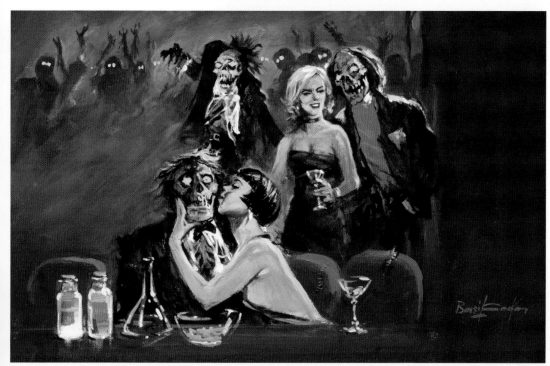

ABOVE:
The Misfits' mascot, as painted by Gogos for the CD American Psycho. *(acrylic, 1997)*

LEFT:
Art from the back cover of Misfits Meet The Nutley Brass. *(acrylic, 2005)*

149

LOOKING BACK
...and Ahead

Looking back over his long and varied career, it's clear that Basil Gogos could have gone in almost any direction he wanted. Classic horror film fans are very lucky that he spent a major portion of his career in the field of monster art.

Asked whether or not he likes being regarded as the world's greatest monster painter, Gogos replies, "I do, because it's the only place where I really excelled. And doing monster art I am usually my own art director, I do each piece the way I would like to paint it. I have total freedom. Whenever I do a monster for a magazine or a client or even for myself, I'm completely free. If people tell me what colors to use, I'm stumped. It gets in the way and it hurts the job. That's why I tell people, 'I will do it my way.' When people tell me what to do it holds me back. In other words, I hate to just render. Most of my career in art, I rendered and I hated that. But the monster portraits I do, the crazy way that I paint them, I do my way, and I love it."

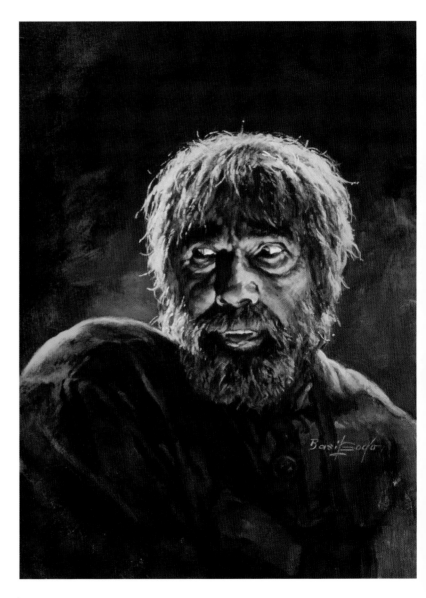

ABOVE:
Bela Lugosi as Ygor in Son of Frankenstein. A far cry from his suave Dracula persona, the gruff and crafty Ygor was one of Lugosi's best characterizations.

OPPOSITE PAGE:
A rather dark interpretation of Boris Karloff as the Monster in Son of Frankenstein.

150

Asked about his plans for the future, Gogos says, "I do want to go more into fine arts. I don't know how the fans are going to take it. I will still do monsters, but I also want to go into fine arts. I do have a plan and, I'd say, so far half a dozen paintings that I plan to do which are on a social level and political level. Eventually I'd like to do The Last Supper actual size. That's what I'd like to do. And I want to see it hanging in the Metropolitan Museum of Art in New York.

" *Basil Gogos doesn't paint pictures of monsters, and never has. What he does is conjure their essences on canvas like a magician. More than that, he conjures our love of these subjects in a manner that defies description or analysis. How does an artist infuse an entire fan community's love of a whole genre into his brushstrokes? I'll never be able to explain it, but I know I'll always be grateful for it. Seeing Gogos' portraits is revisiting the best friends of my childhood.*"

— **Frank Darabont**
Director of The Green Mile *and* the Shawshank Redemption, *Screenwriter of* Frankenstein (1994).

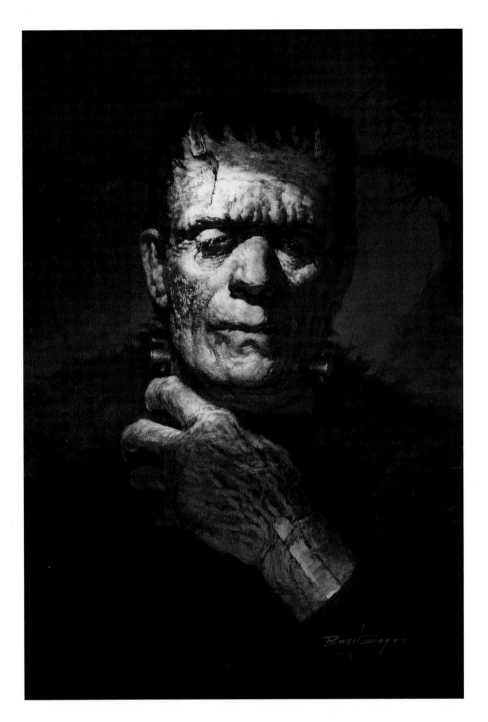

About this dark and moody portrait of Frankenstein's Monster, Gogos says, "I painted it during a rather depressing time in my life. I was supposed to go to Paris with Linda and her daughter but my father was very ill so I stayed behind to be with him. I was very depressed the next day because I couldn't help my father any more than I did. It was winter—very cold. I was also taking care of Linda's little dog, which was a very old dog, and next day the dog died—more depression. The next day was a gray, terrible, snowy, windy day. I went to my studio to try to work and this is what I was painting at the time. The Monster is also dead. I created all this lighting which doesn't exist. It's kind of wrong, but it works. And I kept the colors fairly dark. It reminds me of a depressing time but I love the piece just the same."

Asked if he enjoys modern horror films, Gogos replies. "I liked the monster movies very much up until the special effects became so important. I began to lose a little bit of interest because I am not a fan of special effects over characters. There was an element of romance years ago. Today almost every movie they remake is not as good. I liked *Wolf* with Jack Nicholson. The make-up reminds me of *The Werewolf of London*, which I think is a great make-up. But it was still not like the old movies. I miss the old days where they kept you constantly in contact with the essence of the movie. There was mood and atmosphere, not graphic gore. I don't go for that. As a matter of fact, I was asked to do a cover of this guy with the sharp blades on his hands, Freddy Kruger. And I said, 'No, I won't do it,' because I resent the character. It's a shock character, it's not a monster in the classic sense. So I do appreciate the old movies. There was a romance about them that I miss."

" Basil Gogos' work is a part of me, especially my youth. As an avid reader of Famous Monsters, *well actually I didn't read them much but I loved looking at the images, I am very familiar with his covers. They were always my favorites. You could spot a Gogos cover from a mile away. His bold use of colors and style was like no other. His work has made a lasting impression on this monster kid. I can't wait to see a book filled with his outstanding art work."*

— Rick Baker

Academy Award-winning make-up artist
Star Wars, The Ring, Men In Black, Ed Wood,
& American Werewolf in London.

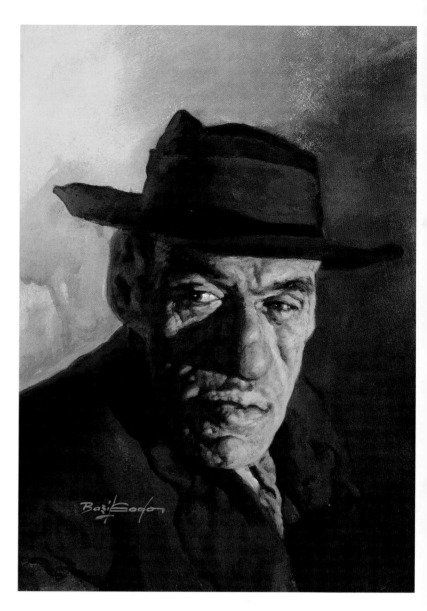

ABOVE:
Rondo Hatton, who portrayed the back-breaking killer, The Creeper in films of the 1940s, was the victim of the glandular decease acromegaly which distorted his facial features.

RIGHT:
A meeting of legends. famous monster artist, Basil Gogos meets legendary Shadow book cover illustrator, Jim Steranko at a 2005 New York appearance.

OPPOSITE PAGE:
A new portrait of Kong, from the original 1933 fantasy classic, King Kong.

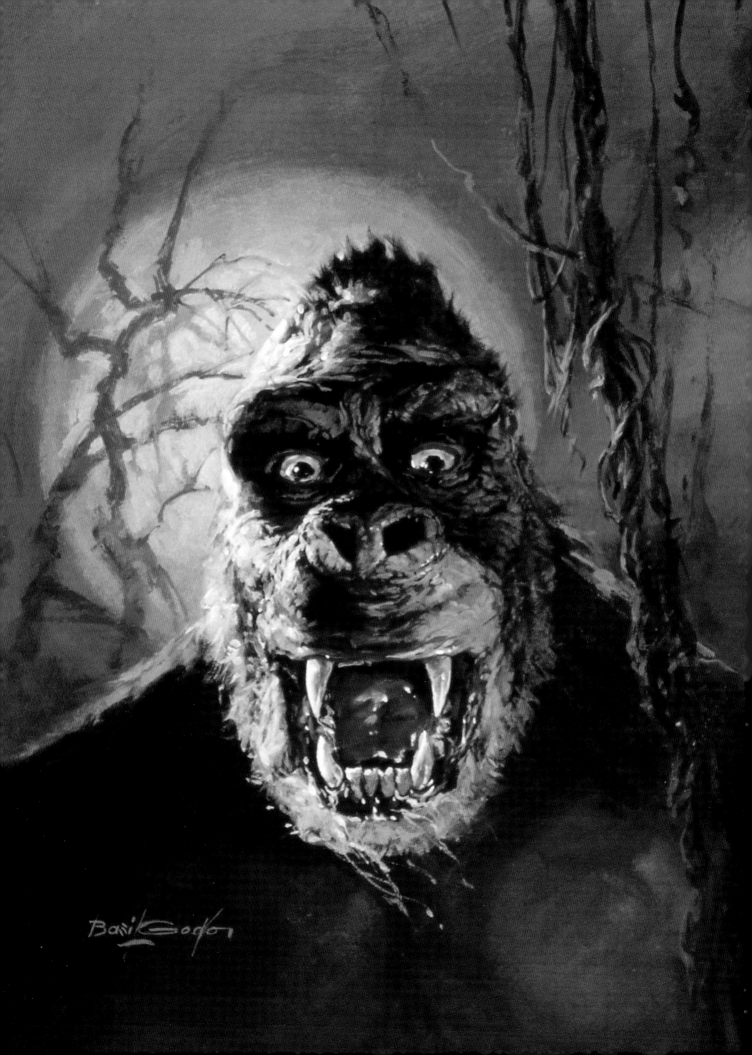

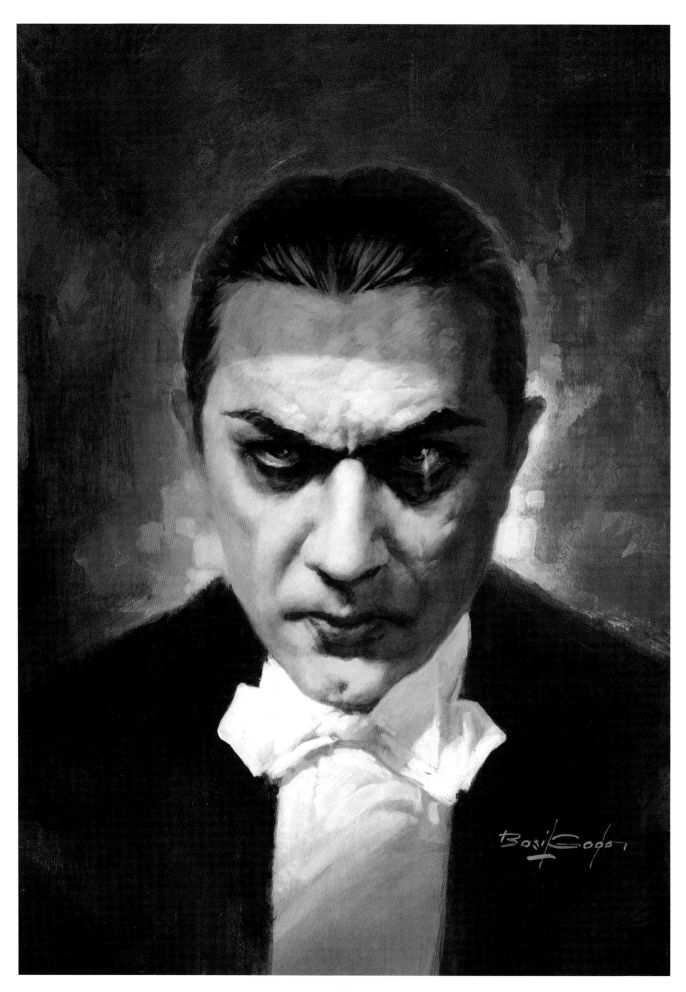

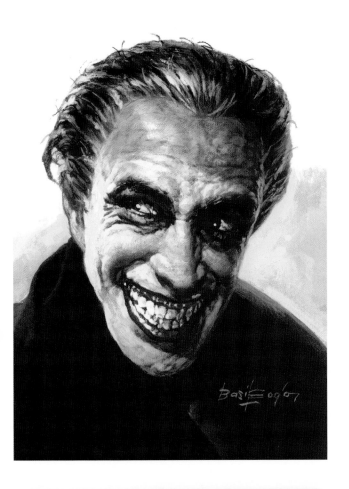

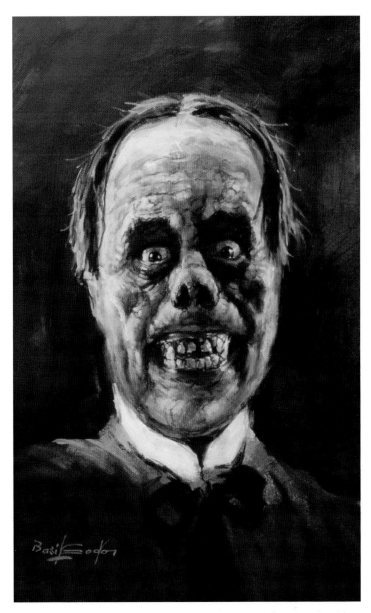

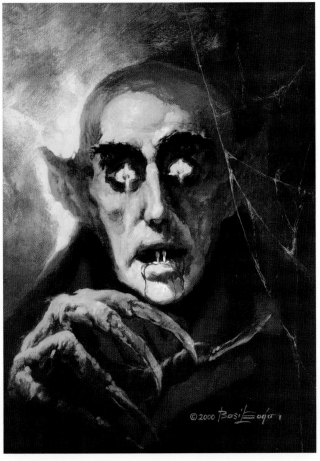

Terrors of the Twenties

TOP LEFT:
Conrad Veidt in the silent film, The Man Who Laughs.
This make-up was one of Batman creator Bob Kane's
inspirations for the look of The Joker.

LEFT:
Max Shreck in the silent German classic Nosferatu.

ABOVE: An interesting new painting of Lon Chaney
as The Phantom of the Opera.

OPPOSITE PAGE:
A sinister looking Bela Lugosi as he appeared in the original
production of Dracula, three years before recreating the
role for the classic film version.

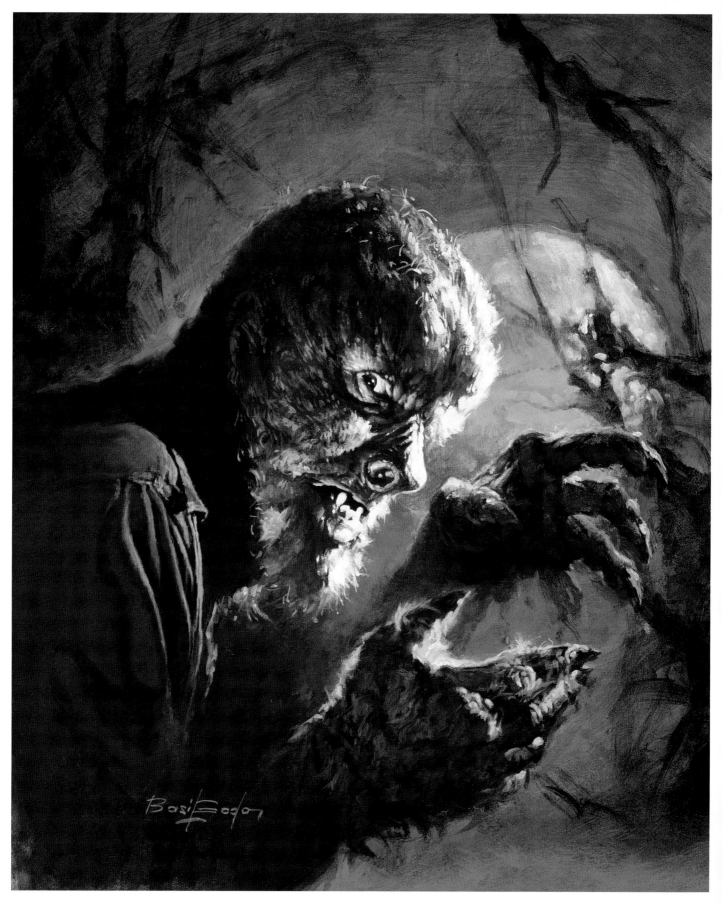

ABOVE: *A recent painting of Lon Chaney, Jr. as* The Wolf Man.

OPPOSITE PAGE: *a recent portrait of Boris Karloff as the Monster in* Bride of Frankenstein *for the cover of the CD,* Rob Zombie presents The Words and Music of Frankenstein.

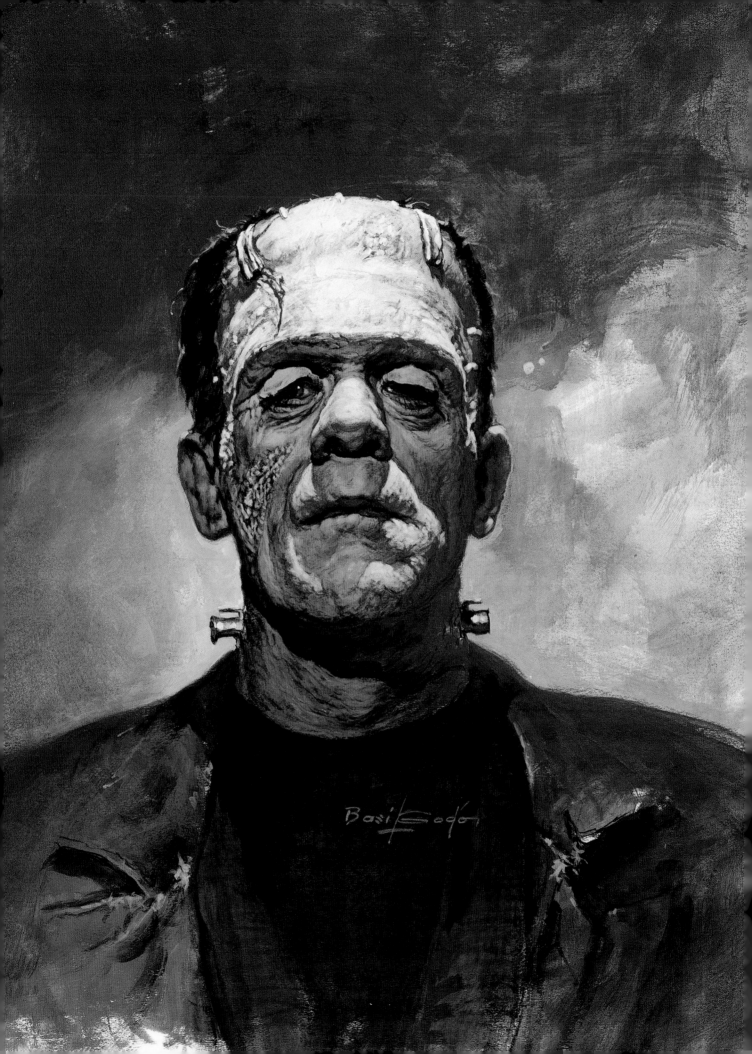

Basil Gogos

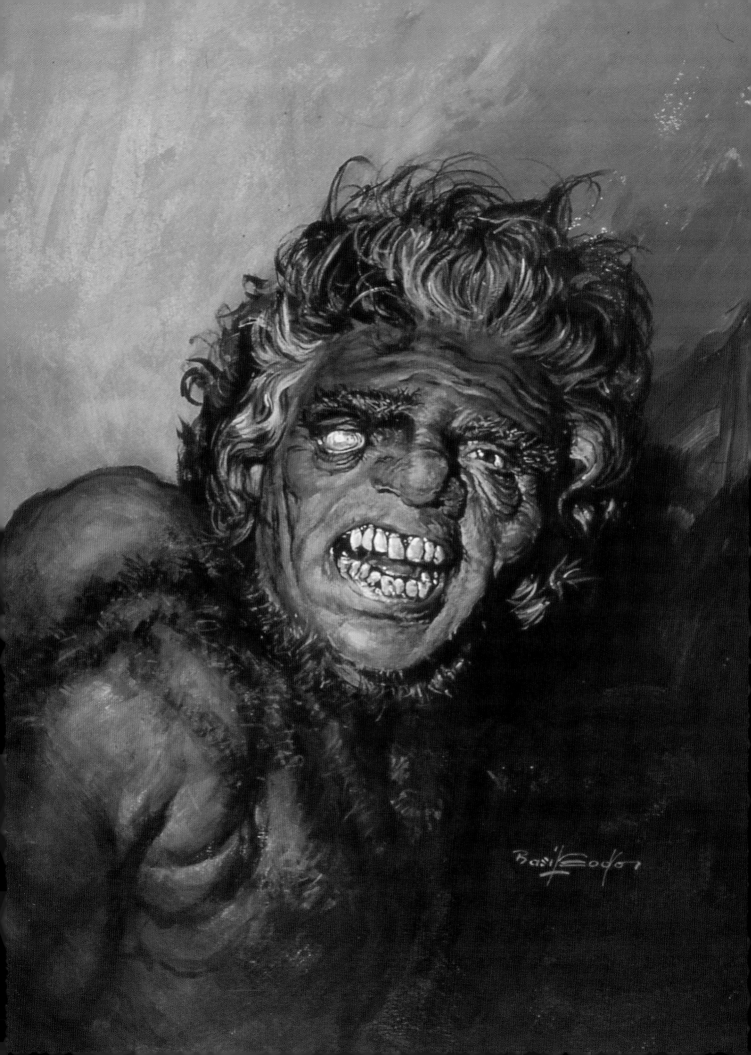

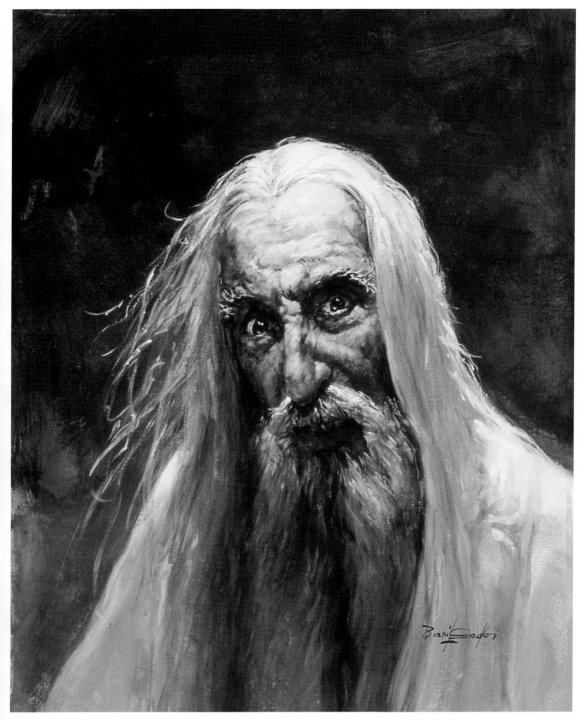

OPPOSITE PAGE:
A recent painting of James Cagney as the Hunchback of Notre Dame as seen in the Lon Chaney biography, Man of a Thousand Faces.

RIGHT:
Horror veteran Christopher Lee in one of his recent roles —as Saruman in Peter Jackson's Lord of the Rings.

Part of Basil Gogos' goal as an artist is to capture the inner feelings of the monster he portrays in his paintings and he hopes that his audience will look past their frightening appearance and recognize the sympathetic side of these monstrous beings. He elaborates, "I believe in the helplessness of the monsters. They are quite helpless. People do often develop compassion for the monster. Like the Creature from the Black Lagoon. When they keep shooting at him when he's on the shore, Richard Carlson says 'That's enough' after they wounded him so badly. The Creature can't help what it is. So that compassion is something that I search for and it seems to come through my paintings. Most monsters well deserve some compassion. As dangerous as they may be, it's a natural thing for them. They're animals, or think like animals, and can't help themselves. They're frightening creatures but nevertheless, they live. And we are always trying to destroy them."

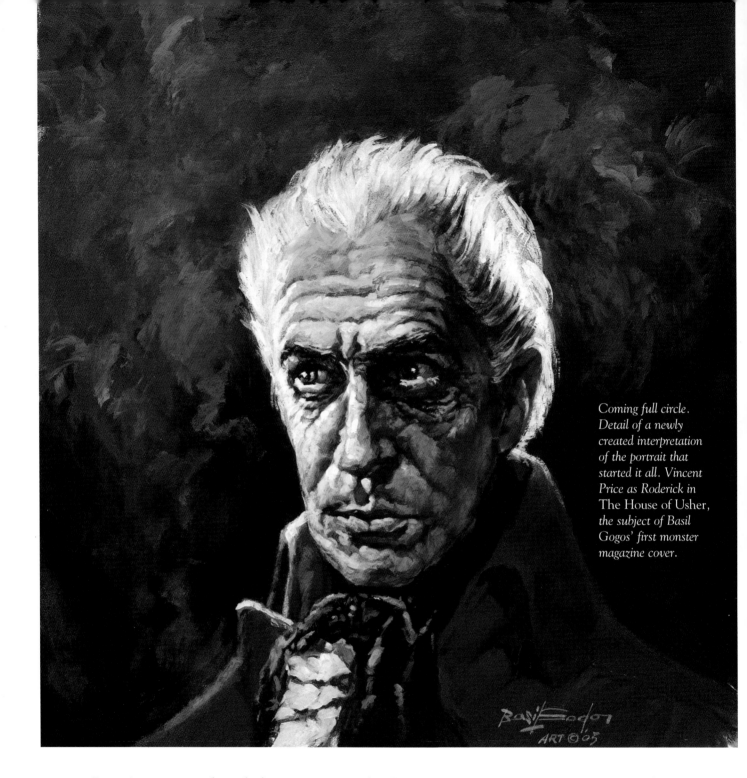

*Coming full circle.
Detail of a newly
created interpretation
of the portrait that
started it all. Vincent
Price as Roderick in*
The House of Usher,
*the subject of Basil
Gogos' first monster
magazine cover.*

Gogos' current work includes commissions for CD covers, movie art, monster portraits for private collectors, and his personal fine art. Looking at the scope of Basil Gogos' career, it seems that he can do almost anything. Gogos responds, "I had been trained to do anything and everything, and do it well. I've been trained well and can compete with anyone in any field."

As proof of that, Gogos recently entered a national competition for wildlife artists. "I came in eleventh out of over 800 entries. Most of these people do nothing but wildlife. I paint monsters, tanks, women. I was awarded a citation from the government for being one of the best wildlife painters in America."

Gogos continues, "That's why I say I was trained to do anything and everything very well. Sometimes that's not a plus in an artist. If an artist specializes in one thing, you become so good that no one can touch you. But often, it's like you divide your talents. The pie gets sliced too thin. You become a jack of all trades—master of none. That's one thing I never experienced. While I worked in many areas, I remain the master of monsters. So, no complaints!"